PAUL STRAND

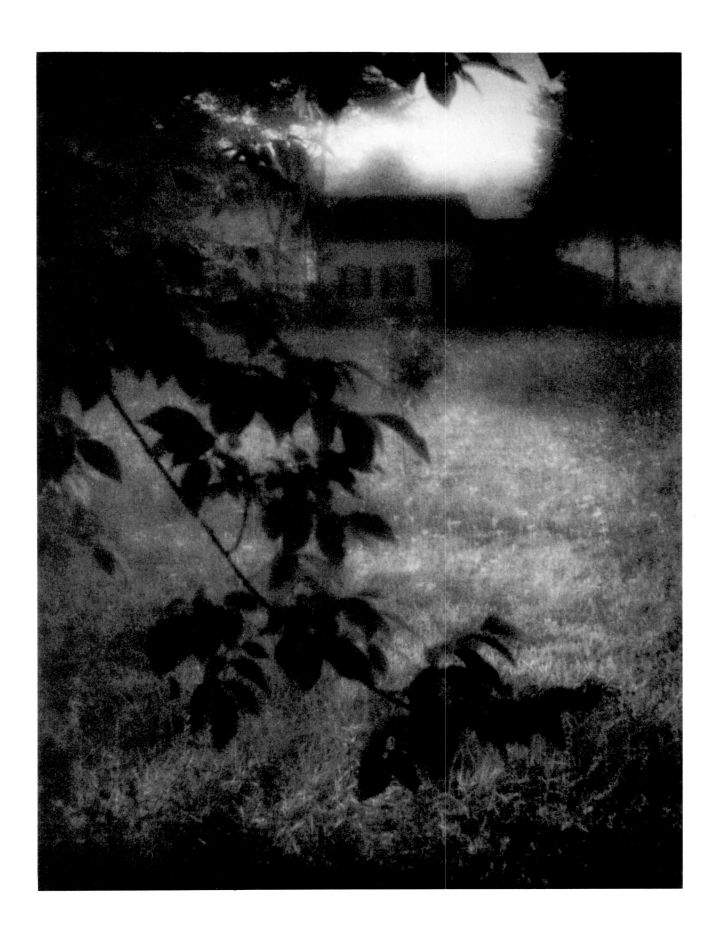

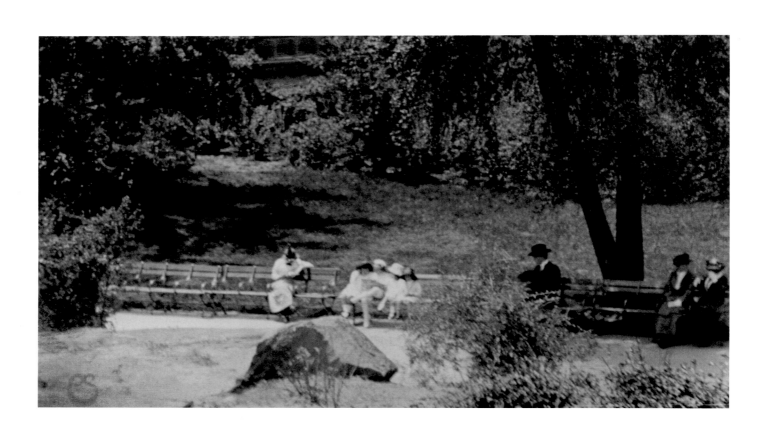

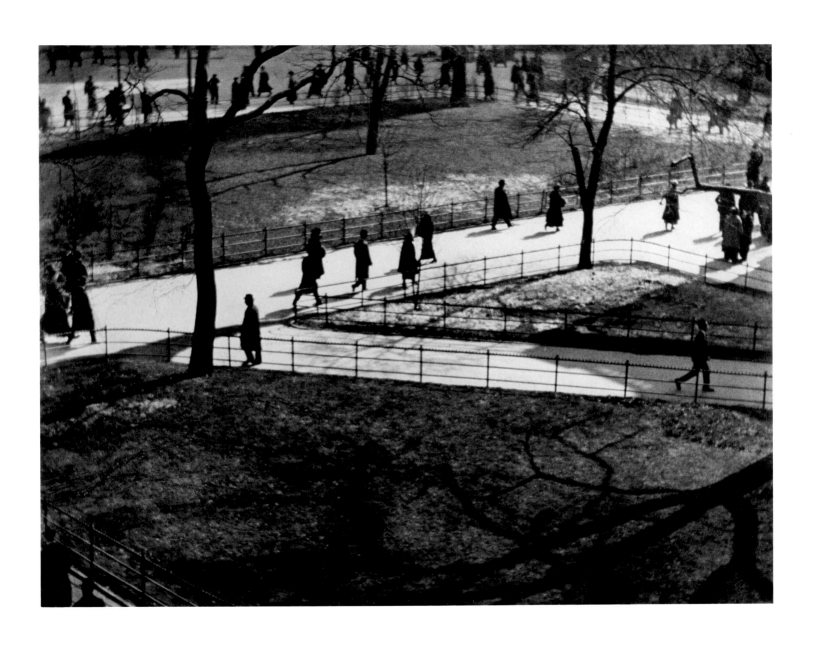

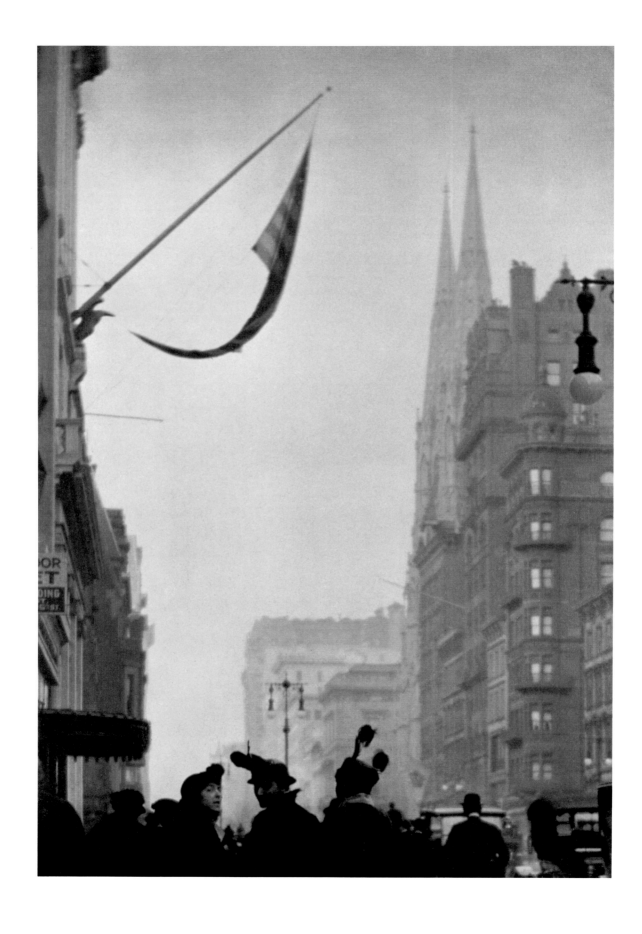

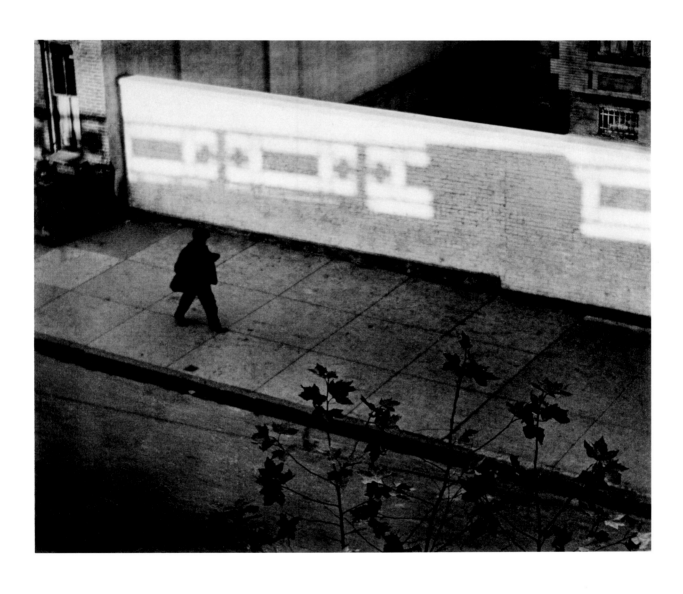

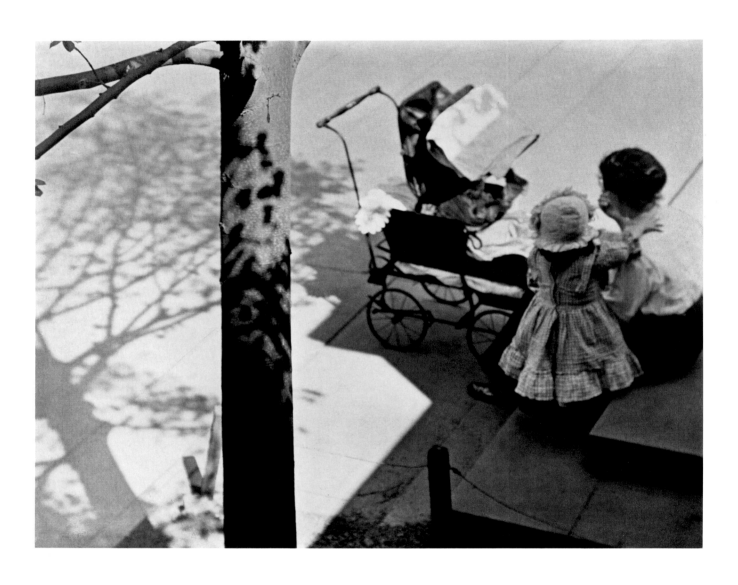

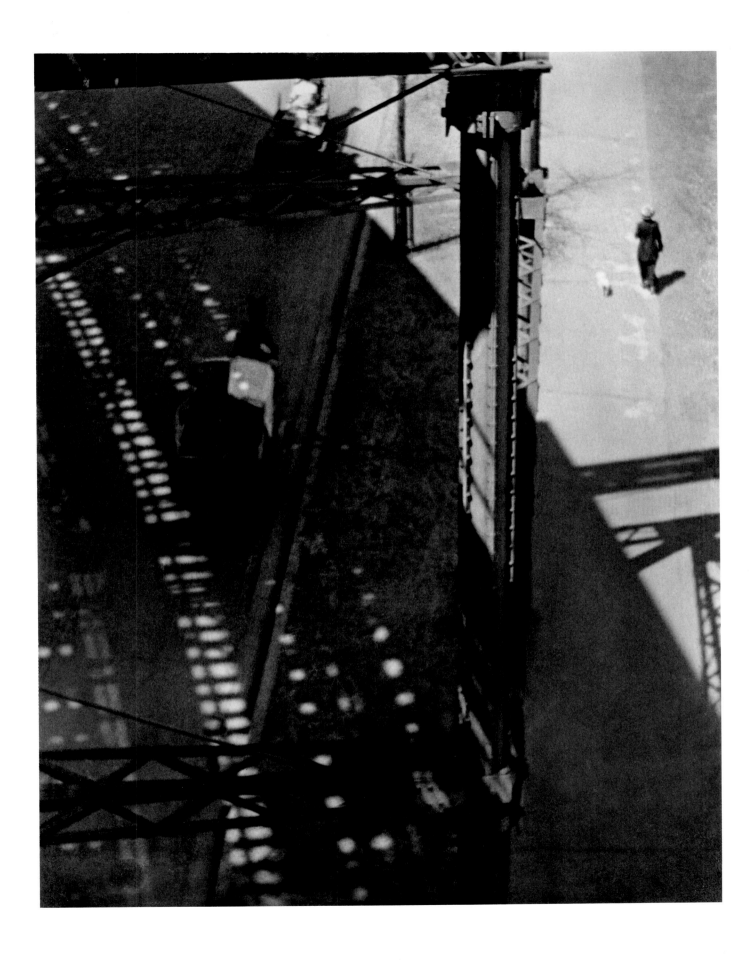

PAUL STRAND

SIXTY YEARS OF PHOTOGRAPHS

PROFILE BY CALVIN TOMKINS

EXCERPTS FROM
CORRESPONDENCE, INTERVIEWS,
AND OTHER DOCUMENTS

AN APERTURE MONOGRAPH

Library of Congress Catalog Card Number: 76-42103
ISBN: Hardcover 0-912334-819
ISBN: Paperback 0-900406-828

Book design by Peter Bradford
Cover design by Stephen Korbet

Duotone separations by Thomas Palmer
Printed and bound in China by
Sing Cheong Printing Co. Ltd.

Aperture Foundation publishes a periodical, books, and portfolios of fine photography to communicate with serious photographers and creative people everywhere. A complete catalog is available upon request. Address: 20 East 23rd Street, New York, New York 10010. Phone: (518) 789-9003. Fax: (518) 789-3394. Toll-free: (800) 929-2323. Visit Aperture's website: http://www.aperture.org

Aperture Foundation books are distributed internationally through:
CANADA: General/Irwin Publishing Co., Ltd.
325 Humber College Blvd.
Etobicoke, Ontario, M9W 7C3.
Fax: (416) 213-1917.
UNITED KINGDOM, SCANDINAVIA, AND CONTINENTAL EUROPE:
Robert Hale, Ltd., Clerkenwell House
45–47 Clerkenwell Green
London, United Kingdom, EC1R OHT.
Fax: (44) 171-490-4958.
NETHERLANDS, BELGIUM, LUXEMBURG: Nilsson & Lamm, BV,
Pampuslaan 212-214, P.O. Box 195, 1382 JS Weesp.
Fax: (31) 29-441-5054.
AUSTRALIA: Tower Books Pty. Ltd.
Unit 9/19 Rodborough Road,
Frenchs Forest, New South Wales
Sydney, Australia.
Fax: (61) 2-9975-5599.
NEW ZEALAND: Southern Publishers Group,
22, Burleigh St. Grafton
Auckland, New Zealand.
Fax: (64) 9-309-6170.

INDIA: TBI Publishers, 46, Housing Project
South Extension Part-I, New Delhi 110049
India. Fax: (91) 11-461-0576

For international magazine subscription orders for the periodical *Aperture*, contact Aperture International Subscription Service, P.O. Box 14, Harold Hill, Romford, RM3 8EQ, United Kingdom. One year: $50.00. Price subject to change.

To subscribe to the periodical *Aperture* in the U.S.A. write Aperture, P.O. Box 3000, Denville, New Jersey 07834. Toll-free: (800) 783-4903. One year: $40.00. Two years: $66.00. Price subject to change.

First edition
10 9 8 7 6 5 4 3 2

Paul Strand died at the age of eighty-five on March 31, 1976. He spent his last days going over his photographic prints, checking their quality, and looking over his many books with an eye to the completion of this volume. Because of his insistence on growth and movement towards perfection in any new project throughout his career and to be true to his vision, the editors examined over three thousand photographs, constituting the main body of the work of a lifetime. There were many discoveries of powerful and handsome images never before available, certain of which are included here.

This book represents the power and force of a major figure of our time. It could not have been made without the constant devotion, endless efforts, and advice of Hazel Strand, who carries on the work of her husband in many ways. Naomi Rosenblum, scholar and friend of the Strands for thirty years, gathered material for the book from the scrapbooks, correspondence, and papers and generously shared excerpts from her notes, tapes of Strand, and research. She has kindly updated the bibliography and chronology. The Strand library contained a valuable and informative interview by Dr. Milton Brown and Walter Rosenblum which was made for the Archives of American Art. Excerpts from his interview are included.

The letters and papers are now part of the Paul Strand Collection at the Center for Creative Photography, University of Arizona, Tucson, Arizona. The photographs on pages 3, 5, 7, and 57 were provided through the courtesy of The Museum of Modern Art. The photographs on pages 47, 55, and 79 were provided through the courtesy of the National Gallery of Art.

Stephen Korbet provided the design for the cover; and Peter Bradford, who worked with Strand before on the two volume retrospective monograph published in 1972, provided the typography and design for the book. Sidney Rapoport and Stevan Baron directly supervised the printing to insure facsimile reproduction. Ann Kennedy assisted me in making the selection and sequence, providing diligent and thoughtful support at every step.

MICHAEL E. HOFFMAN, Editor

TABLE OF CONTENTS

PHOTOGRAPHY has been with us now for nearly a hundred and fifty years, and the old argument over its aesthetic status—is it or is it not an art?—was resolved long ago. The major art museums all collect and exhibit photographs as a matter of routine, many art schools offer courses in photography, and the number of galleries that sell photographic prints is steadily increasing. So far, however, the medium has produced surprisingly few major artists. There are, of course, any number of great photographers —men and women whose perception, diligence, and technical mastery have made them famous in such fields as pictorial journalism and fashion photography—but the number of photographers who have gone beyond this level of competence to produce images that will bear comparison with the work of, say, a Matisse or a de Kooning is extremely small. In this century, by general agreement, America has produced only three photographic artists of this calibre: Alfred Stieglitz, Edward Weston, and Paul Strand. Stieglitz died in 1946, Weston in 1958. Strand continued adding quietly to his immense body of work until his death in April, 1976, at the age of eighty-five.

The word "quietly" applies to the work as well as to the man. Strand's photographs do not call attention to themselves. They lack the dramatic intensity of nearly any print by Weston or Stieglitz, whose images often seem to be straining to escape from the frame. Strand's images are at rest within the frame—at rest in a space charged with a dense and complex life of its own. The longer one looks at them, the more they reveal. His career is a rare modern case of the artist virtually disappearing into his art. And yet, paradoxically—as several critics noted in reviewing the large retrospective of Strand's work that opened at the Philadelphia

Museum of Art in 1971 and subsequently toured the country—what is almost as remarkable as the quality of the work is the consistency of Strand's vision. Although his range of subject matter is wider than that of many other well-known photographers— portraits, landscapes, abstractions, machinery, details of natural forms, architecture, and village life in various parts of the world being among his recurrent themes—his methods and his ways of seeing changed so little that the photographs he made in Mexico in 1966 are impossible to differentiate from those he made there thirty years earlier. It would be hard to think of another twentieth-century artist whose work is characterized by such a serene and untroubled self-assurance, and in this sense it might be said that Paul Strand was an anachronism. He believed in the almost extinct virtues of craftsmanship, asserting (as he did in 1922) that "quality in work is prerequisite to quality of expressiveness." He worked for much of his life without much material reward, and only in recent years did he attain anything like wide recognition. Moreover, as his pictures eloquently demonstrate, he retained all his life the unfashionable conviction that human dignity was not only desirable but frequently attained.

"I remember travelling with Strand in Italy some years ago and introducing him to the magnificent frescoes of Piero della Francesca in the Church of San Francesco in Arezzo," the art historian Milton Brown has written. "The rapport between the two artists was immediate. Strand wanted to see all of Piero's works available in northern Italy, and we did, in Borgo San Sepolcro, Urbino, Rimini, and Milan; his appreciation of the great Renaissance master was intuitive and profound. It was not strange, since they have so much in common, that Strand should respond to Piero's serene grandeur, the peasant robustness transformed into patrician dignity, the real transmuted into the ideal, the ordinary in man and the transitory in nature con-

verted into eternal symbols, all expressed with an impeccable sureness of means and a not too easy elegance, since it is not an elegance of fashion but of spirit. Strand's art, like Piero's, is the expression of a nobility of mind as well as style. In his sight the meanest things take on importance, the lowliest of people assume heroic stature."

Strand made very few concessions to the advancing years. He was a compact, sturdy man with an upright bearing and a strong, calm presence that made him seem both taller and younger than he was. In spite of increasing deafness and cataract operations on both eyes, he kept right on working with all his customary energy and precision, in the darkroom and behind the camera. A few of the nearly five hundred prints in the Philadelphia retrospective were old platinum prints that he had made before 1937, but the majority were new, printed by Strand in the darkroom that he designed for himself in his house in the village of Orgeval, some thirty kilometres west of Paris, where he and his third wife had lived since 1955. As it often took Strand three days of solid work to print a negative to his satisfaction, the printing job required more than two years, and during that period he had little time left over for photographing. He managed, however, to put together a book of his photographs on Ghana, and from time to time he talked impatiently of going back to Morocco to finish his work for a book on that country. Except during his early years, when he used a 3¼ x 4¼-inch reflex camera, Strand worked mainly with the big, heavy equipment of an earlier era—with an 8 x 10-inch Deardorff view camera and a 5 x 7-inch Graflex that he started using in 1931. "I just don't like that little 35-millimetre image," he said. He had no interest in color, which he looked upon as insufficiently developed for the kind of work that interested him.

"It's a dye," he said. "It has no body or texture or density, as paint does. So far, it doesn't do anything but add an uncontrollable element to a medium that's hard enough to control anyway." In Egypt in 1959, he began working with a 2¼ x 3¼-inch hand-held reflex camera, because certain subjects seemed to require more mobile equipment. Eventually he came to favor the smaller camera, but there were still occasions when he worked in the manner of a nineteenth-century master like Atget, setting up his tripod, retreating under the black headcloth, and composing on the groundglass the images that he would then reproduce, with absolute fidelity, in the darkroom.

John Szarkowski, director of the Department of Photography at the Museum of Modern Art, has compared the career expectancy of most creative photographers to that of left-handed pitchers. "The medium is so transparent," Szarkowski observed. "There's so little to hide behind. When your perceptions fail you—when your seeing begins to get lazy or habitual—there's no place to hide. A painter has millions of ways of putting one color next to another. He can hide in the richness of the painting process. But not the photographer. Strand's achievement is really heroic. He's been making great photographs for sixty years."

Strand's own view of the matter was typically anachronistic. In a century whose major artists have continually stressed form over content, he believed in the sustaining power of subject matter. "Almost all the things of the world have their own character," he said in 1973. "I think that what exists outside the artist is much more important than his imagination. The world outside is inexhaustible. What a person feels about life is not inexhaustible at all." Strand was sitting in a canvas chair in the small basement apartment that he and his wife kept on East Fifth Street, near St. Mark's Place, for their visits to this country. He spoke slowly, reflectively, his unmistakably New York intonation softened by a

slight but agreeable lisp. "Hazel and I just flew back from Los Angeles," he said. "From the opening of my exhibition out there. And looking down at parts of Nevada and Arizona from the air was—well, thrilling. The world is such a complex of marvellous things, and if you can find a way of using that complexity in your work, then it's endless. What counts for the artist is to do something he's never done before. That's what stretches him, makes him grow."

The conversation touched on contemporary art, which Strand no longer kept up with, and on the deliberate denial of craftsmanship in such avant-garde forms as Conceptual and "process" art. Could art really exist without craftsmanship? "I suppose so," Strand said after a moment. "Although I don't personally know any significant form of art in which craftsmanship plays no part. It's one of the instruments of graphic speech, it's part of the orchestra. Some artists use the full orchestra, some use less, but I don't know of any who throw it away. People want to know what the content is, I think. What you describe, and what I haven't seen, sounds like coming to the end of the road and not yet finding another road to travel. But to announce that you have come to the end of the road is not a very interesting announcement."

STRAND WAS BORN and brought up in New York City. The family's name was originally Stransky; Strand's father changed it shortly before Paul, his only child, was born, in 1890. The family was living then in a brownstone on East Seventy-third Street, but three years later they moved to a house on West Eighty-third, near Riverside Drive, which was where Strand grew up. The household consisted of Strand and his parents, an unmarried aunt, and Strand's maternal grandmother, Catherine Arnstein, who was the real center of the ménage. She and her husband had come over from Bohemia (now western Czechoslovakia) about 1840. Grandfather Arnstein had done well in the lace business in New York but then had lost nearly everything in the stock market, leaving little inheritance. The house on Eighty-third Street was bought and given to Grandmother Arnstein by her son-in-law, a successful lawyer for the U.S. Rubber Company named Nathaniel Meyers, and the family lived on the combined earnings of Strand's Aunt Frances, who taught one of the city's first public kindergarten classes, and his father, Jacob Strand, who was for many years a salesman of French bric-a-brac, enamel cooking ware, and other household items.

Strand was given a Brownie camera by his father when he was twelve, but he was so taken up then with the pleasures of spinning tops, roller-skating, and bicycling on the uncrowded streets (the first automobiles were just starting to appear, and the fire engines that Strand loved to chase after were horse-drawn) that he paid little attention to it. In 1904, however, Strand's parents, alarmed at the rough behavior of a number of kids from Hell's Kitchen in the local public school, enrolled him, at considerable financial sacrifice, in the Ethical Culture School, on Central Park West. One of the science teachers there was Lewis W. Hine, a young sociologist whose powerful photographs of children in factories would soon play a major part in the passing of new child-labor laws. Hine, who by this time had begun to photograph immigrants arriving at Ellis Island and then to follow them into the slums where so many of them became trapped, gave an extracurricular course in photography at Ethical Culture. Strand and about six other students signed up for it. They learned the fundamentals of camera and darkroom work, and how to use an open-flash pan of magnesium powder for indoor photography. Hine also took them to Stieglitz's Photo-Secession Gallery, at 291 Fifth Avenue, and it was here that Strand, discovering the work of David Octavius Hill and Robert Adamson, Julia Margaret Cameron,

Gertrude Käsebier, Clarence White, and other pioneers—including, of course, Stieglitz himself—decided, at seventeen, what he wanted to be in life. No matter what else he had to do to support himself, he wanted from that day to become "an artist in photography." He had no interest in going to college, which would have been a further strain on the family finances in any case. For a year or so after he graduated from Ethical Culture, he worked as an office boy in his father's importing firm. The firm was bought out by another company in 1911, whereupon Paul, in the face of severe family misgivings, took all his savings and spent them on a trip to Europe. For six weeks, he devoured the Continent country by country, visiting all the major museums and monuments and covering vast distances on foot. ("I had boundless energy in those days.") He came back in the fall to a job with an insurance firm, which he loathed. A few months later, toward the end of 1911, he quit and went into business for himself as a professional photographer.

Ever since his class with Hine, Strand had been spending most of his free time photographing, at first with a cumbersome 8 x 10-inch view camera, which he had on more or less permanent loan from his well-to-do uncle, and later with an English-made Ensign reflex plate camera that he bought himself. He joined the Camera Club of New York, which had good darkroom facilities, and which he was able to use as a portrait studio. Strand's mother felt that photography was not a suitable profession for anyone who wanted to get ahead, but his father seemed from the outset to understand it. "I think he knew right away what kind of photographer I wanted to become," Strand said. "My father was not an intellectual man, but he was immediately interested by what he saw when I took him to the Photo-Secession Gallery, and he developed an extraordinary feeling for pictures. He felt that art was important."

Strand did a good deal of portrait work at first. He also travelled around the country taking pictures of colleges and fraternity houses, which he would then hand-tint and sell to students. His expenses just about equalled his income, but he saw a lot of the country, and in the work that he did for himself he steadily sharpened his vision and developed his personal style. Since his days with Hine, he had been experimenting constantly. He worked his way through most of the currently fashionable photographic styles, which were, for the most part, attempts to make photographs look like paintings. Subjects were exposed in diffused light and were slightly out of focus, or even deliberately blurred—one English landscape photographer of this period achieved his effects by kicking his tripod during exposure—and prints were made by a variety of chemical processes that thickened the pseudo-painterly soup. Although Stieglitz had often championed the work of the better practitioners of such "pictorial" photography and had shown it at "291," most of Stieglitz's own groundbreaking prints were examples of what was coming to be known as "straight" photography—that is, photography without special effects or manipulation. For several years, Strand had periodically been taking his work to "291," and receiving criticism from Stieglitz. He had also been absorbing the Stieglitz credo. As Nancy Newhall put it in the catalogue for Strand's 1945 show at the Museum of Modern Art, "Stieglitz pointed out that photography in its incredible detail and subtle chiaroscuro has powers beyond the range of the human hand. To destroy this miraculous image, as some members of the Photo-Secession and Strand himself at the time were doing, was to deny photography."

Stieglitz made no distinction between photography and other forms of visual art, and at "291" he

showed—frequently for the first time in America—the work of Cézanne, Matisse, Picasso, Braque, and other European painters. Strand found it all fascinating and baffling. "Like most of the critics then, I was puzzled by it," he said. "But I had a feeling that something very important was happening, and I wanted to know more about it." In an effort to understand what Picasso and Braque were up to, Strand made a number of abstract photographs—closeups of pottery bowls, patterns of shadows on a front porch. It was a vital step in his development, he believed. "From it I learned how you build a picture, what a picture consists of, how shapes are related to each other, how spaces are filled, how the whole must have a kind of unity." Having learned this much, he never again felt the slightest need to work in pure abstraction; he simply applied the new knowledge to photographs like "White Fence," whose striking composition arises from the relationship between nine brilliant fence posts in the extreme foreground and the dark barn behind them.

"White Fence" was taken in 1916, during a visit to the upstate town of Port Kent, and it could be said to contain the seeds of all Strand's future work. At this point, however, he still felt like a New Yorker, and the city, its inhabitants, and its dynamic patterns of movement and life fascinated him. "One of the elements I wanted to work with then was people moving in the street," he once said. "I wanted to see if I could organize a picture of that kind of movement in a way that was abstract and controlled. I became aware, for instance, of those big dark windows of the Morgan Building, on Wall Street. One of my classmates from school worked there, I remember; it always seemed too bad, because I thought he could have done something more in keeping with his abilities. Anyway, I was fascinated watching people walk by those huge, rectangular, rather sinister windows—blind shapes,

actually, because it was hard to see in—and one day I went and stood on the steps of the Subtreasury Building and made a photograph trying to pull all that together. I don't know how I did it, really. At that time, film emulsions were so slow, and I couldn't have been shooting faster than a twenty-fifth of a second."

Strand's New York photographs are light-years away from the misty moods of the pictorialists. His New York is a harsh and threatening place, and the strains of living in it are etched into the faces of the poor and the elderly whom he photographed. "I suddenly got the idea of making portraits of people the way you see them in New York parks—sitting around, not posing, not conscious of being photographed," he recalled. "People involved in the process of daily living. But how could you conceal the camera in order to do this? There was no such thing as a candid camera in those days." Strand's solution was to take the shiny brass lens from his uncle's old view camera and attach it to one side of his Ensign reflex. By holding the camera so that the false lens pointed straight ahead and the real lens stuck out under his left arm, partly concealed by his sleeve, he was able to photograph someone at right angles to the apparent subject. Most of the early portraits, including the famous "Blind Woman"—a closeup of a blind newspaper dealer on the corner of Lexington Avenue and Thirty-fourth Street—were made this way. It was a nerve-racking method, because there was always the possibility that someone would realize what Strand was doing. "I never questioned the morality of it," he said. "I always felt that my relationship to photography and people was serious, and that I was attempting to give something to the world and not exploit anyone in the process. I wasn't making picture postcards to sell. But then one day, out walking with the camera, I saw an old

woman with a cage of parakeets. She was selling fortunes, which the birds would peck out. I walked by her without even opening the camera, and then a little later I came back, and she immediately attacked me. 'You're not going to take my picture!' she said. It was like mental telepathy. Anyway, that finished me, at least for the time being. I decided to wait for a better technique."

About every two years, Strand brought his work to Stieglitz for criticism. He also showed it to Clarence White and to Gertrude Käsebier, whose advice was kind but not particularly useful. "They didn't help me develop," he said. "Stieglitz did. He had this great clarity of purpose, and he had no desire to use the camera to paint with. Anyway, in 1915 I really became a photographer. I had been photographing seriously for eight years, and suddenly there came that strange leap into greater knowledge and sureness. I brought a group of my things in to show Stieglitz, and when I opened up my portfolio he was very surprised. I remember he called to Edward Steichen, who was in the back room at '291,' and had him come out and look, too. Stieglitz said, 'I'd like to show these.' He also told me that from then on I should think of '291' as my home, and come there whenever I wanted. It was like having the world handed to you on a platter. It was a very great day for me, matching, in a sense, the day that Hine took us to Photo-Secession and I saw the work of those other photographers for the first time."

Stieglitz showed Strand's work at "291" in March, 1916, and he published a number of Strand's photographs that year in *Camera Work*, the magazine that he had made into the leading organ of modernism, not only in photography but in all the visual arts. *Camera Work* ceased publication in 1917, for financial reasons; the final issue was devoted entirely to Strand's new photographs. In his introductory note to this issue, Stieglitz wrote that in the history of photography there were very few photographers who had done work of any lasting quality. Strand, he said, was someone "who has actually done something from within. . . . The work is brutally direct. Devoid of all flim-flam; devoid of trickery and of any 'ism'; devoid of any attempt to mystify an ignorant public, including the photographers themselves. These photographs are the direct expression of today."

It was an auspicious launching. At the age of twenty-five, Strand had become a respected member of the Stieglitz inner circle, which included the painters Max Weber, John Marin (Marin, who lived in New Jersey, would come across the river to play billiards with Strand), Arthur Dove, Georgia O'Keeffe, and Marsden Hartley; the critic Charles Caffin; the caricaturist Marius de Zayas; and the photographers Edward Steichen, Frank Eugene, and Alvin Langdon Coburn. It was a lively period in American art, with the repercussions of the 1913 Armory Show still spreading rage and glee in unequal measure. "The atmosphere around Stieglitz and '291' was that of a group of people with strong common interests," Strand recalled. "Stieglitz provided the central leadership—no doubt about that. He used to speak of '291' as a laboratory, a place to evaluate the quality of the pictures and of people's reactions to them." The art critics and the derrière-garde painters continued angrily to repudiate the "senseless" aspects of Cubism and other advanced trends; many of the same people also clung to the notion that photography, because its tools were mechanical and chemical, could not be considered a valid form of art. "We were consciously fighting for the recognition of our medium," Strand said, "and the painters fully supported us." Strand joined the skirmish lines and laid out his own artistic credo in an article that appeared

in the magazine *Seven Arts* in 1917. Photography, he wrote, found its raison d'être as an art form in its unique and absolute objectivity. The photographer must develop and maintain "a real respect for the thing in front of him, expressed in terms of chiaroscuro through a range of almost infinite tonal values which lie beyond the skill of human hand. . . . The fullest realization of this is accomplished, without tricks of process or manipulation, through the use of straight photographic methods. It is in the organization of this objectivity that the photographer's point of view toward life enters in, and where a formal conception born of the emotions, the intellect, or of both is as inevitably necessary for him before an exposure is made as for the painter before he puts brush to canvas. . . . Photography is only a new road from a different direction, but moving toward the common goal, which is life."

As a polemicist, Strand lacked the slashing eloquence of Stieglitz. On the other hand, he was even more uncompromising than his mentor in judging fellow-artists. Speaking before the Clarence H. White School of Photography in 1923, Strand said flatly that the only two photographers who had met the test of art so far were Stieglitz and David Octavius Hill, the nineteenth-century Scottish portraitist. (Today, he would enlarge the list to include Atget, Cartier-Bresson, and perhaps Mathew Brady.) Most photographers, he explained, still made the absurd error of trying to use the medium as a shortcut to painting, instead of recognizing and working with the elements that were unique to photography. The essential photographic element, as he had written earlier, is time—the unique moment in time, captured and held forever. "If the moment be a living one for the photographer—that is, if it be significantly related to other moments in his experience, and he knows how to put that relativity into form—he may do with a machine what the human brain and hand through the act of memory cannot do." Strand never had the least desire to

try painting or sculpture; for him, the challenge of photography was infinite, and so was the subject matter. "Above all, look to the things around you, the immediate world around you," he told the students at the Clarence H. White School. "If you are alive, it will mean something to you, and if you know how to use it, you will want to photograph that meaningness."

Strand printed nearly all his early negatives on expensive platinum paper, which he imported from England. Platinum offered a longer and richer scale of tonal values from black to white than silver-bromide or chlorobromide papers did, and platinum prints would last a great deal longer. Strand experimented with ways to deepen and enrich the tones even further, adding to the prepared paper a platinum emulsion he had made himself, and then gold-toning it to intensify the blacks. His results astonished other photographers. Walker Evans once said that the original platinum print of Strand's "Blind Woman" (now owned by the Metropolitan Museum) influenced his whole development. Strand made platinum prints until 1937, when the paper became impossible to get. He often said sadly that any photographic material of high cost and superior quality was apt to become unobtainable sooner or later, because the industry was geared to producing for the amateurs who have made photography the world's most popular hobby.

It was not possible, of course, to earn a living from Strand's sort of photography. Stieglitz sold a few Strand prints at "291" for between two hundred and two hundred and fifty dollars each, but the prices barely covered the expensive and time-consuming process of making the prints. By 1922, at any rate, Strand was supporting himself not by still photography but by work as a free-lance motion-picture cameraman. Drafted into the Army in 1918,

he had been sent as a hospital-corps trainee to the Mayo Clinic, in Minnesota, where watching the Mayo brothers operate gave him the idea of filming surgical operations and showing the films to medical students. Strand served for eighteen months as an X-ray technician in the Army hospital at Fort Snelling, Minnesota. When he got out of the service, in 1919, he tried his hand for a while at advertising photography—his clients were Hess-Bright ball bearings and Eno's fruit salts—but early in 1922, just as this new field was becoming commercially rewarding, he was approached by some people who wanted to form a small company to make medical films, and Strand, remembering his Mayo Clinic experience, agreed readily to become their cameraman. He had acquired a little experience in movie work already, having collaborated in 1921 with Charles Sheeler, the painter, who owned a French motion-picture camera, on a short documentary film about New York, entitled "Mannahatta." The film, which was silent, had subtitles taken from Walt Whitman's writings, and it played for a week at a Broadway movie house under the title "New York the Magnificent" (the theatre owner thought Whitman's title too arcane), but neither Strand nor Sheeler could afford to make another. In 1922, though, Strand's new backers authorized him to go out and buy the best movie camera available for making medical films. The best camera, Strand found, was the Akeley. It had been designed by Carl Akeley, the African explorer, specifically for taking pictures of wild animals in the bush. Movie cameras in those days were cumbersome behemoths, mounted on huge tripods that had one handle for moving the camera up and down and another for moving it sideways ("panning"); it was almost impossible to work both handles simultaneously so as to follow a fast-moving subject. Akeley, however, had worked out a series of friction gears in the tripod head, which enabled the cameraman to pan and tilt smoothly and simultaneously using only one handle, and a small company had been set up to meet the demand for his invention. No sooner had Strand arranged to buy the Akeley camera, however, than he was informed that his backers were withdrawing their support. "I never did find out what had happened," he said later. He went back in some embarrassment to the Akeley company, to explain his dilemma. The Akeley people suggested that Strand buy the camera himself. There were four or five "Akeley specialists" working in New York then, they told him, making a good living by doing free-lance film work for newsreels and Hollywood studios. Strand, with no job and no prospects, had just inherited twenty-five hundred dollars from the estate of his wealthy uncle, and twenty-five hundred dollars happened to be precisely what the Akeley cost. He bought it. "It was a very beautiful camera," he said. "I'd already fallen in love with it anyway." The first thing he did was to take it home and photograph it with his still camera, taking a series of closeups of the interior mechanism that are among the most beautiful machine photographs ever made.

For the next ten years, Strand earned his living as an Akeley specialist. He filmed sports events for Pathé News and Fox Films, and went down to Louisville every spring to cover the Kentucky Derby. He lugged his heavy equipment—camera, tripod, and film case weighed in at ninety pounds—to the top of the Yale Bowl and the Harvard Stadium for football games, and he shot, edited, and put together films for several successive graduating classes at Princeton, depicting the athletic and social highlights of the senior year. Occasionally, he was hired to shoot action sequences for

Hollywood films. He climbed twenty-two stories above the street to film Richard Dix's double clinging to a steel girder of the Telephone Building, on West Street, which was then under construction, and he helped to shoot the Battle of Lexington—in Plattsburg, New York—for "Janice Meredith," starring Marion Davies. "I accepted every job that came my way, and it didn't do me a bit of harm," he said. He earned thirty-five dollars a day at first, and eventually, by demanding it, he got fifty. His real interest, though, remained still photography, which he practiced on weekends and whenever else he could find the time.

IN 1922, STRAND had married Rebecca Salsbury, a strikingly handsome artist, whose father, Nate Salsbury, had been Buffalo Bill's partner and manager. Becky Strand was a great friend and admirer of Georgia O'Keeffe, whom Stieglitz married in 1924; friends considered the two women remarkably similar in looks and personality. To save money, the Strands lived with Strand's family in the house on West Eighty-third Street—Strand's mother and grandmother had both died by that time, his mother in the influenza epidemic of 1919—in an upstairs suite that they transformed into a modern atelier, with white walls and very little furniture, and with photofloods pointed at the ceiling for light. It was not until 1926 that the young Strands had enough money saved to go away in the summer. They went to Colorado, where Strand photographed at Mesa Verde National Park, experimenting with closeups of tangled roots and blasted tree trunks. Later, they went to Taos. Mabel Dodge Luhan, to whom they had an introduction, let them use one of her houses there for two weeks. Strand liked the country but was put off by Mrs. Luhan, whom he thought

domineering, destructive, and rather silly in her self-appointed role as the doyenne of Taos. "I hadn't the slightest interest in photographing her," he said. The next two summers, the Strands went to Georgetown Island, in Penobscot Bay. Their neighbors there were John Marin, Marsden Hartley, and Gaston Lachaise, all of whom he did photograph, either then or later. (Strand considered Lachaise one of the three leading modern sculptors—the others were Brancusi and Lehmbruck—and he was both flattered and pleased when Lachaise offered to trade a small bronze for a Strand print.) Strand spent the two summers photographing mushrooms, rocks, plants, a cobweb and other natural details—usually in extreme closeup.

"I've always had an interest in the things that make a place what it is, which means not exactly like any other place and yet related to other places," Strand once said. "Growing things are part of the quality and the character of a place; the things that grow by the sea are not like the things that grow, say, in the middle of Kansas. It's the same with rocks. Rocks by the sea are different, because the sea has washed them and done things to them, and trees by the sea are very special, too. Incidentally, I discovered something that first summer at Georgetown that was vitally useful to me. You see, if you want to photograph growing plants, flowers, grass, or whatever, and if you want to do it at a very small lens opening and with a long exposure—two or three minutes—then you have a problem, because there's always a wind, and they move. I solved that by trial and error. I found that when I sensed the wind coming I could close the shutter, wait until the wind had passed, and reopen the shutter. The plant would have always returned to the exact same spot it had been in before. That way I could get an absolutely clear, needle-sharp picture."

The problems of dealing with larger landscapes did not really emerge for Strand until the summer of

1929, when he and his wife went around the Gaspé Peninsula. "The landscape problem is the unity of whatever is included," according to Strand. "In a landscape, you usually have foreground, middle ground, distance, and sky. All these have to be related. This is very difficult to do, of course. There are plenty of landscapes in art where the sky has no relation to the land—some of the Impressionists, like Pissarro, made that mistake. I would say that the landscapes of Cézanne are the greatest of all, because not only is every element in the picture unified but there is also unity in depth; there is this tremendous three-dimensional space that is also part of the unity of the picture space. Anyway, I became conscious of the need to master this problem."

Strand's work in the Gaspé that summer, done with a 4 x 5-inch Graflex hand camera, was a continuation of his search for what he called "the essential character of a place and its people." In Strand's pellucid Gaspé landscapes, with their marvellously balanced images of land and sea and sky, of boats and houses, of fences and barns, it is almost possible to infer the sounds and smells of the place; the sense of peace and stillness seems to emanate from the land itself, rather than from the photograph. Strand's landscapes are seldom spectacular or awesome, in the way that Edward Weston's and Ansel Adams' are. Weston, a Californian who had come to New York in 1922 and met Stieglitz and Strand, noted in his daybook in 1929 that both he and Strand were using trees and rocks as subject matter—"he on the Atlantic Coast, I on the Pacific"—and a year later he was wondering anxiously whether this might lead to accusations of plagiarism. In reality, their work was profoundly different. Weston's images had a dynamic, sculptural power that riveted the eye; Strand's were like tapes-

tries, with every part of the picture space working together. As for Ansel Adams, he and Strand first met in New Mexico, where Strand photographed during the summers of 1930, 1931, and 1932. Adams, who had been trained as a musician, was staying in one of Mabel Dodge Luhan's houses; the Strands had rented another. When Mrs. Luhan abruptly informed Adams that she needed his house for someone else, the Strands invited him to come and stay with them for a few days. The Strand house was about four miles from the adobe church of Ranchos de Taos, whose thick walls and buttresses were replastered by hand every year by the Indians. Strand used to watch the sky, and when he saw a storm coming he would get in the car, head for the church, and have his camera set up by the time the storm got there. What have come to be known as "Strand clouds"—heavy, lowering shapes holding rain and threat of storm—appear in a great many of his photographs of the arid Southwest, suggesting that the essential character of a region may have a good deal to do with the essential character of the artist who is depicting it. A friend of Strand's in those years remembers him cursing under his breath whenever fluffy, cottony cloud formations, which he referred to as "Johnson & Johnson," took over the sky; they never appear in his prints.

Henwar Rodakiewicz, a photographer who was then living in Taos, took Strand around to some of the ghost towns of the Old West—to St. Elmo and to Aspen, Colorado, which had not yet been discovered by Walter Paepcke. Strand photographed their crumbling wooden houses, and caught echoes of the frontier in a worn door latch or a corner of adobe wall. The quality of Strand's negatives impressed Adams so deeply that, as he said later, he decided to devote himself exclusively to "straight" photography. Strand, however, was not at that period a great encourager and promoter of young

photographers. Wholly concentrated on his own work, uncompromising in his standards, and rather stiff in personal relations, he kept even his admirers at a distance. His sense of humor took the form of elaborate and elephantine puns and limericks, some of which were days, or even weeks, in the making. He had no talent for simulating polite interest or for disguising what he thought or felt. Strand's admiration extended to a very few photographers aside from Stieglitz, and even Stieglitz was not sacrosanct. Stieglitz's aestheticism, which expressed itself toward the latter part of his life in photographs of cloud formations that he called "equivalents," seemed to Strand increasingly removed from what he himself wanted to do in photography. "I'm a politically conscious person," Strand once said. "I've always wanted to be aware of what's going on in the world around me, and I've wanted to use photography as an instrument of research into and reporting on the life of my own time. It was probably just inevitable for us to come to some sort of parting of the ways." The parting was never complete, for the two men continued to meet on friendly terms until Stieglitz's death. But after 1932—when Strand went to Mexico and stayed for two years—they saw one another far less frequently.

In 1932, Strand's marriage was coming apart. Toward the end of that summer—the third they had spent in New Mexico—Mrs. Strand returned to New York, and Strand headed down into Mexico. He had made friends with Carlos Chávez, the Mexican composer, in Taos the previous summer (Chávez, too, was on Mabel Dodge Luhan's string) and had written to him about the possibilities of photographing in Mexico. Chávez urged him to come, and Strand set off in his Model A Ford. The Mexican landscape awed him. "The minute you get into Mexico, you begin to see a range of mountains that must be part of the American chain but are

completely different," Strand observed. "They have a different feeling—something I found a little threatening and sinister." For many years, Strand had believed that one had to know a country well before attempting to photograph in it, but in Mexico he found himself paying no attention to this dictum. Some of his finest Mexican photographs, he said, were made during his first few days in the country. In Mexico City, Chávez extended a warm welcome. As conductor of the Mexican Symphony Orchestra and director of the National Conservatory of Music, he wielded considerable authority. He arranged for Strand to exhibit his photographs in a Ministry of Education building, and he also wangled a government commission for Strand to work with his nephew, Augustine Velásquez Chávez, on a report on art education in rural schools in the State of Michoacán. Strand and the young Chávez travelled together, and Strand began for the first time to make portraits with the aid of a prism. Ever since his experience with the woman selling fortunes in New York, he had been looking for a better technical method of making portraits of people who were not aware of being photographed. In 1931, in New York, he had sold his 4 x 5-inch Graflex and bought a 5 x 7 Graflex, which had a shutter that allowed for automatic exposures of up to one minute, and he had had the lens fitted with a removable extension that concealed a fine optical prism. With this extension in place, the lens would photograph at ninety degrees to the angle at which it was pointed. The portraits that Strand took in Morelia, Pátzcuaro, and other towns in western Mexico with this device were extraordinarily successful. The subjects were usually shown full-face, looking gravely at the big camera that they do not suspect is focussed on them. There

is a beauty and a gentle dignity about each face—even the faces of the children—that suggest Strand's feelings about them. More than ever, his portraits were acts of love.

Strand was enthusiastic about the work of the great Mexican mural painters Rivera, Siqueiros, and Orozco, and also about the social reforms that were taking root in Mexico after decades of insurrection and bloodshed. When Carlos Chávez suggested that Strand take charge of a five-year plan to make films that would reflect the real concerns of the Mexican people, Strand immediately set to work drawing up a series of proposals. He and Chávez and Narciso Bassols, the Minister of Education, were in agreement that the principal audience for these films would be Mexico's eighteen million Indians, most of whom were illiterate. According to Strand, the three men were also agreed that there should be no "filming down" to anyone; the highest aesthetic standards would always apply, on the theory that the best art would appeal to the largest number. The first—in fact, the only—film to come out of this high-minded endeavor was "Redes" ("Nets"), whose English title is "The Wave." Strand and Augustine Chávez conceived the idea and wrote the outline for the film, a part-documentary, part-fictional feature whose plot had to do with a strike by poor fishermen against a merchant who was exploiting them. Strand got his Taos friend Henwar Rodakiewicz to come down and work out a detailed shooting script, and when Rodakiewicz had to go back to the States for a prior commitment he got *his* friend Fred Zinnemann, then an aspiring young Hollywood director with no films to his credit, to direct it. The film is about sixty-five minutes long and contains many stunning images that could very well have been Strand stills; one critic said later, a trifle sardonically, that it was "the most beautiful strike ever filmed." Strand photographed it with his Akeley, hand-cranking at three revolutions a second instead of the customary two, because that was what sound film required; according to Rodakiewicz, Strand would get excited now and then and crank the handle even faster, which has led some film historians to credit him with the first use of slow motion as a cinematic device. Only one professional actor was used—the exploiting merchant—and he turned out to be the film's only obvious ham. The rest of the cast consisted of local fishermen of the town of Alvarado, on the Gulf Coast, near Veracruz. "The Wave" took nearly a year to make, in part because of Strand's insistence that every detail be perfectly realized. The shooting of one scene was held up for a month because one of the fishermen, the helmsman in the lead boat, took the notion one morning to get a haircut. By the time the film was finally edited, in the fall of 1934, Lázaro Cárdenas was President of Mexico and the previous administration's five-year film plan had been shelved.

STRAND PACKED UP and went back to New York. He was feeling somewhat at loose ends. Divorced—Rebecca had gone to live permanently in New Mexico—and no longer so close to Stieglitz, he gravitated to what might appear an unlikely new association: the Group Theatre. Harold Clurman, Lee Strasberg, and Cheryl Crawford, the three Group directors, wanted to build a permanent repertory company that would perform contemporary plays on the highest possible artistic level, and Strand, although never much of a theatregoer, had become interested in their work. Consequently, when he got back to New York in late 1934, he was delighted to find that the Group was riding high; in fact, its production that winter of Clifford Odets' "Waiting for Lefty" was the hit of the season.

In those Depression years, the Group was considered to be somewhat left-wing in its political sympathies. Actually, as Clurman pointed out in his book "The Fervent Years," the Group's directors and players were political naifs, concerned almost totally with the aesthetics of the theatre. They were particularly interested in the aesthetics of the theatre in the Soviet Union, and Strasberg had modelled his own work with actors on the celebrated "method" of Stanislavsky. The productions of the Moscow Art Theatre; the films of the Russian directors Eisenstein, Pudovkin, and Dovzhenko; and the social context that had given birth to this creative ferment—all were a source of great interest to many American intellectuals of the period. Indeed, in 1935 Clurman told Strand that he and Cheryl Crawford were going to Moscow to see for themselves. Would he come along? Strand was eager to go. He met Clurman and Crawford in Moscow that summer, and stayed a little more than two months. They received tickets to all the major theatres and met the great theatre figures and film people. Sergei Eisenstein looked at a few feet of film stock from "The Wave," holding it up to the light, and said jovially that he could see Strand was essentially a still photographer rather than a filmmaker—a comment that struck Strand as "a little overfast, but I didn't mind." (Actually, Strand took no photographs in Russia.) Later, Eisenstein invited Strand to work with him on a new film (Strand had brought his Akeley along), but the difficulties of getting a work permit proved to be insuperable.

In New York at this time, a number of young photographers were becoming interested in the possibilities of documentary films. Excellent documentaries were then being made in England, but in spite of the great legacy of Robert Flaherty's "Nanook of the North" (1922) and "Moana" (1926), the form was dormant here, and Flaherty himself was working in England. In a period when perhaps twelve million Americans were unemployed, the newsreels of the day featured naval vessels docking and bathing beauties pirouetting. The "March of Time" series, which started in 1934, was a big improvement in this field, but serious filmmakers wanted to go much further with the form; influenced by the work of the Group Theatre, they wanted to make documentaries that dealt with complex social issues, and that did so with all the resources of the cinematic art. "We felt the need for the development of an independent film movement run by artists," Leo Hurwitz, one of their number, has recalled. Hurwitz, Ralph Steiner, Sidney Meyers, Lionel Berman, Irving Lerner, and Ben Maddow had banded together in an informal association called Nykino (with a nod to the Soviet director Dziga Vertov's Kino-Pravda newsreels). Although Strand's Mexican film had not yet been released in the United States, they knew about it, and Strand had attended several of their meetings in Steiner's studio before going to Moscow. "They had the same attitude toward filmmaking that I had in Mexico," Strand said. "They felt that a documentary should have the highest possible aesthetic content and dramatic impact."

On his return from Russia, Strand was invited by Steiner and Hurwitz to work with them on "The Plow That Broke the Plains," a documentary on the Dust Bowl. Sponsored and financed by the United States Resettlement Administration, one of the New Deal agencies, it was to be produced and directed by Pare Lorentz, a film critic who had never yet produced or directed a film, and, as Hurwitz and Steiner outlined the project, it was to show how the misuse of the land for short-term profits had combined with nature to produce what would today be called an ecological disaster. None of the three

photographers knew Lorentz well, and in Strand's view this was the real root of the troubles that began as soon as they left New York for Wyoming and Montana, to film farmlands as they had looked before the Dust Bowl.

"Lorentz saw us off at the railroad station and handed us the shooting script, which he had written himself, and which none of us had seen until that moment," Strand recalled. "We read it on the train with mounting astonishment. We couldn't understand it. It just wasn't a guide to the sort of action that we could take with the camera."

Leo Hurwitz felt the same way. "The script was full of personal visions and fantasy," he said in 1971. "For example, Lorentz had one scene in which a lot of men in top hats would walk across a field, get on tractors, and plow up the field. The idea was clear enough—that the rich who profited by grain deals were the ones who were destroying the land—but there was no way that we could see to make the scene work with the rest of the material."

When their train stopped at Buffalo, they sent a wire to Lorentz saying they couldn't understand his script and would he please send them another as soon as possible. No new script was waiting for them when they got to Montana, so, rather than lose time, they decided to go ahead on their own with background work. They filmed what the Great Plains had once looked like, with cattle and sheep grazing on the tall grass that, farther south, had been plowed up indiscriminately to plant wheat. But unless the film was to be all background they needed a script. "Finally, we wired Pare again to say we were writing our own script," Hurwitz recalls. "We headed down to the Texas Panhandle to film the real Dust Bowl stuff, and on the way we stopped off in Alliance, Nebraska, where I rented a typewriter and knocked out a script."

Lorentz met them in Dalhart, Texas. There was no direct clash of wills, but matters were sufficiently tense. Steiner, who had become increasingly uneasy about the revolt—he now feels that they could perfectly well have shot from Lorentz's script, as he himself did later from Lorentz's equally poetic script for "The City"—worked with Lorentz, and Strand and Hurwitz worked together as a separate film unit, and notwithstanding a certain lack of communication, they managed to shoot the necessary footage. None of the three photographers had any further contact with the picture, which Lorentz edited, and which struck them all, when they saw it, as surprisingly good. Hurwitz has said it was "a great surprise" to him to find that Lorentz had done such a brilliant editing job, although he insists that the finished film bore little relation to Lorentz's original script. (The men in top hats were not included.) "The film is first-rate, so I don't understand why people are so busy being resentful," Strand said a few years ago.

Filmmaking, in any case, had become Strand's full-time occupation. The informal Nykino group evolved in 1937 into Frontier Films, a nonprofit production company dedicated, as Strand once put it, to making films that would be in some sense warnings. "We were very concerned about what was going on in the world," Strand said. "We were very concerned about the Spanish Civil War. Someone in the government once called people like us 'premature anti-Fascists,' which was pretty shocking and infuriating. It wasn't that we told an untruth—it was that we told the truth too soon." Strand was president of Frontier Films from 1937 until the company dissolved, in 1942. During this time, Frontier completed seven documentaries: "Heart of Spain," edited by Strand and Hurwitz from footage that was shot, mostly in Madrid, by two amateur cameramen, and that dealt with the pioneering

blood-transfusion work being done for the Republican side by the Canadian doctor Norman Bethune; "China Strikes Back," about the training of the Red Army in Shensi Province, with shots of the young Mao Tse-tung and Chou En-lai; "People of the Cumberland," about a school in Tennessee, filmed by Steiner and directed by a novice named Elia Kazan; "Return to Life," another film shot in Spain, produced and directed by the young French photographer Henri Cartier-Bresson; "White Flood," about glaciers, filmed by the naturalist Osgood Field, who was a Frontier trustee; "United Action," about the daily lives of striking U.A.W. workers in Detroit, sponsored by the union; and "Native Land," with a commentary by Ben Maddow, and directed, filmed, and edited by Strand and Hurwitz. By far the most ambitious of the lot, "Native Land" was based on the Senate's LaFollette-Thomas Committee hearings on civil-rights violations throughout the United States, and, in particular, on the campaign by some large corporations to break the developing power of the labor unions. The film lasts nearly two hours, and it took four years to make, with one eight-month hiatus when Strand and Hurwitz ran out of money and had to raise additional funds. Strand was very proud of the film, which mixes straight documentary material with dramatic reenactments—his second wife, a young Group Theatre apprentice named Virginia Stevens, is featured in the final scene at the grave of the slain labor leader—but, unlike some of the other Frontier films, it was not widely shown. It was released in 1942, after the United States had entered the Second World War, and exhibitors were not eager for films about civil-rights violations.

During the war, some of the Frontier people worked for the government or for the Army, making training or propaganda films. Strand and Hurwitz went to Washington to propose the formation of a film unit that would work with troops in the field, but they were turned down. Later, they were as-

signed to write a script for a film about the cargo run to Murmansk, but the film was never made. Hurwitz feels sure that in both cases they were rebuffed because of their "premature anti-Fascism" and their work on "Native Land." Strand did do some film work for the government agencies in 1943. He also conceived and put together for a show at the Art Students League a large photographic chronicle of the first twelve years of the Roosevelt Administration—he was a great admirer of Roosevelt, and the exhibition was intended to help his reelection. But after 1942 he made no more films of his own. "Things do have an ending, although not always one you can be happy about," he said once. "I'm proud of all the films Frontier made. We were learning how to dramatize documentary material, to involve people emotionally, just as the story films did. But I never had any desire to be simply a cameraman." After ten years as a filmmaker, Strand returned, at the age of fifty-three, to still photography.

HE HAD NEVER really left it completely. In 1936, there had been a new series of photographs of the Gaspé, where he and Virginia Stevens spent their honeymoon. In 1940, he had spent months working with a printer on a hand-gravure portfolio of his Mexican prints. (The portfolio included twenty gravures and sold for fifteen dollars; today the Museum of Modern Art insures its copy for a thousand.) For ten years, Strand had been working under great pressure in collaboration with others, and now he was content to work quietly and on his own. In the spring of 1944, he went to visit his friend Genevieve Taggard, the poet, and her husband, Kenneth Durant, in the West River Valley of Vermont, a region that appealed to him so much that he got a room at a neighboring farmhouse and stayed several months, photographing. The haunting portrait of "Mr. Bennett," a farmer who lived

across the road from the Durants, dates from this period. "He died six months later," Strand has said. "That's one of the things in his face, although I didn't know it then." In 1945, Nancy Newhall, in charge of the Department of Photography at the Museum of Modern Art while her husband, Beaumont Newhall, the regular curator, was in the Army, proposed a Strand retrospective. Strand and Mrs. Newhall worked together on this show, which contained a hundred and seventy-two photographs, covering thirty years' work, and was the first major retrospective that MOMA ever devoted to a photographer. During their collaboration, Mrs. Newhall suggested to Strand that they do a book together about New England. She had been struck by the powerful "sense of place" running through his work. A New Englander herself, she thought it would be interesting to combine Strand's photographs of the region with writings by New Englanders from the earliest days to the present. Strand was much taken with the idea. For the next few years, then, while Nancy Newhall combed the New York Public Library for quotations, from Cotton Mather to Van Wyck Brooks, Strand travelled and photographed in various parts of New England. He spent six weeks with his old friend John Marin at Cape Split, Maine; their neighbor was a lobsterman, whose wife, Susan Thompson, became the subject of what may be the loveliest of all Strand portraits. Strand, as he later wrote, was looking for "images of nature and architecture and faces of people that were either part of or related in feeling to [New England's] great tradition." Eventually, he and Mrs. Newhall sat down together and worked out the combination of text and photographs, in associations that were poetic rather than concrete. The result was "Time in New England," published in 1950. Although the reproduction of Strand's photographs fell far short of his expectations, he found that the process of making a book in which text and photographs inter-

acted so as to enrich one another appealed to him enormously. "It was a major turning point in my whole development," he said.

Needless to say, there was little money to be made from books of this sort, but by now Strand no longer needed to earn a living. After years of marginal struggling, his father had become quite successful in business—among other things, he was the distributor of Domes of Silence, the little metal devices that keep chair feet from scraping the floor. Jacob Strand believed in what his son was doing, wanted to help him, and did so. "He had gone to work at the age of twelve, but he retained a marvellous openness and tolerance," Strand recalled. "He must have had something of the artist in him. During the twenties, when John Marin was having financial problems, Stieglitz got together a group of people who each agreed to give Marin two hundred dollars a year for three years, at the end of which they would be entitled to a Marin watercolor valued at twelve hundred dollars. My father joined, and when it came time for him to pick his watercolor he picked the top one. I always felt great support from him. He made me feel that what I wanted to do with the camera was all right."

One thing that Strand had long wanted to do with the camera was to make a book about a village—a book in which he would try, as he put it, "to find and show many of the elements that make this village a particular place where particular people live and work. The idea came from my great enthusiasm for Edgar Lee Masters' 'Spoon River Anthology,' " he said. "I had considered doing it in Taos when I was there, but then I left and never went back, and the filmmaking started." The book that Strand envisioned would in no way derive from the sort of photojournalism that such magazines as *Life* and *Look* were helping to develop. "I haven't

really got a journalistic streak," he said once. "That was always the part of my work with the Akeley that I detested. I wanted to avoid anything that would take me away from my particular way of looking at things." Interest in doing his village book was rekindled during his travels in New England. But by the time "Time in New England" was published, Strand had begun to feel a little uncertain about doing a book on an American village. He was disturbed by what he saw happening in this country. Leo Hurwitz and a number of his former colleagues had been blacklisted as dangerous radicals by the film industry and were having trouble finding work. Strand's thoughts turned to Europe. "The intellectual and moral climate of the United States was so abused, and in some cases poisoned, by McCarthyism that I didn't want to work in an American village at that time," he explained. "It was not in any way a rejection of America; it was a rejection of what was happening in America just then. Also, I had an impulse to travel—to see what was happening elsewhere in the world." He had not been to western Europe since 1911, when he was twenty-one. Moreover, there was another marriage in prospect. In 1949, the year his second marriage ended in divorce, Strand met Hazel Kingsbury, who, after working for several years as an assistant to Louise Dahl-Wolfe, the fashion photographer, had enlisted in the Red Cross during the war and served as a photographer, travelling extensively in the European and Far Eastern war zones. She and Strand, who were married in 1951, went to France together in the spring of 1950.

For the first few months, the Strands travelled around the country, looking for the right village in Brittany, in the Charente, in Provence, and elsewhere. They never found it. "That was our fault," Strand said. "We could have worked in many places. But we didn't know anything about

French life or French people, and it was discouraging to find that at six-thirty every evening all the houses were shuttered. We had the feeling of being barred from close contact. On the other hand, I did eventually begin to see things to photograph that I thought were very much France—things I'd never seen anywhere else. So although we didn't find our village, I ended up doing a lot of work."

Strand's French photographs, published in a book called "La France de Profil," showed a countryside and a way of life that now, twenty years later, have all but disappeared. There are no shots of familiar monuments, and not a single picture taken in Paris—just as in his New England book there are no pictures of Boston or any other large city. Strand's France is rural, particular, and very old. As Claude Roy wrote in his introduction to the book, "He let himself drop into the taciturn depths of the French nation with the submissiveness of a pebble that falls to the bottom of a well, and made all kinds of everyday discoveries on his way. What he had to tell us on his return, that wise New Englander companion of the Tour de France—ah! it wasn't so gay, flattering, or delightful . . . it was very beautiful."

The Strands found their village the following year, in Italy. The screen writer Cesare Zavattini had agreed to work with Strand on a book about an Italian village, and, after doing some work in the town of Gaeta, near Naples (where the poverty was so overwhelming that women offered to sell their babies to them), they settled on Zavattini's own home town of Luzzara, in the Po Valley. "There was nothing immediately stirring or attractive about the place, but Hazel and I weren't looking for picturesqueness," Strand said later. "The plainness was a challenge; it meant you had to look closer, dig into the life with more intensity." The Strands spent

about two months photographing Luzzara and its inhabitants—five weeks in the spring of 1952 and three weeks in the fall. The resulting book, called "Un Paese," with an Italian text by Zavattini, strikes some people as an unaccountably sombre portrait of Italians (in whom sombreness is not exactly a national trait), but it contains some of the strongest and most eloquent photographs that Strand has ever done. The book's summation is in the famous group portrait of the Lusetti family, tenant farmers, in front of their house—a composition that the British art critic John Berger found thoroughly comparable in expressiveness and moral authority to the work of the French seventeenth-century painter Louis Le Nain.

THE MORAL DIMENSION in Strand's work became more and more apparent after his move to Europe. Over the next twenty years, in all the places where he chose to work—the Outer Hebrides, Egypt, Morocco, Ghana, Rumania—what he looked for, and frequently found, was the enduring dignity of those to whom he once referred in a speech as "the plain people of the world, in whose hands lie the destiny of civilization's present and future well-being." Avoiding cities and crowds, working slowly with his big cameras, he seemed sometimes to be making statements about the present in terms of the undying past. Even in his series of portraits of French artists and intellectuals, made during the nineteen-fifties, what strikes the viewer is not so much the uniqueness of each individual as the moral energy that has shaped his or her character. Strand approached his famous subjects directly, making no effort to pose them. Climbing onto the wooden stepladder that an Italian carpenter had made him so that he could place his camera on a level with the subject's eyes, he photographed them in their homes and in natural light, without tricks or effects of any kind, and he rarely even spoke to them while he was working. Strand did not want to "create" the situation or the atmosphere of the subject by telling his subjects where to stand or sit or how to look. Somehow, they all—Picasso and Cocteau and Sartre and Malraux and the others—seemed to reveal themselves, at the moment Strand pressed the shutter, with the simple and unself-conscious directness of Hebrides Islanders or Egyptian fellahin. "There are a lot of people in the world I have no desire whatsoever to photograph," Strand said once. "I like to photograph people who have strength and dignity in their faces; whatever life has done to them, it hasn't destroyed them. I gravitate toward people like that."

Some critics believe that Strand's post-nineteen-fifty photographs are not as strong, overall, as the work he did earlier. There is a certain ambiguity about human character in the early Strand—an ability to look unblinkingly on meanness and ugliness as well as on strength and dignity—which is rarely evident in his later work. He has been criticized for photographing Egypt and leaving out the flies and the dirt and the poverty. "You just can't have *all* heroes," as one Strand admirer put it. There is another view, however, which finds in the European photographs a depth and complexity of pure image-making that no photographer before him has ever approached. "Look at some of the photographs of Moroccan markets," says Michael Hoffman, the person mainly responsible for organizing the Strand retrospective in 1971. "Look at the detail, and the relationships of the figures, and the sense of complex, dense life. One could really *live* in that time and that place. The image itself takes on a life inside the print. It's very mysterious, what goes on in a Strand print, and I don't think it can be explained."

Until 1971, at any rate, there was very little discussion of Strand's more recent work, because very few Americans had seen it. "Time in New England" went out of print almost immediately, and the books that were published in Europe—"La France de Profil," in 1952; "Un Paese," in 1955; "Tir a'Mhurain," in 1962 (the title is Gaelic for "Land of Bent Grass," which is the old name for South Uist Island, in the Outer Hebrides); "Living Egypt," in 1969—were not readily available in the United States. The consequent neglect of his reputation had no appreciable effect on Strand. He kept right on doing what he wanted to do, living simply on the inheritance from his father and dedicating himself wholly to work of the most exacting standards. He was helped immeasurably by his wife. Having been a professional photographer herself, Hazel Strand was able to take over some of the technical details of his work. She often developed his negatives, did the spotting and cataloguing of finished prints, and handled much of the correspondence with publishers and museums. In the field, she would make a rough sketch and note down the pertinent information for every photograph he made, and she also smoothed the way for him through bureaucracy, dealing easily and tactfully with, for example, African officials and natives whose language she did not speak but with whom she managed somehow to communicate with great good humor. It is doubtful whether Strand could have done what he did in the last decade—the decade of his seventies and early eighties—without her help. "I've had enough experience in my life so that I don't worry much about things," Mrs. Strand told a friend in 1973. "Once Paul gets under the dark cloth, he's completely oblivious of everything. I'm the one who sees to it that no bare feet get caught under the tripod." When Strand spoke in his later years about "our" work, as he often did, he meant to imply that it was a full-fledged collaboration.

The Strands never really made a decision to live permanently in Europe—it just seemed to happen that way. For several years, while they were working on the French and the Italian books, they had their base of operations in Paris—first in the Hôtel l'Aiglon, on the Boulevard Raspail, and later in a fifth-floor walk-up apartment on the Boulevard Auguste-Blanqui. In 1955, they began to look for a house in the country, mainly so that Strand, for the first time in his life, could have a fully equipped darkroom; for one nearing sixty-five, makeshift accommodations in converted bathrooms seemed an unnecessary handicap. When they bought an old house in the tiny village of Orgeval, near Paris, they were thinking vaguely of eventual resale. But Strand had his ideal darkroom built there, and Hazel restored and enlarged the garden, and eventually they stopped thinking of leaving. The house was airy and comfortable and full of books (all the latest photography books), and the walled garden, with its rows of espaliered pear trees and its flowering walks and borders, was a delight in all seasons. Strand photographed in it a good deal; he was making a new book of these pictures, to be called *On My Doorstep*. Their trips into Paris became increasingly few and far between, but they visited the United States at least once a year, and kept in touch with what was going on there. In 1965, Strand refused, along with Robert Lowell and others, to attend a White House arts-festival luncheon because of his opposition to American politics in Indochina, and he published a letter to that effect in the *Times*. Although Strand could be mistaken for a Frenchman—his handsome, nearly bald head was thought by many people to bear a striking resemblance to Picasso's—he never did learn much French, and when the Strands went for dinner to the house of one of their French friends, that and his increasing deafness made it hard for him to fol-

33

low much of the conversation. It didn't seem to bother him.

In recent years, among the visitors who made their way to Orgeval to see the Strands were a number of young American photographers, and this pleased Strand enormously. He liked to talk with them, and they liked to listen to what he had to say. The subject, of course, seldom veered from photography. "The young people often ask me how I choose the things I photograph," Strand said, one day in 1974. "The answer is, I don't. They choose me. All my life, for example, I've been photographing windows and doors. Why? Because they fascinate me. Somehow they take on the character of human living. Why did I photograph that white fence up in Port Kent, New York, in 1916? Because the fence itself was fascinating to me. It was very alive, very American, very much part of the country. You wouldn't find a fence like that in Mexico or Europe. Once when I was in the Soviet Union, I was taken out into the country by Edouard Tisse, the cameraman for Eisenstein and others, and along the way I saw a fence against dark woods—it was a very special fence, containing the most amazing shapes. And I felt then that if I'd had the camera with me I could have made a photograph that had something to do with Dostoevski. That fence, and those dark woods, gave the same sort of feeling you get in reading 'The Idiot.' You see, I don't have aesthetic objectives. I have aesthetic *means* at my disposal, which are necessary for me to be able to say what I want to say about the things I see. And the thing I see is *outside* of myself—always. I'm not trying to describe an inner state of being."

Strand also liked to disabuse his visitors of the notion that he was unbendingly "pure" and uncompromising in his use of the medium. "I've made lots of compromises in my time," he said, laughing soft-

ly. "There was a period when the photographers around Stieglitz thought you should never enlarge—that you should only make contact prints. I got the reputation of never making an enlargement, but that wasn't true even then. All those early things I did in New York—the 'Blind Woman' and the bowls and the Wall Street pictures—were taken with that small Ensign reflex camera. When I got ready to print them, I'd first make a contact positive on a glass plate, and then put it in the enlarger and project it onto an eleven-by-fourteen-inch glass plate, and from that I'd make a contact print on platinum paper. You couldn't enlarge directly on platinum, because the enlarger lights weren't strong enough then; you had to expose in daylight. I've always felt that you can do anything you want in photography if you can get away with it. Another one of those early pictures of mine—it was published in *Camera Work*—was taken from the window of a courtroom the first time I was ever called for jury duty. I shot down at some people in City Hall Park. Well, there was one group of three people that should really have been two people. I took the third person out. Retouched him out in the darkroom. I had no great feeling of guilt over that. Of course, I don't agree with this method of just shooting and shooting and hoping to find something later in the darkroom. I've done all sorts of retouching when there's been a functional reason for doing it, and I crop negatives in the enlarger all the time. In general, I agree with Cartier-Bresson, who says he always uses the whole negative. That's the best way to work. It's only when you know how to work that way that you have the right to crop. But it's not a great issue. The only great issue is the necessity for the artist to find his way in the world, and to begin to understand what the world is about.

"Cartier-Bresson has said that photography seizes a 'decisive moment,' " Strand went on. "That's true, except that it shouldn't be taken too narrowly. For instance, does my picture of a cobweb

in the rain represent a decisive moment? The exposure time was probably three to four minutes. That's a pretty long moment. I would say the decisive moment in that case was the moment in which I saw this thing and decided I wanted to photograph it. Many of Cartier-Bresson's photographs are truly capturings of moments that were exceptional—for example, his great photograph of the children playing in the ruins of a Spanish town; it's like a dance that could be interrupted at any moment by the fall of another artillery shell. But with me it's a different sort of moment."

For several months before the cataract operations on both his eyes in 1973, Strand could barely see. Walter Rosenblum, a photographer and teacher of photography and one of Strand's closest friends, went with his wife to Orgeval during this time and stayed a few days. "He never stopped working," Rosenblum recalls. "He'd put a negative in the enlarger and get Hazel to tell him what was showing on the easel and when it was in focus. He reminded us of Renoir at the end of his life, painting with brushes strapped to his wrists." The operations were successful; Strand resumed his old work habits. He seemed to take real pleasure in the recognition that came to him late in life—the retrospective exhibitions and the critical acclaim that followed them—but there were never any real distractions from the work at hand. He finished his book on Ghana and worked closely on its layout. He travelled back and forth from Orgeval to New York, conferring with editors and printers, planning new trips and new photographic projects. For a long time he managed more or less successfully to ignore the increasing pain in his right shoulder, which was eventually diagnosed as an inoperable bone cancer.

In the last year of his life, Strand agreed to work with a young darkroom technician, Richard Benson, on a portfolio of original prints. It was something he had never done before—Strand, who rarely made more than one or two permanent prints at a time from a negative, could not conceive of turning out as many as fifty, and it had never occurred to him that anyone else could make a satisfactory print of a Strand photograph. (The Mexican portfolio of 1940 was done in hand-gravure). The fact that it did prove possible delighted him beyond measure. Starting in the fall of 1975, at the house in Orgeval, he worked every day with Benson, supervising each step in the printing process, getting every detail exactly right, making no compromise. The portfolio, which he called On My Doorstep, contained eleven photographs—not enough for Strand. They did another, of six photographs, in an edition of fifty. A very sick man by this time, Strand let himself be persuaded to continue the process. Four portfolios were produced in all, plus editions of four single photographs on platinum paper. Strand worked a lot of the time in bed, wearing on his bathrobe the rosette of the Commander of the Order of Arts and Letters, which had recently been conferred on him by the French Minister of Culture, and of which he was enormously proud (the French rarely give official recognition to photographers). He approved the final master print late in March, 1976, and then, without saying anything to Hazel, he stopped entirely what had been for several months a minimal intake of food and water. He died quietly a few days later.

"I think Thoreau's comment that 'you cannot say more than you see' is profoundly true," Strand told a visitor, a few months before his death. "It's the final measure. When you come to the end of seeing—when seeing is only looking—then you've reached the end of your road. I don't know, but it seems to me that if I could go on for another fifty years, I'd have no hesitation in saying that I would be very busy."

37. Blind Woman, *New York 1916* 38. Man, *Five Points Square, New York 1916*
39. Fifth Avenue, *New York 1915* 40. White Fence, *Port Kent, New York 1916* 41. Abstraction—Bowls, *Connecticut 1915*

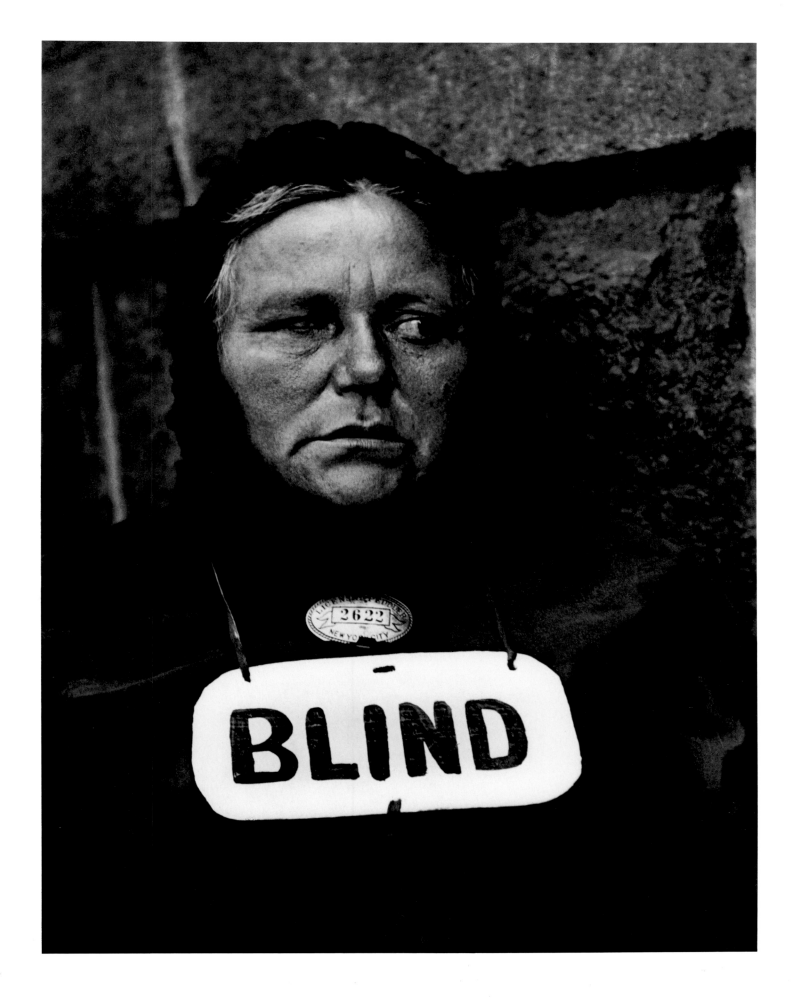

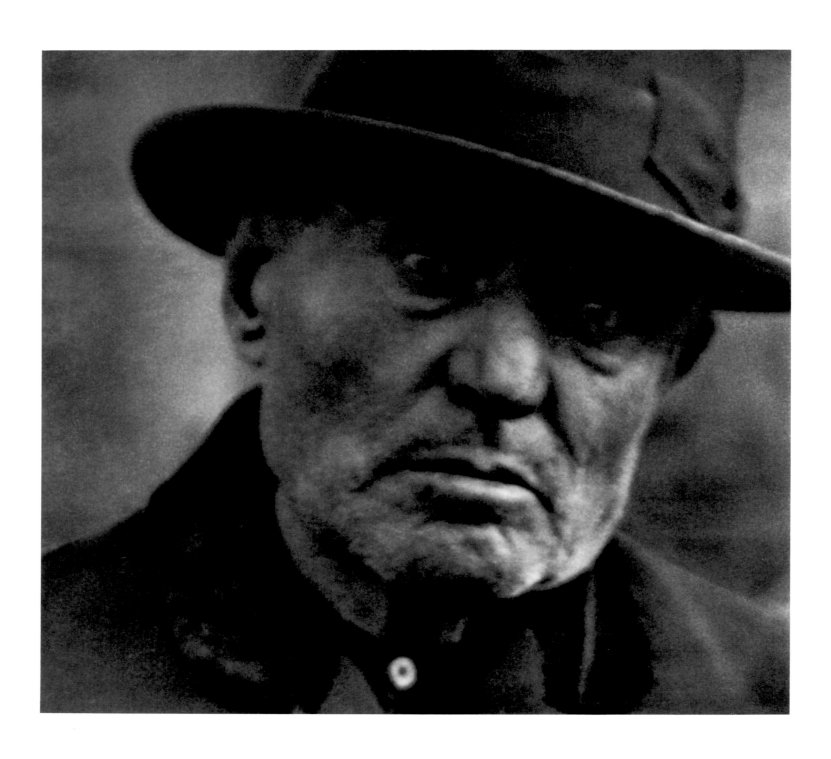

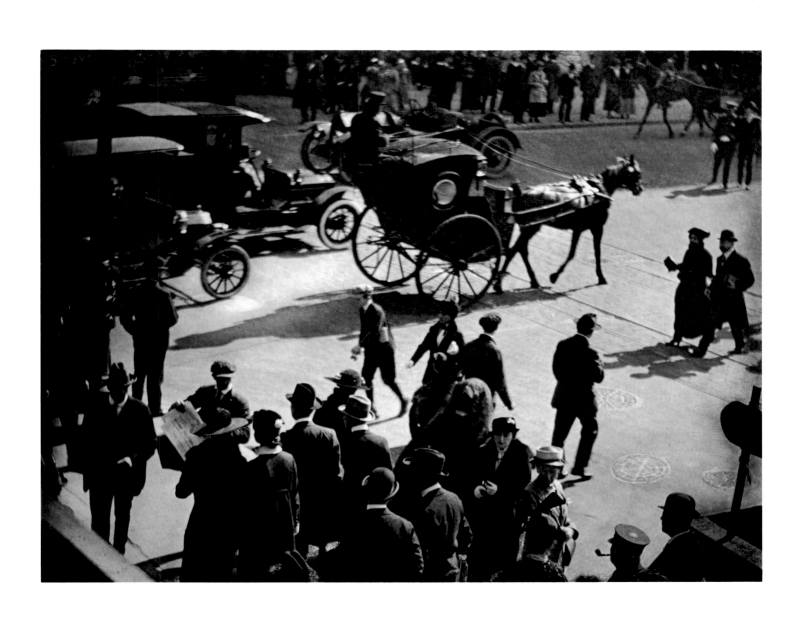

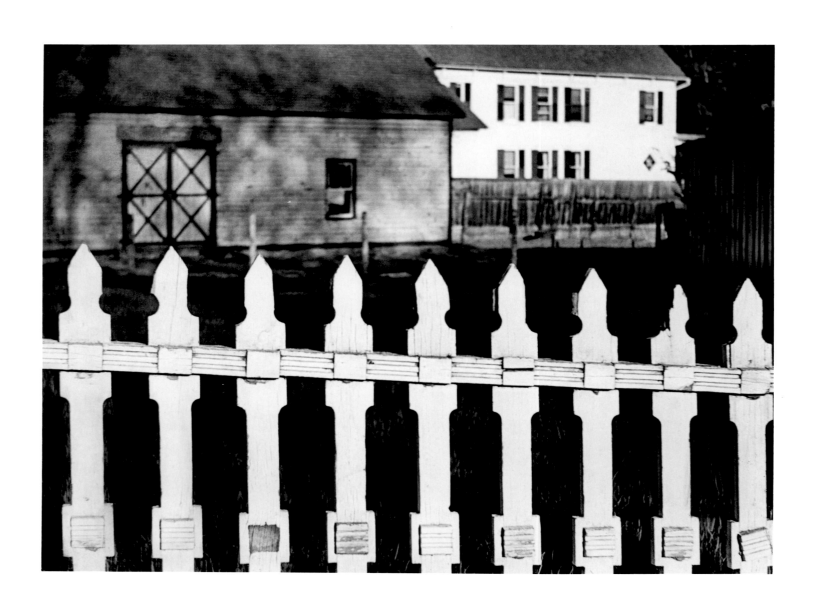

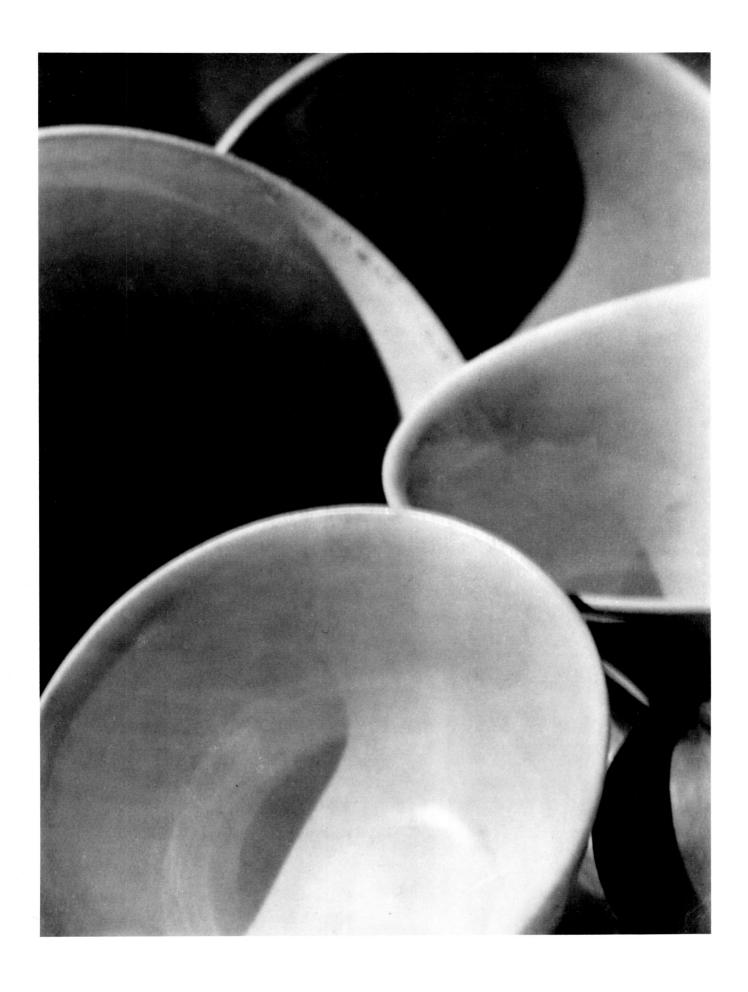

43. Fishing Village, *Gulf of the St. Lawrence, Gaspé 1929* 45. Black Horse on the Beach, *Perce, Gaspé 1929* 46. Fish Houses, *Gaspé 1936*
47. Gaspé, *1936* 48. Farm, *Corea, Maine 1945* 49. By the Sea, *Maine 1945* 50. West River Valley, *Vermont 1944*
51. Village, *Gaspé 1936* 52. Sails and Clouds, *Gaspé 1929* 53. Beaching the Boat, *Perce Beach, Gaspé 1929*

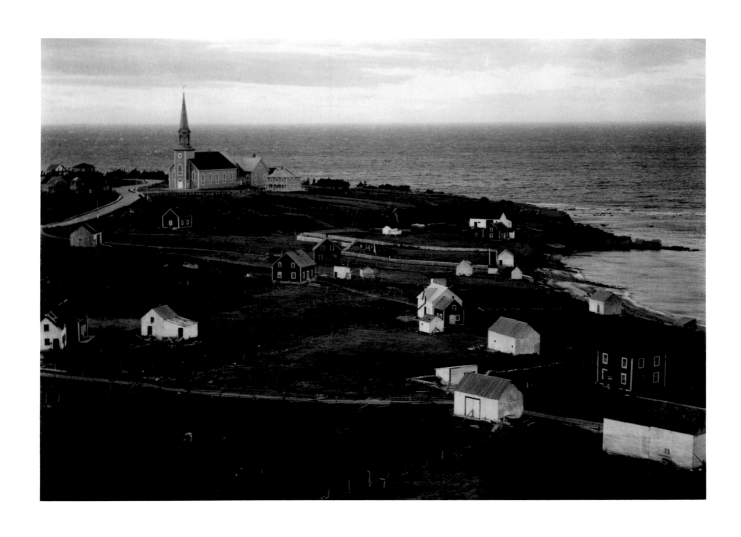

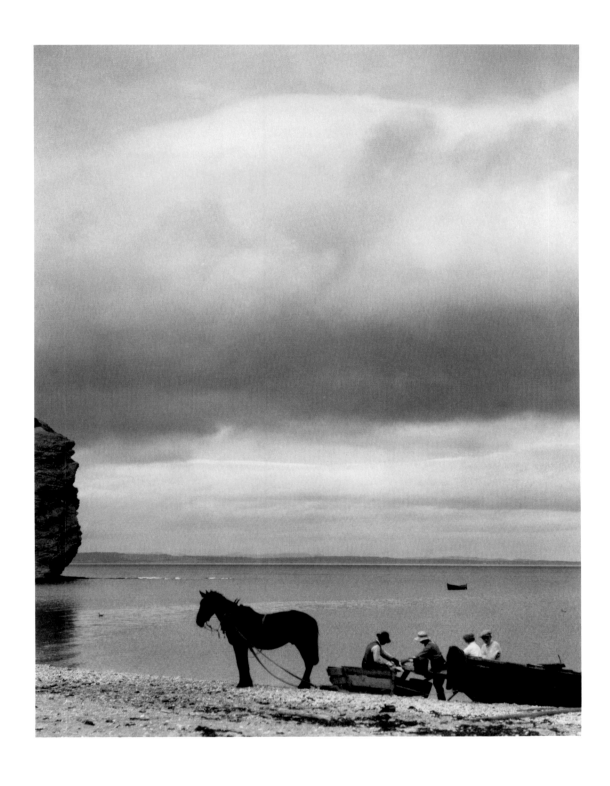

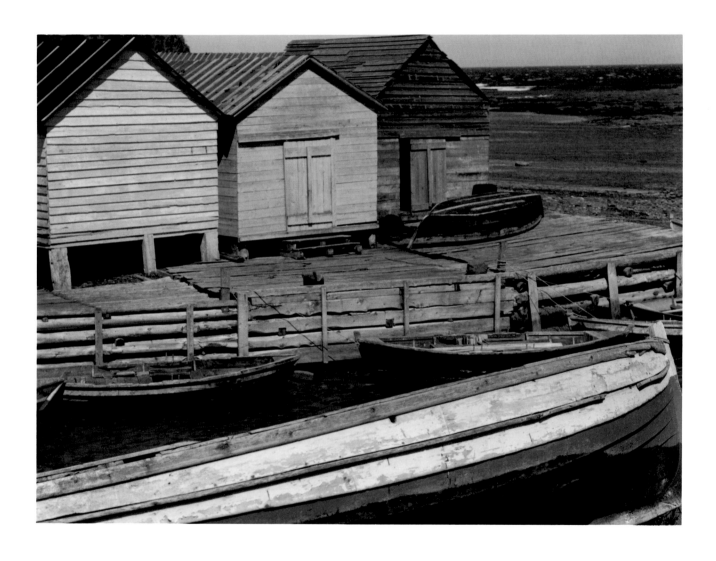

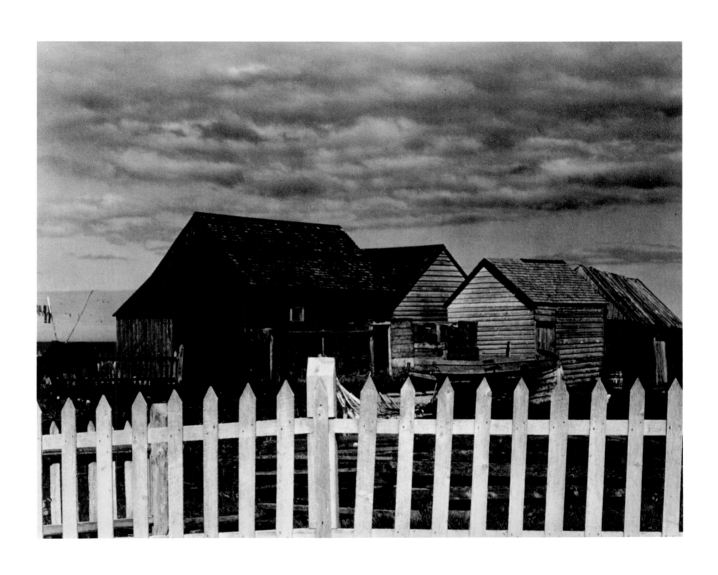

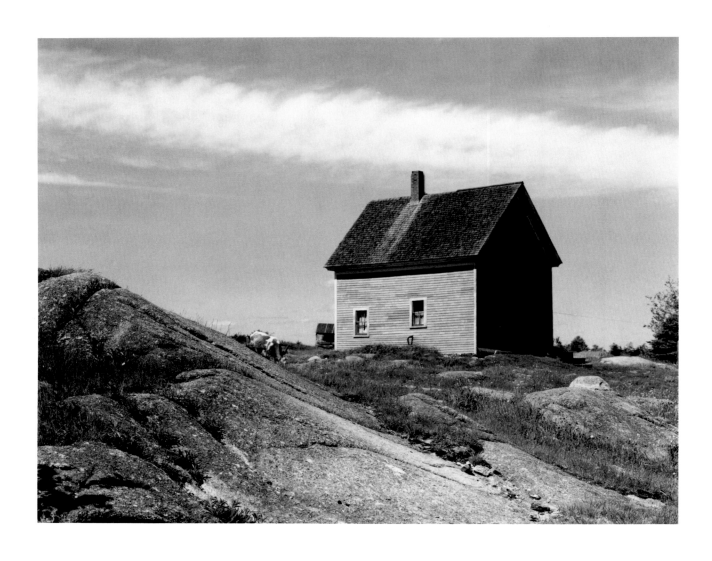

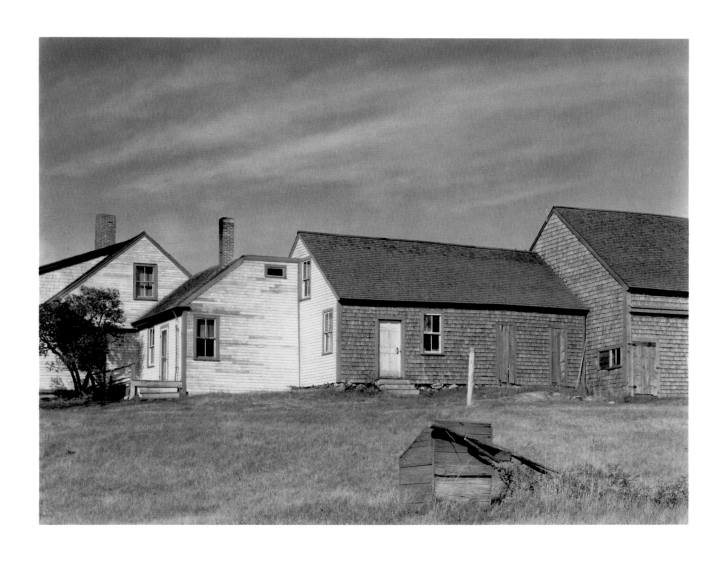

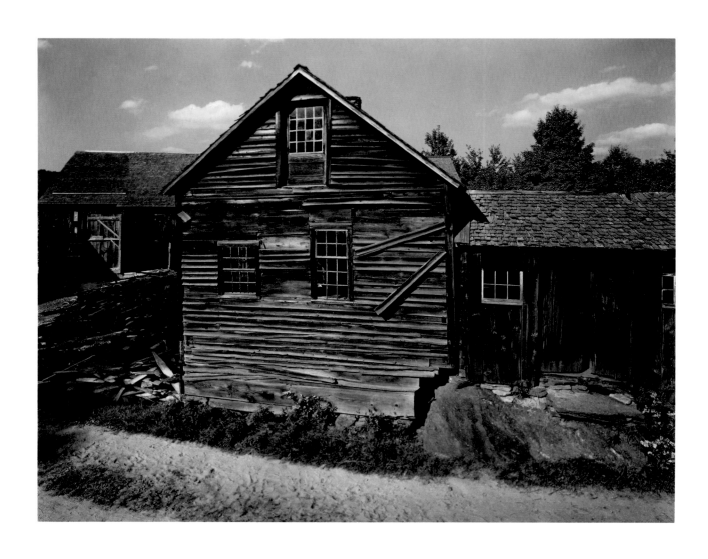

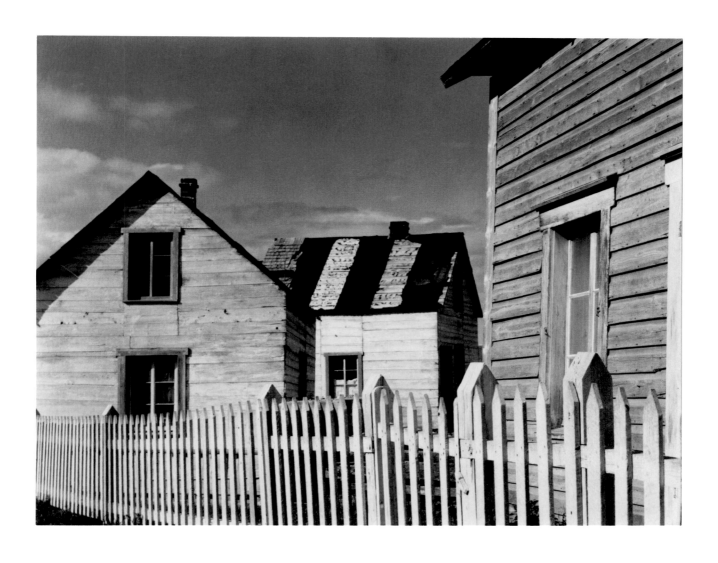

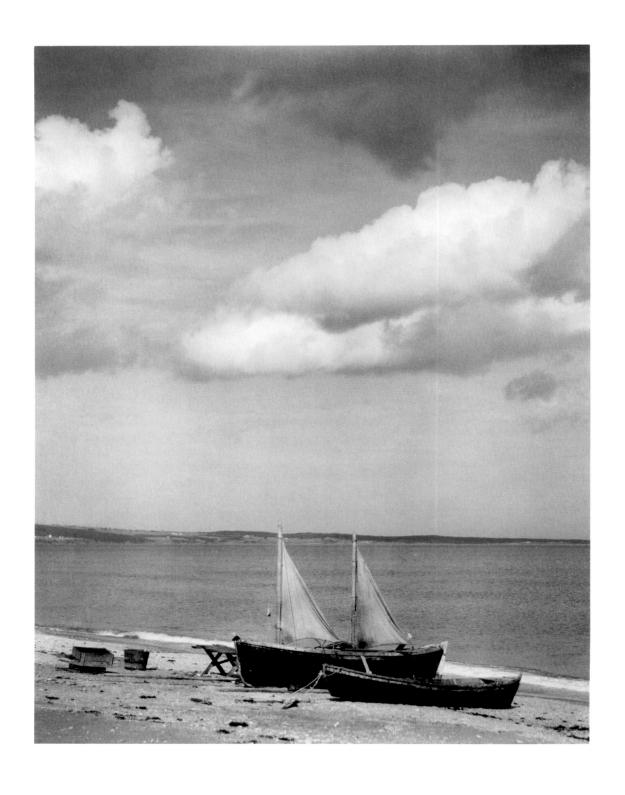

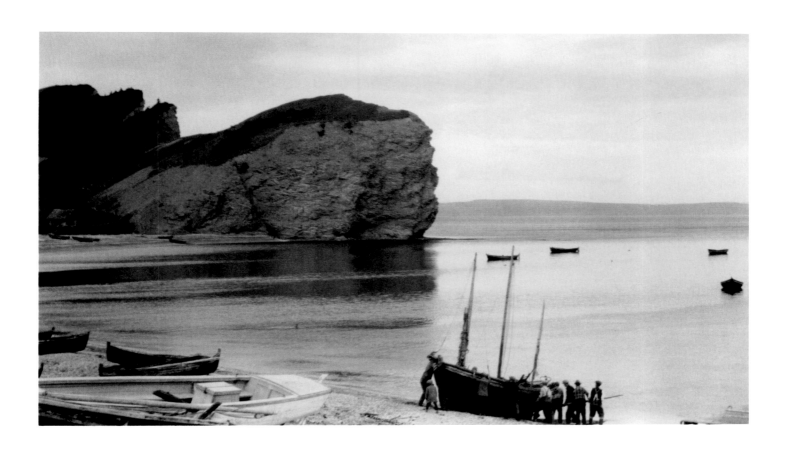

55. Rebecca, *New York c. 1922* 57. Gaston Lachaise, *Georgetown, Maine 1927/28* 59. Alfred Stieglitz, *Lake George 1939*
60. John Marin, *Cape Split, Maine 1945* 61. Marsden Hartley, *Georgetown, Maine 1927* 63. Georges Braque, *Varangéville, France 1957*

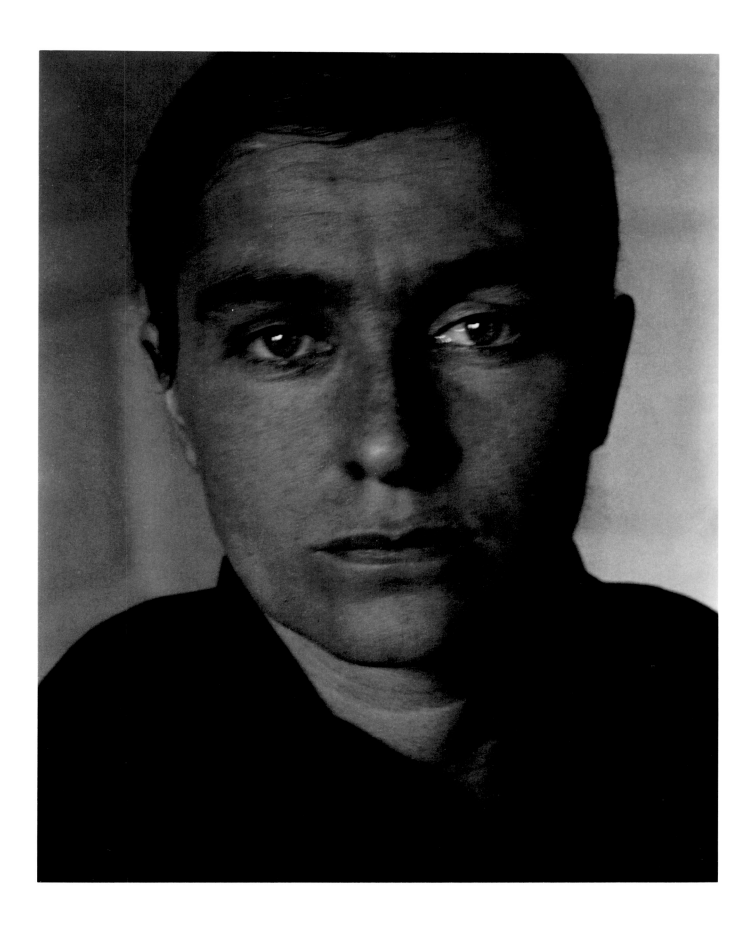

55

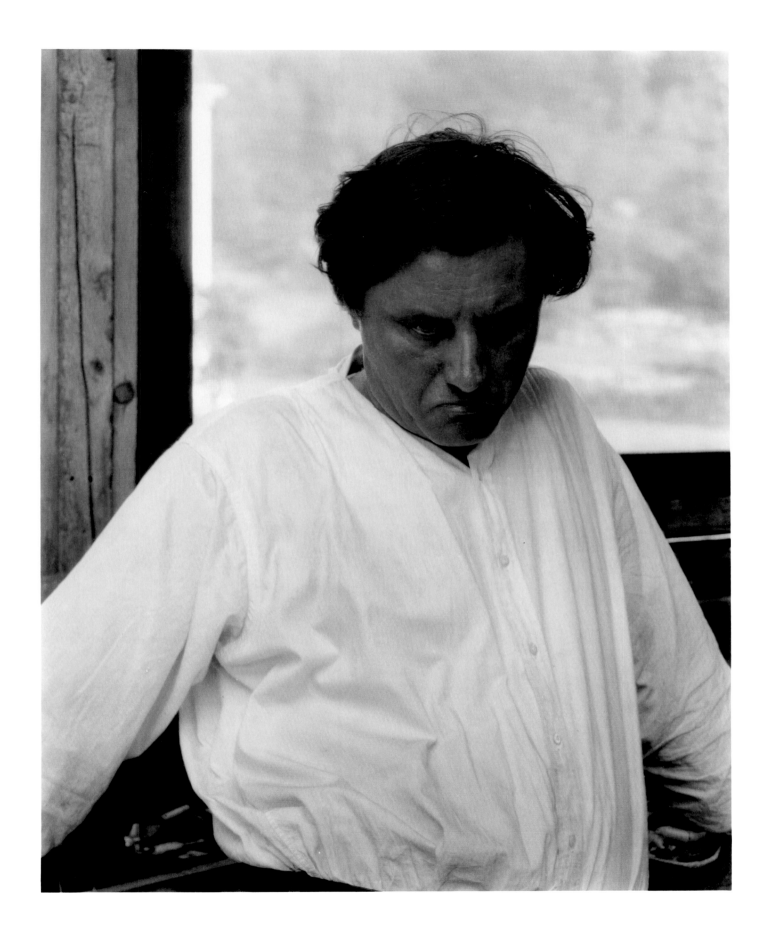

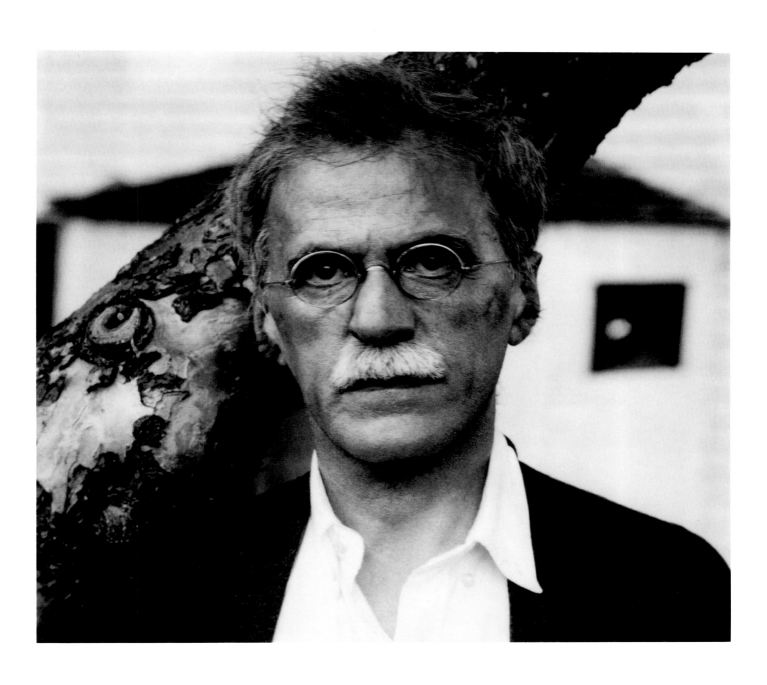

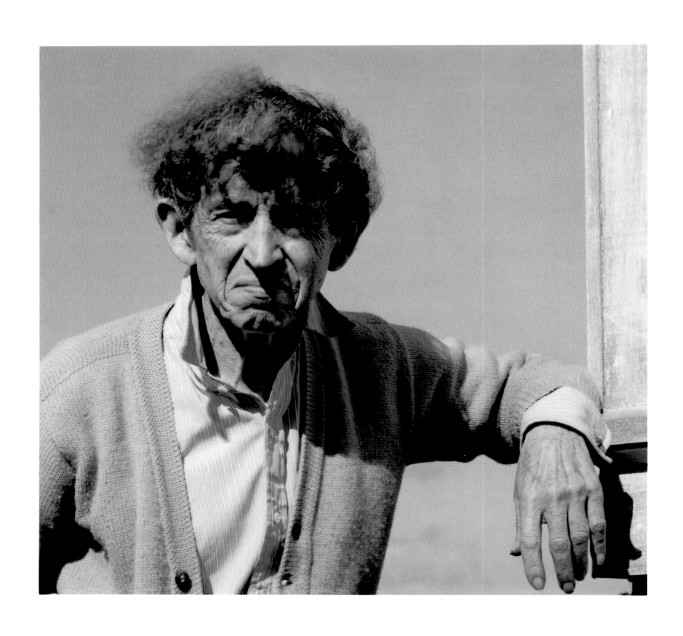

60

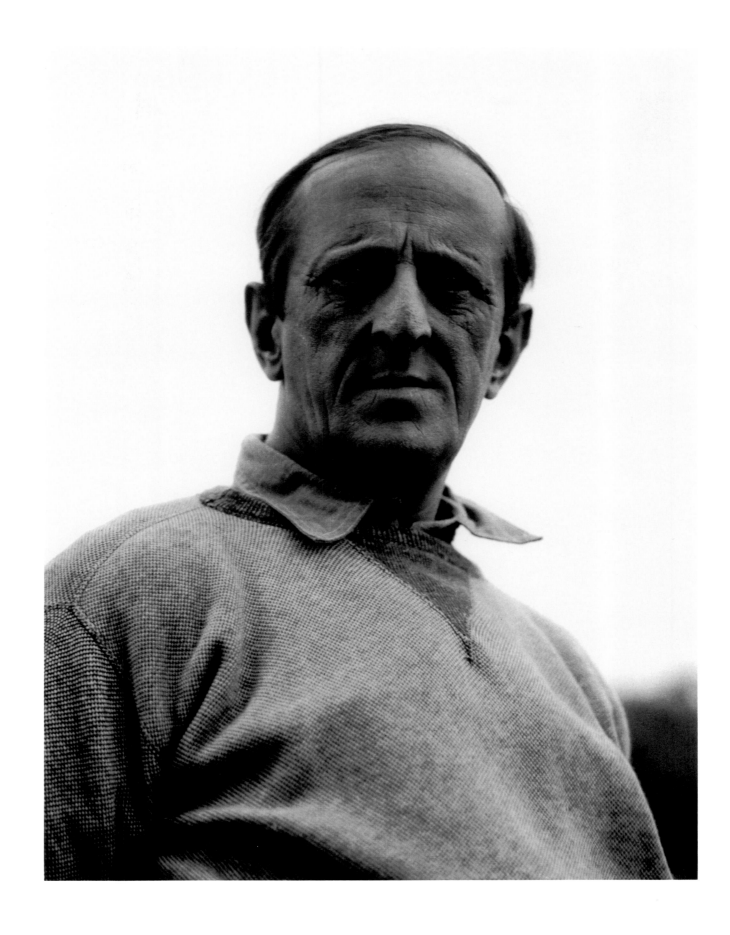

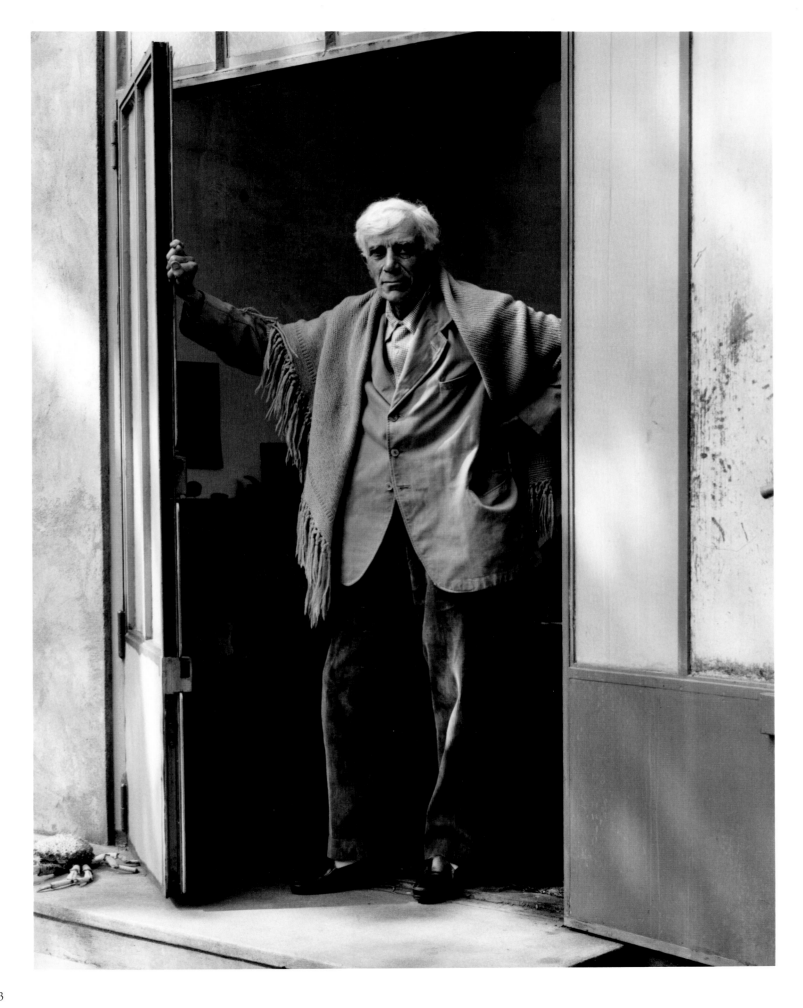

65. Wire Wheel *1920* 67. Lathe, *New York 1923* 68. Drilling Machine, *New York 1923* 69. Akeley Camera, *New York 1922*
70. Iron Gates Dam Construction, *Rumania 1967* 71. The Docks, *Constanta, Rumania 1967* 72. Harvesting in the Baragan, *Rumania 1967* 73. Oil Refinery, *Tema, Ghana 1963*

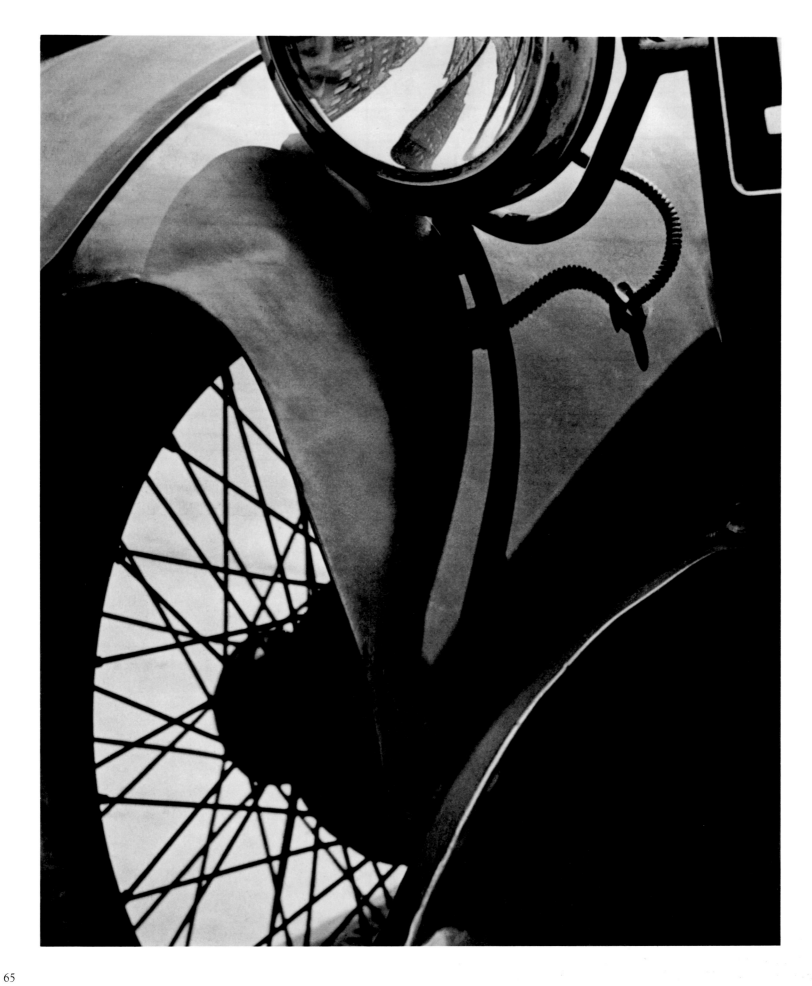

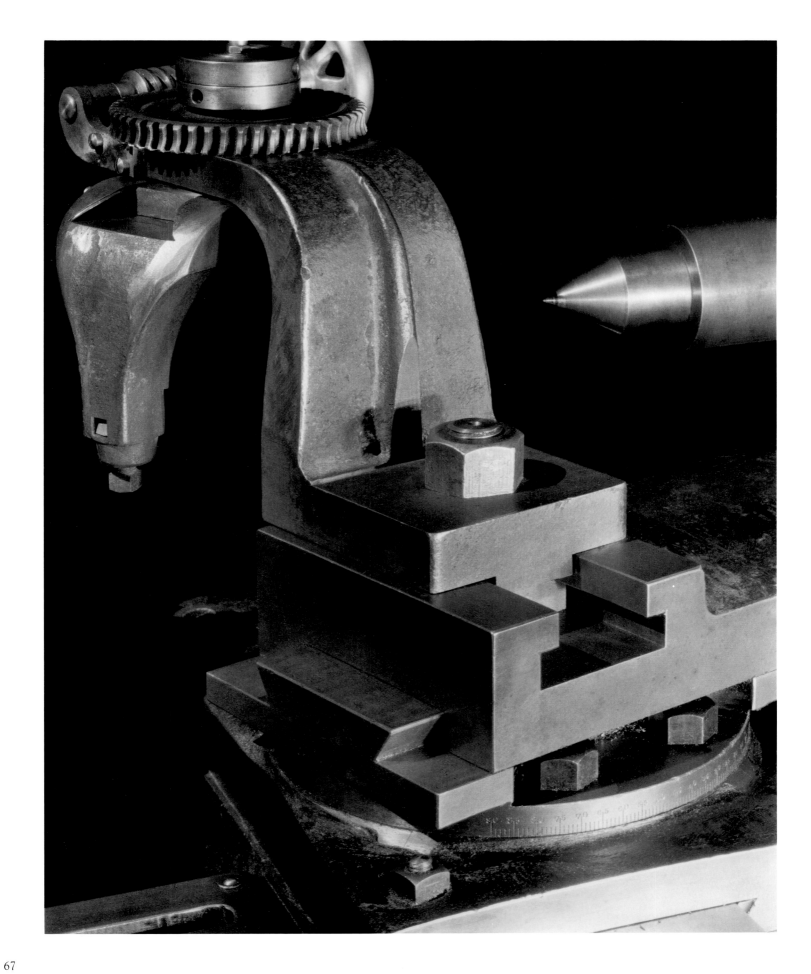

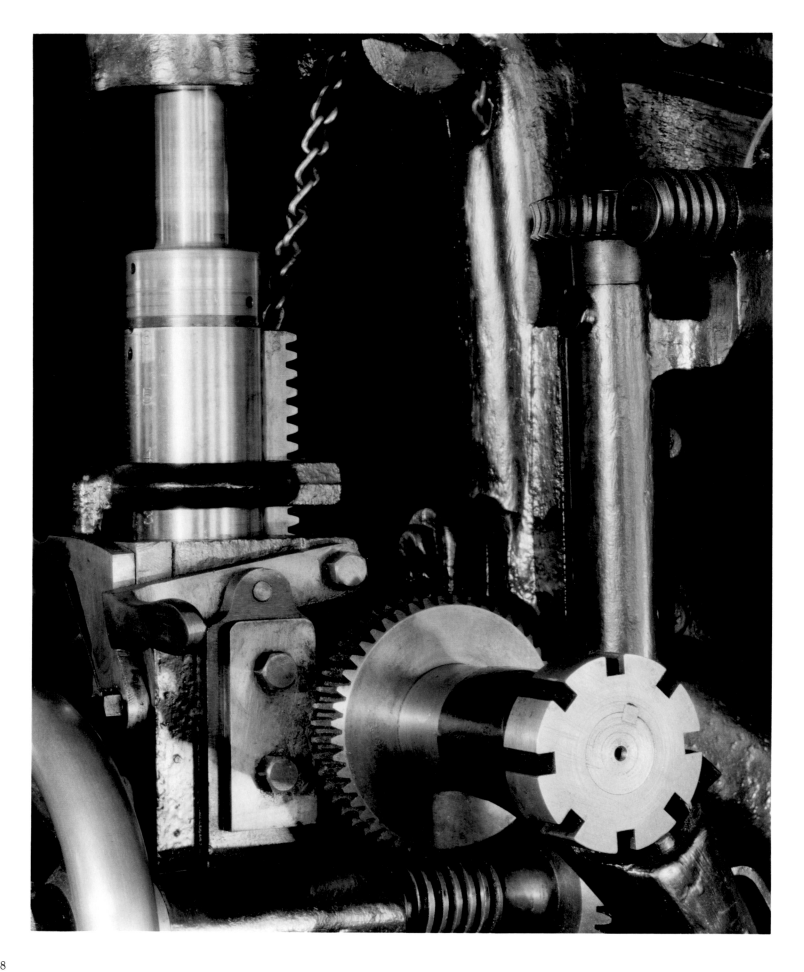

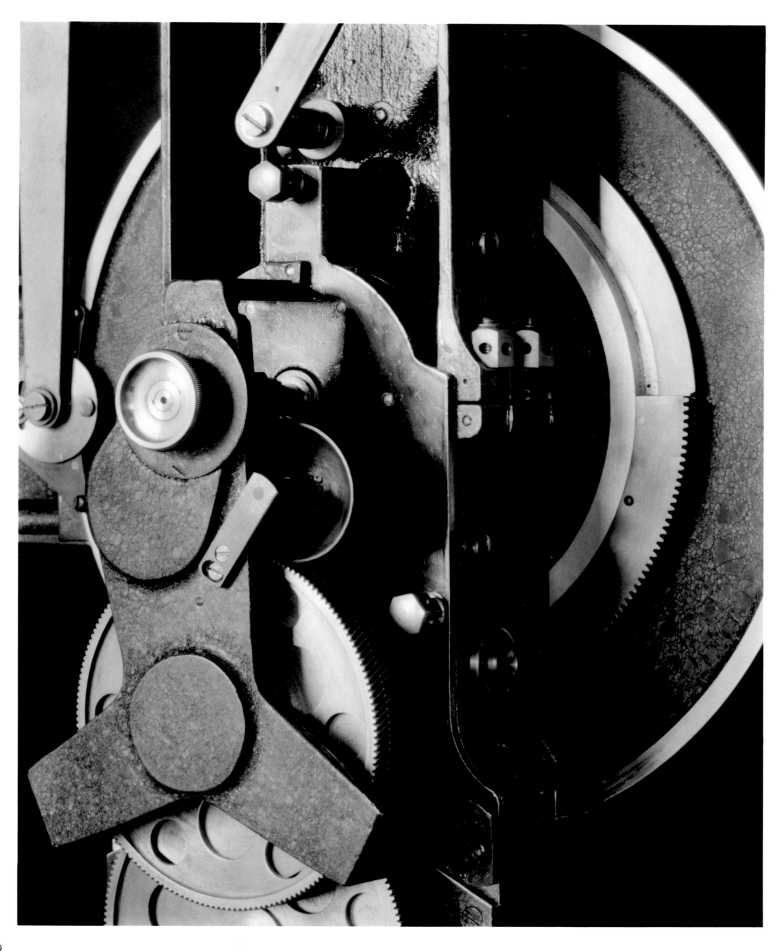

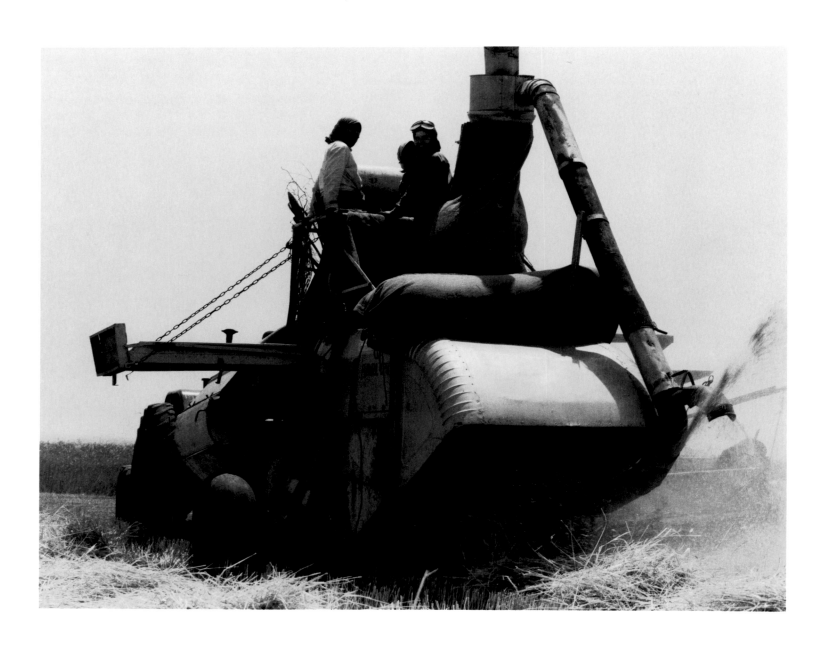

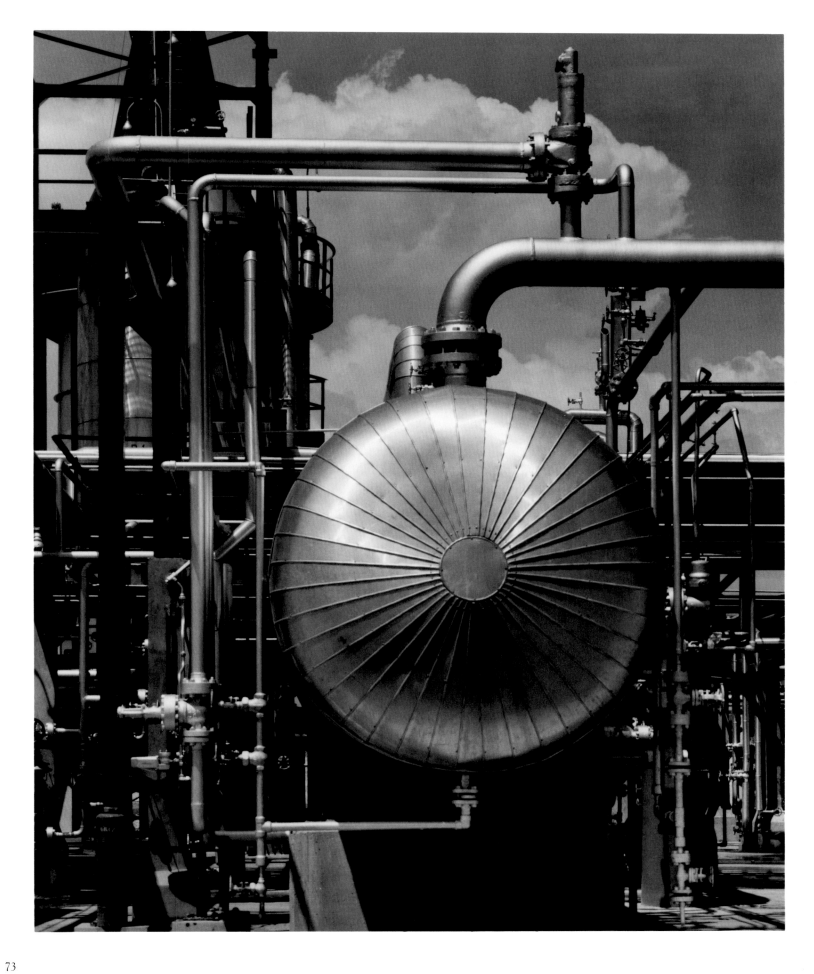

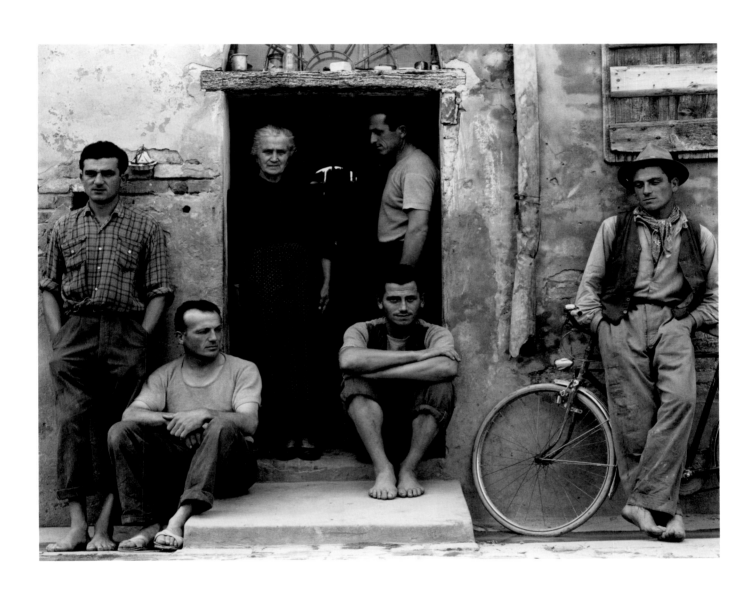

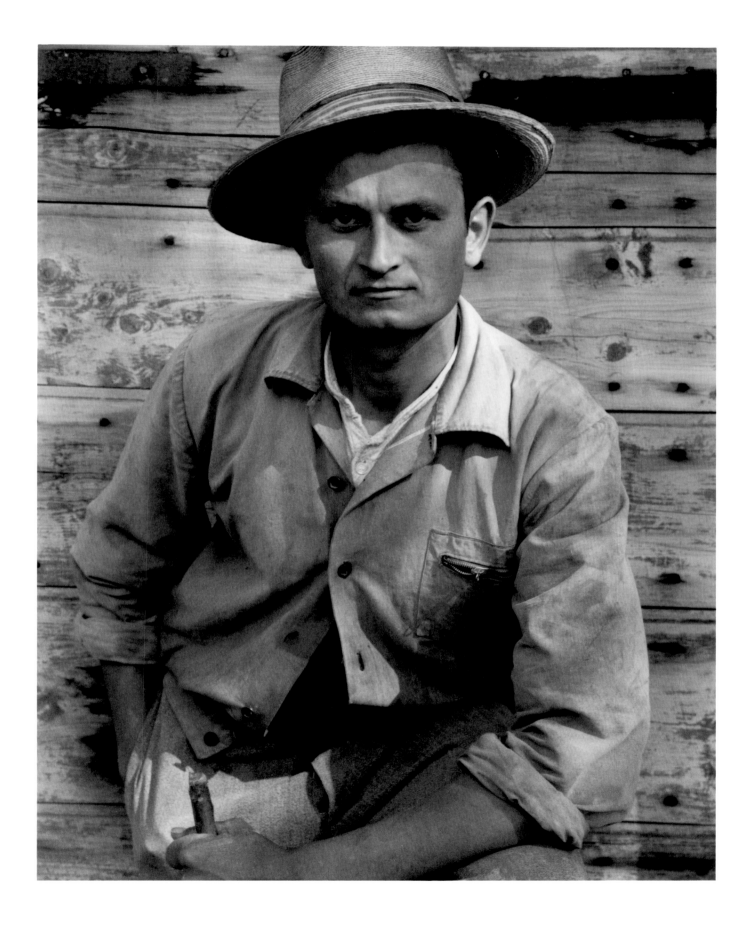

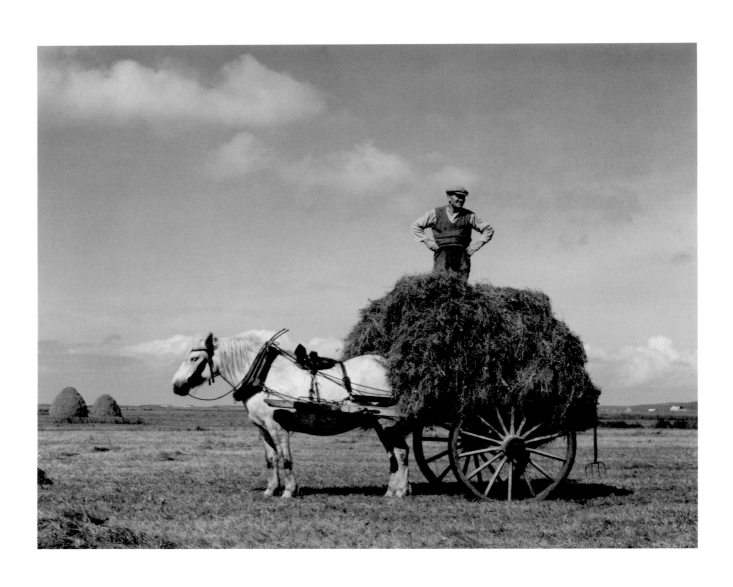

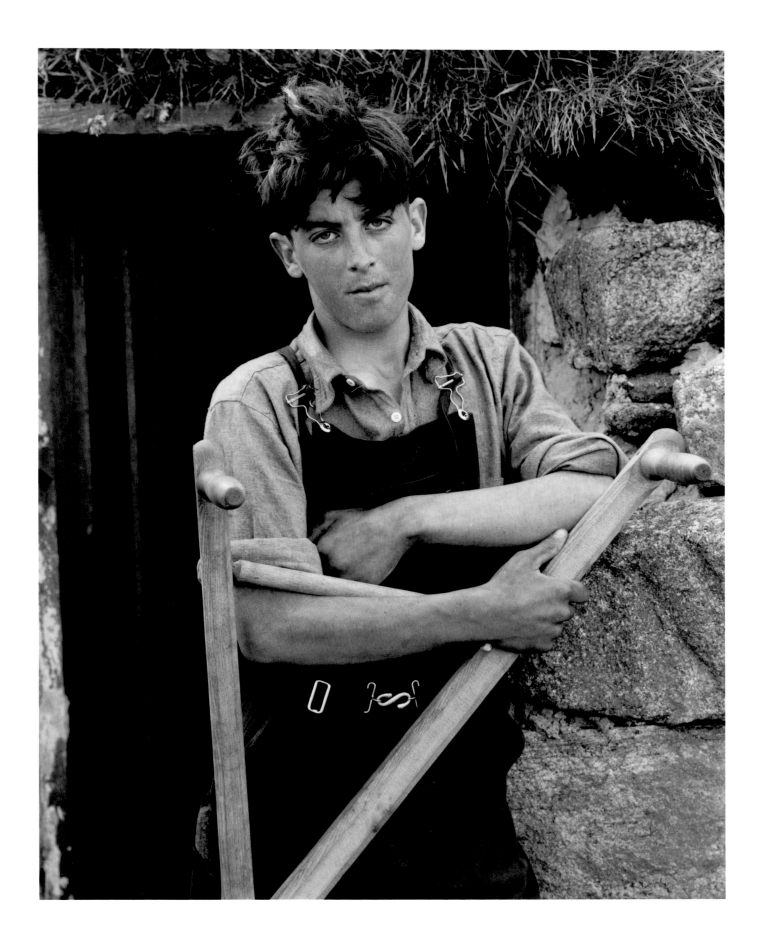

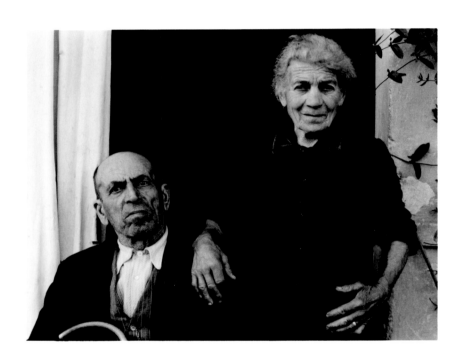

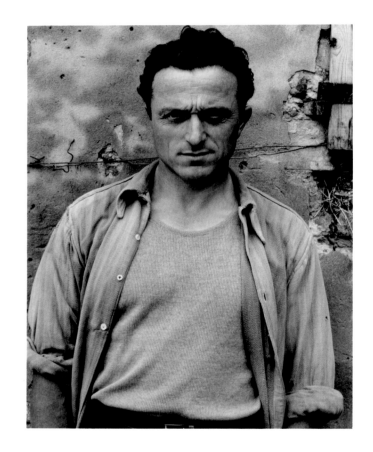

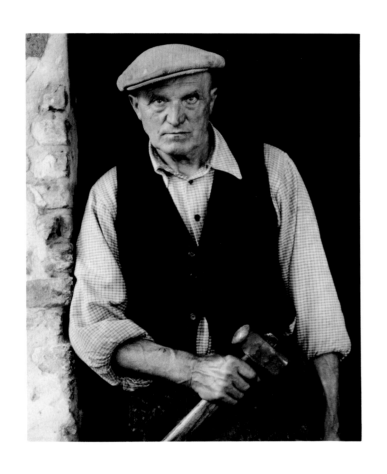

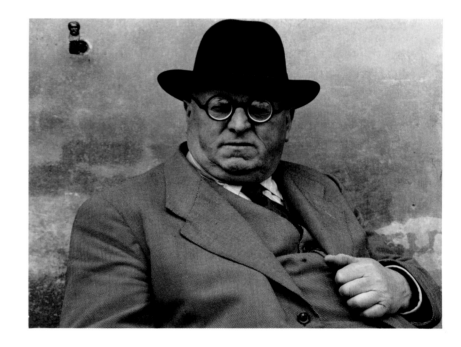

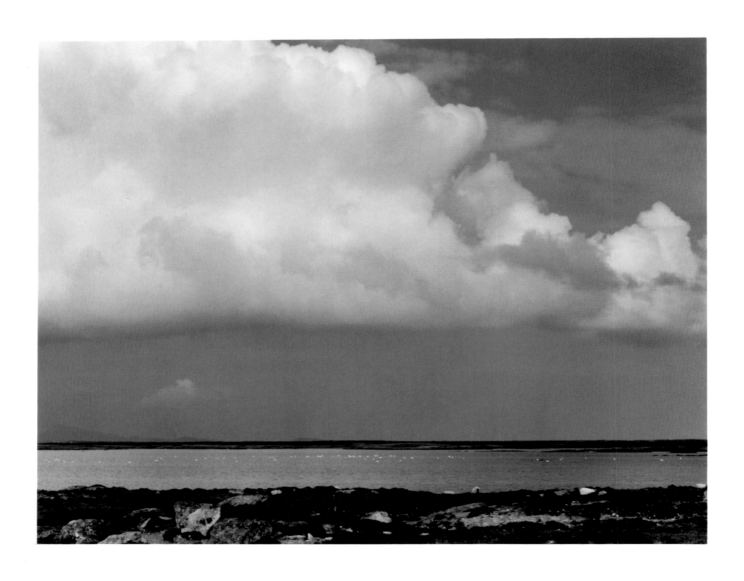

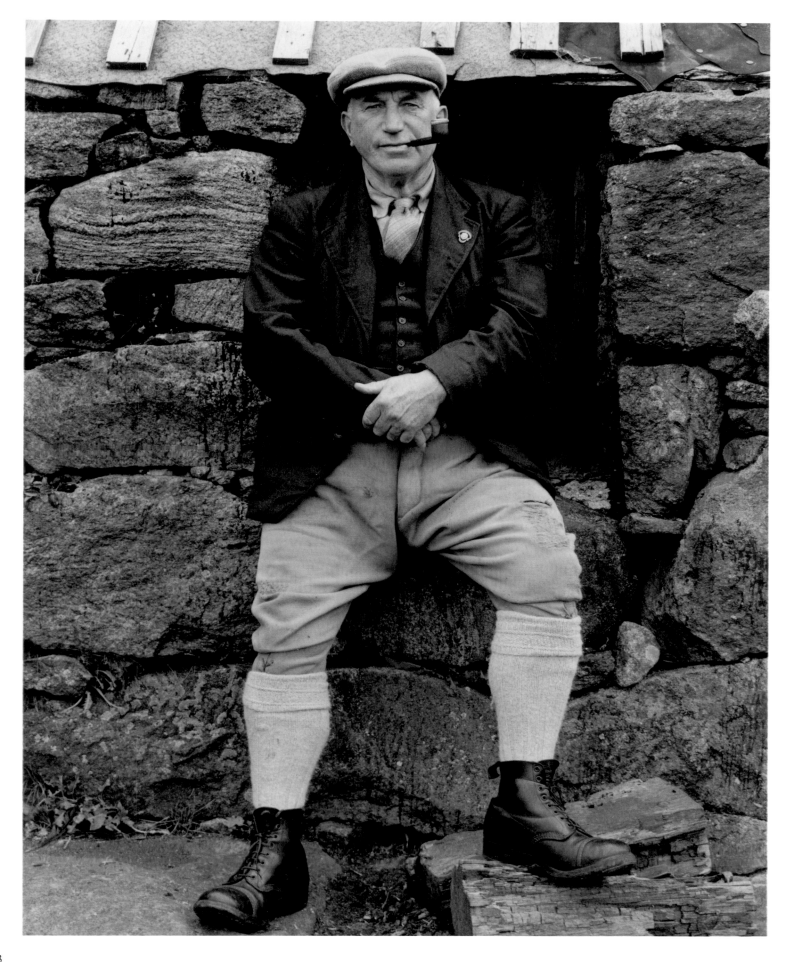

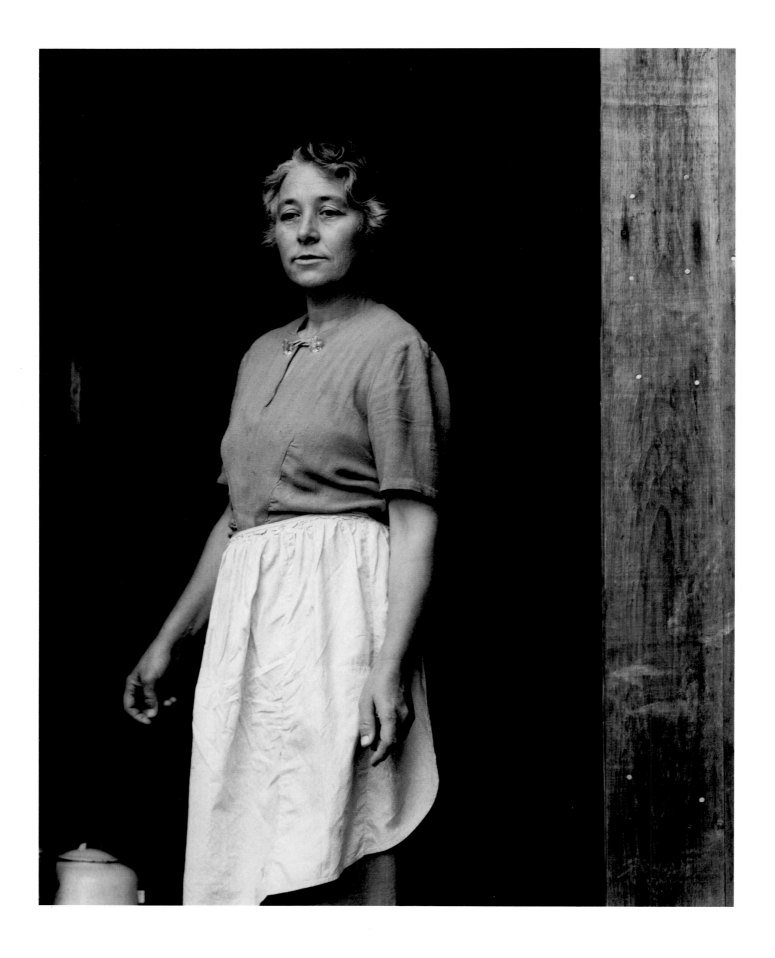

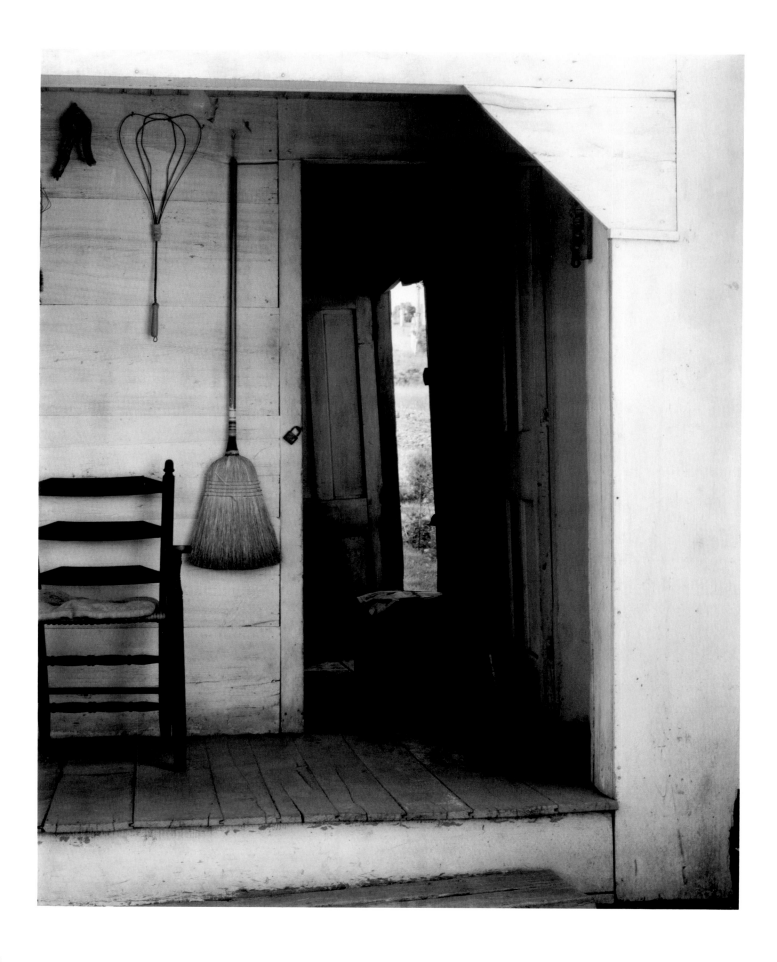

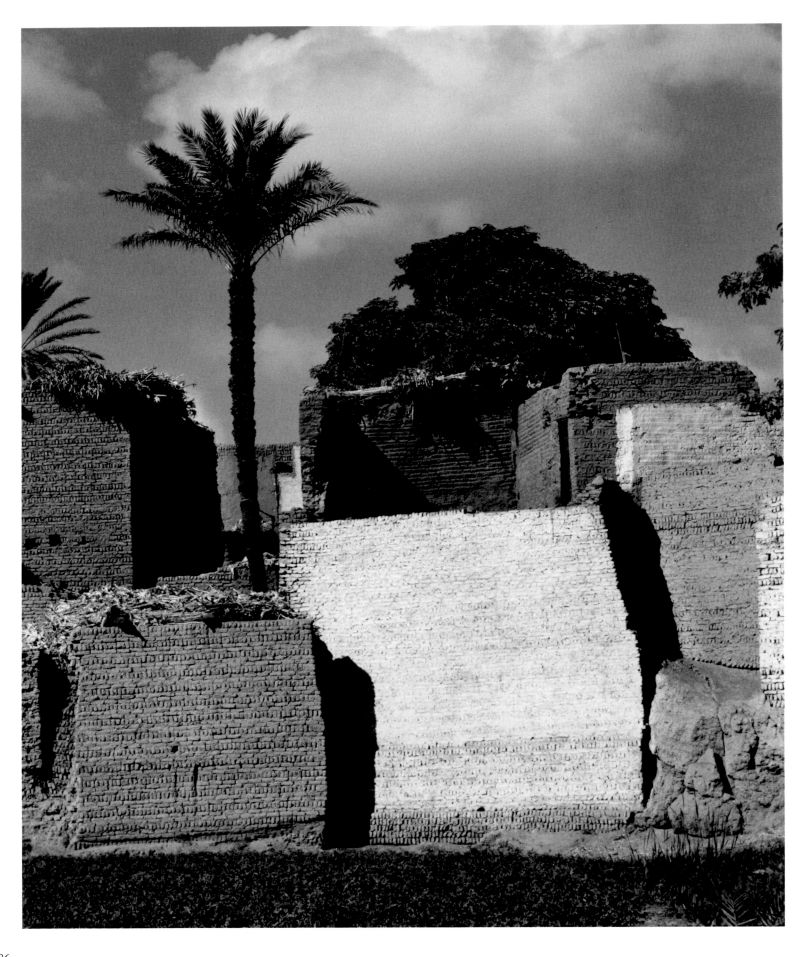

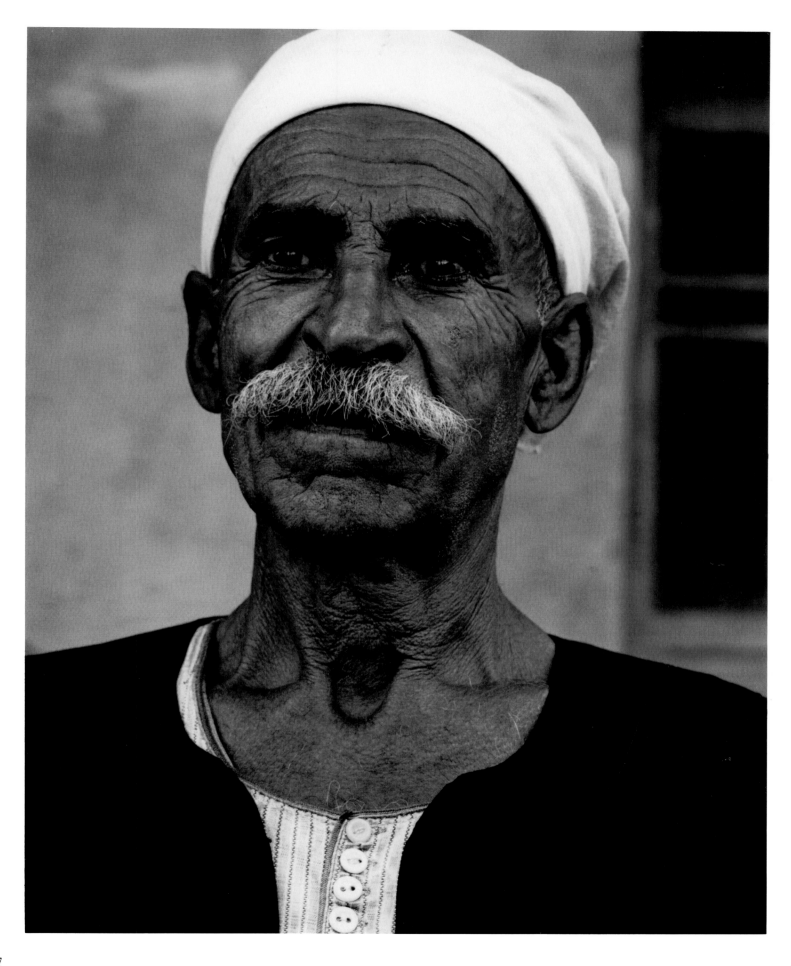

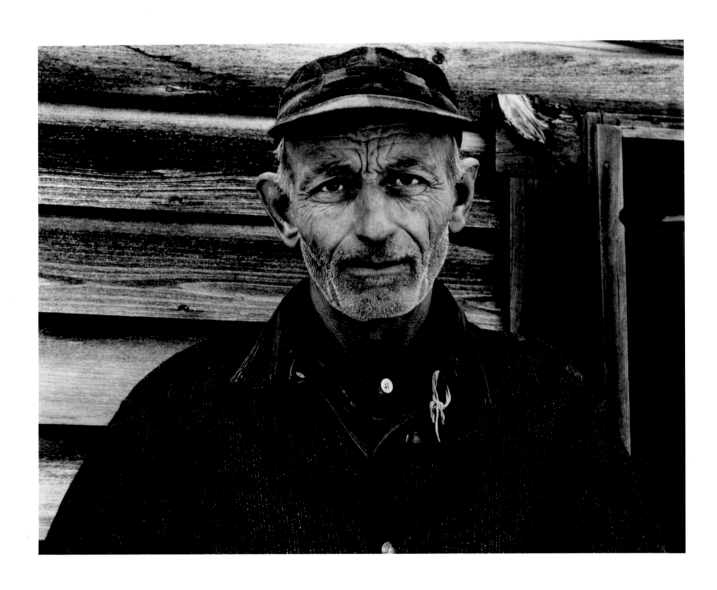

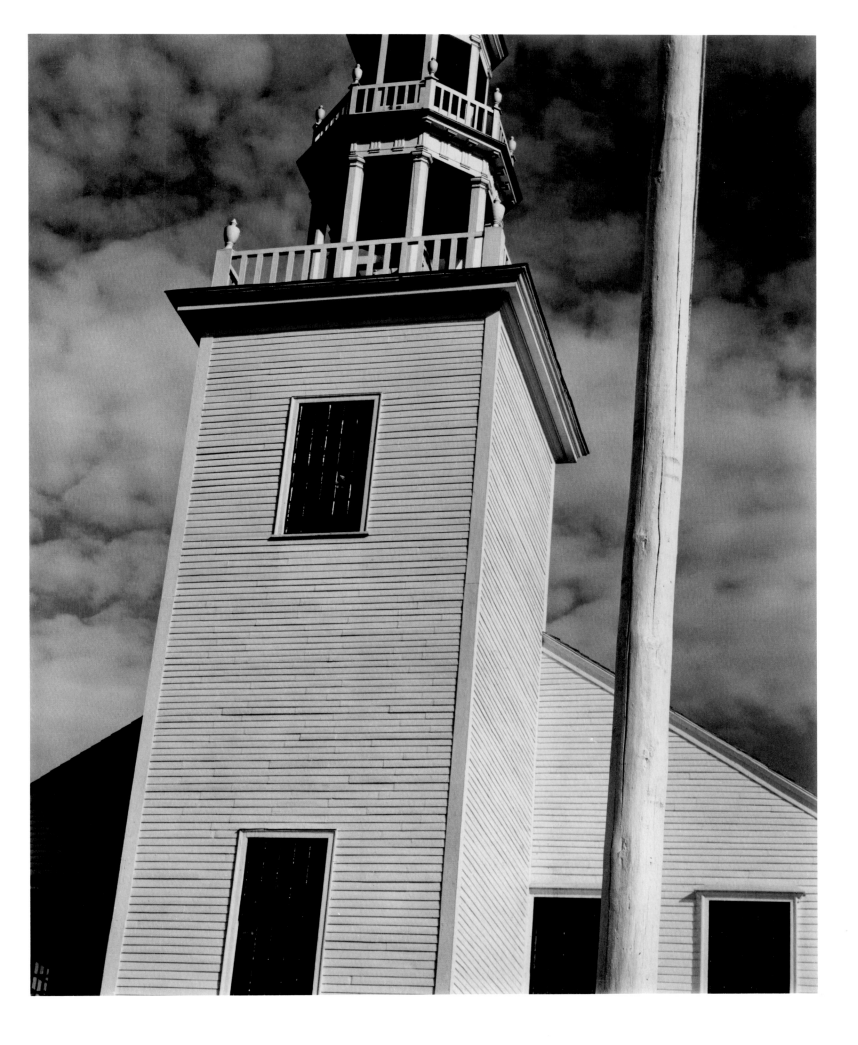

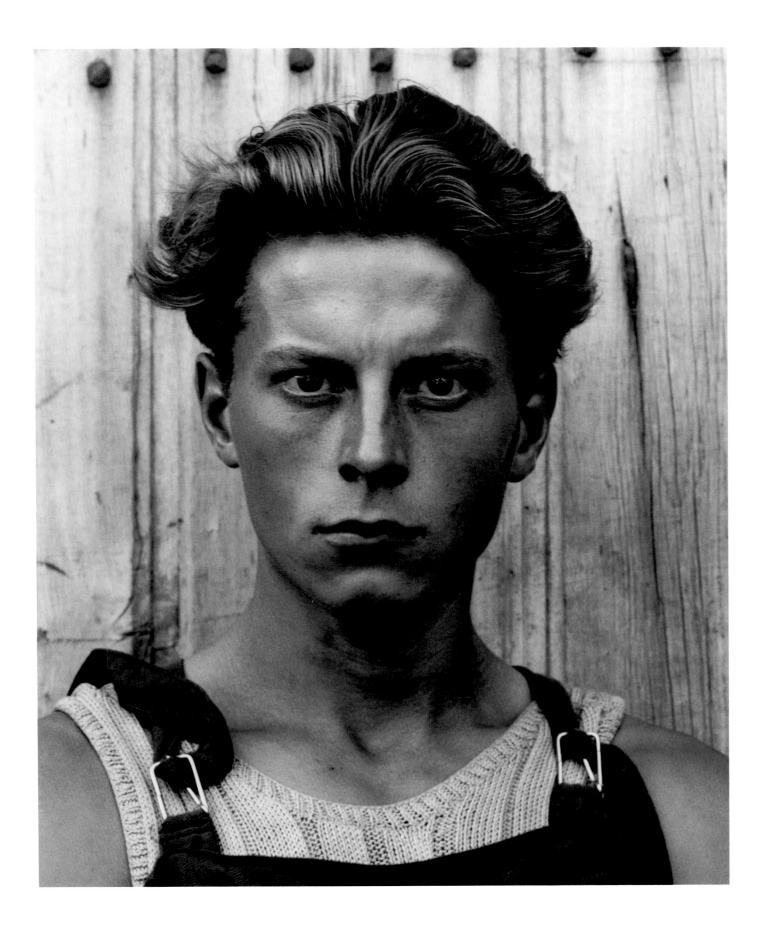

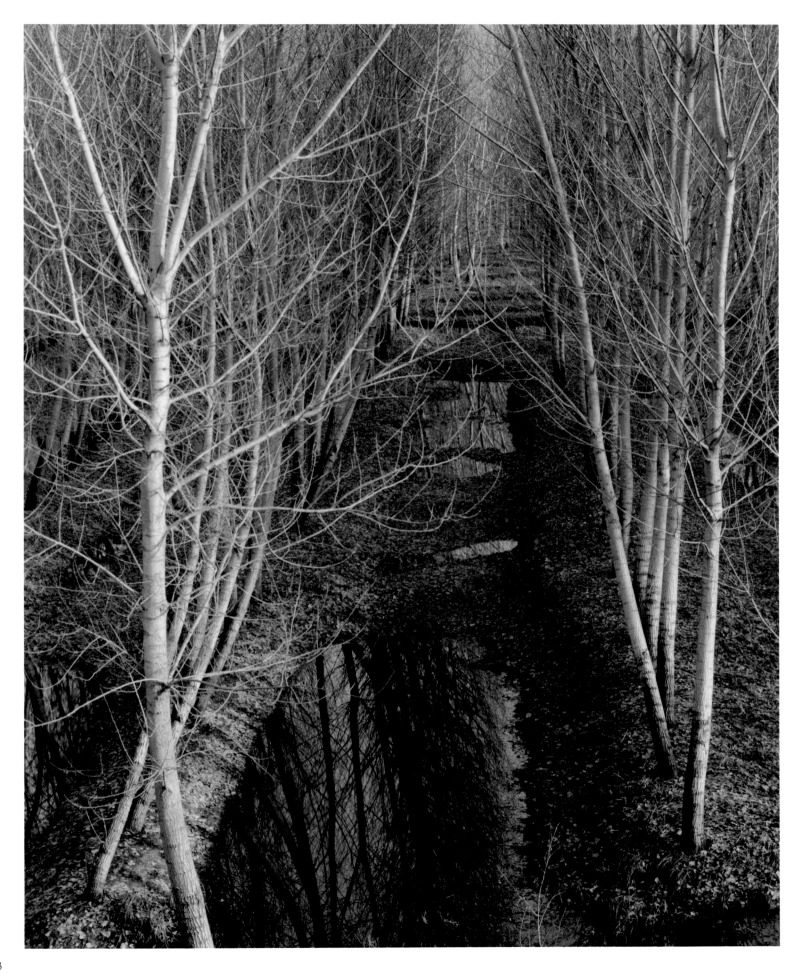

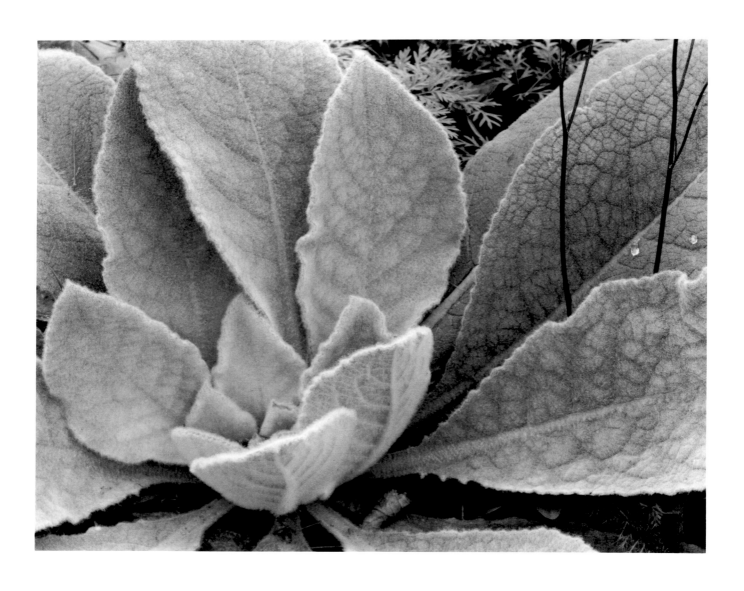

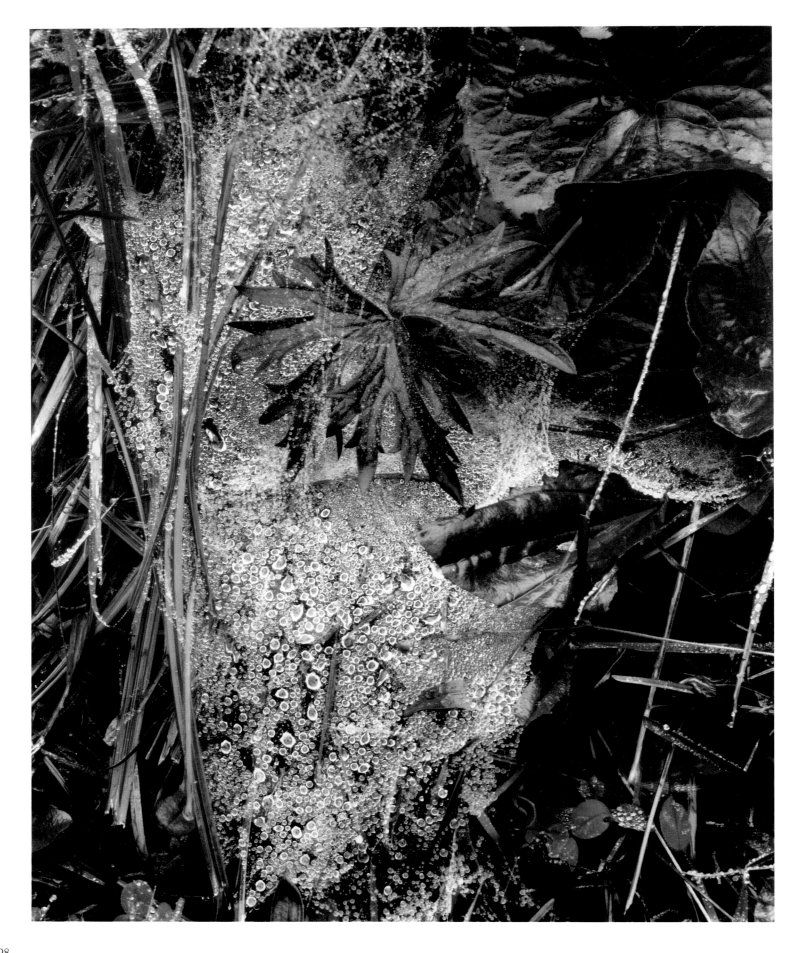

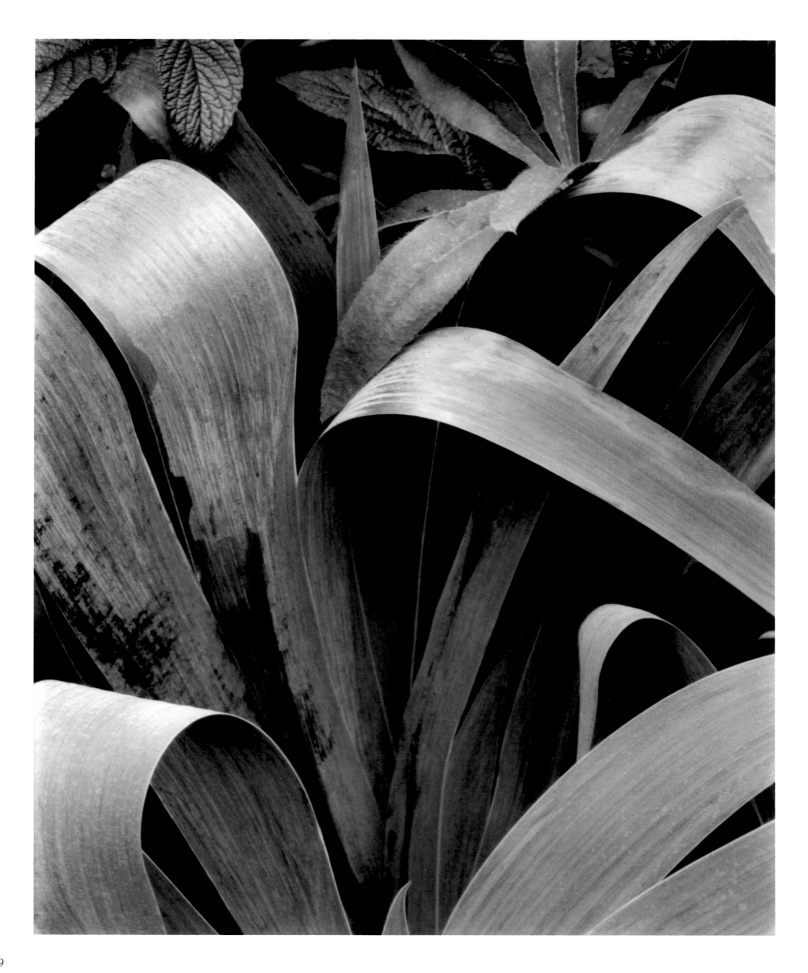

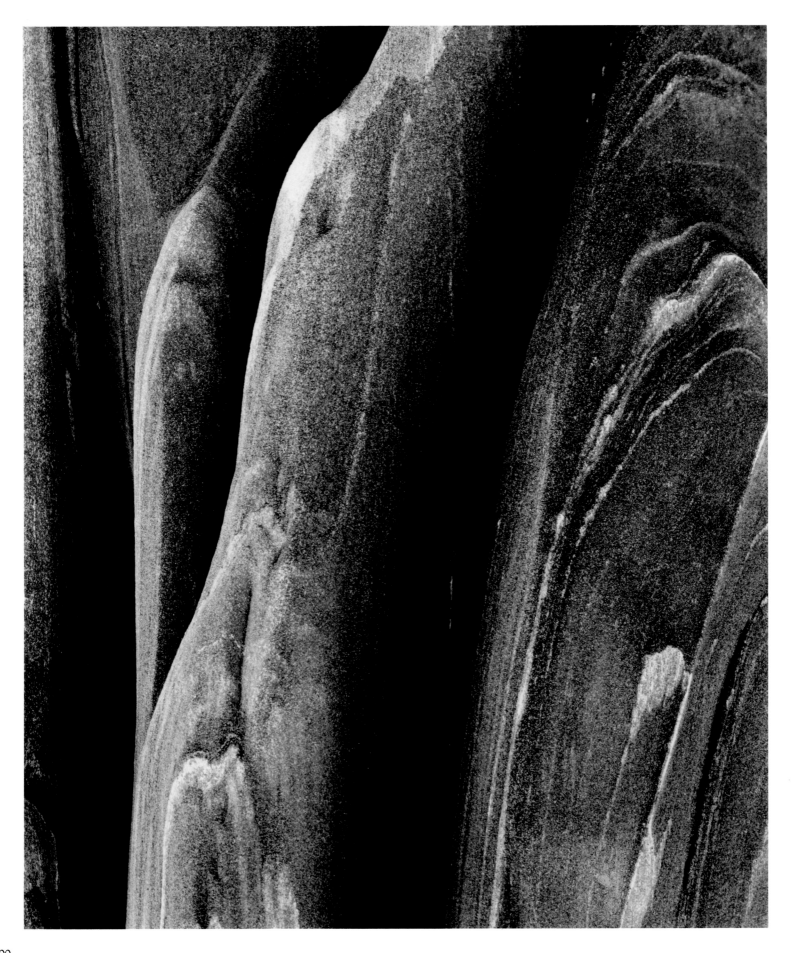

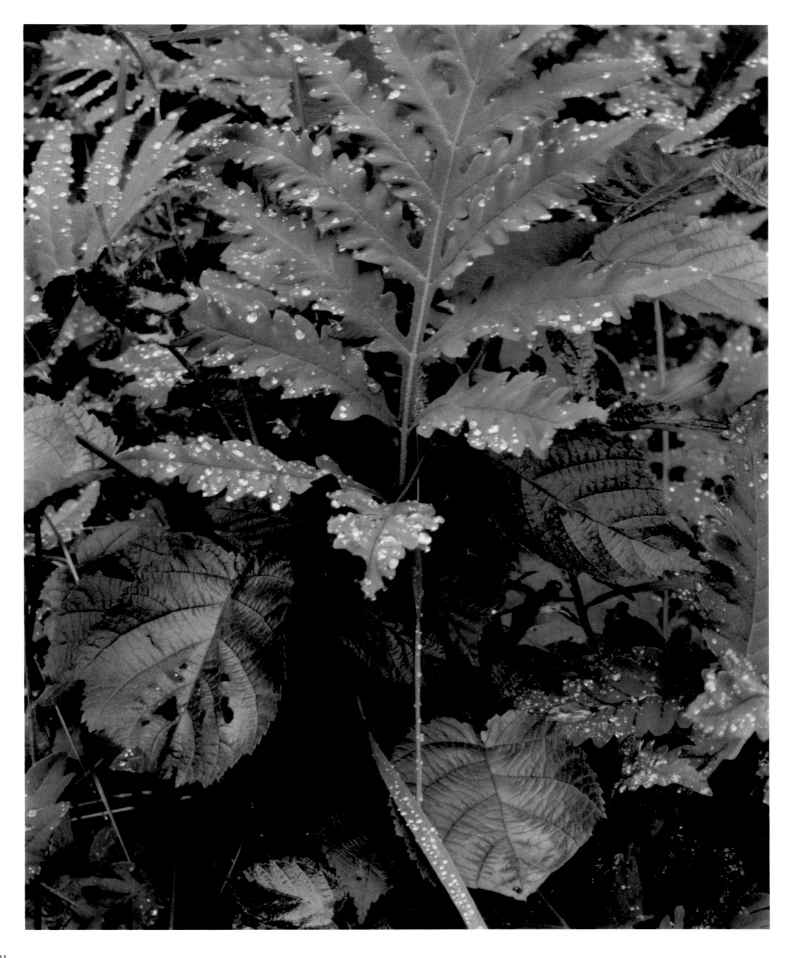

103. The Market, *Luzzara, Italy 1952* 104. On the Beach, *Cape Coast, Ghana 1963*
105. Fiesta, *Heutsotzingo, Mexico 1966* 106. Market, *Ouarzazate, Morocco 1962*
107. Camels at Rest, *Upper Egypt 1959* 108. Shop, *Nauplion, Greece 1965*
109. Women, *Stes.-Maries-de-la-Mer, France 1950* 110. Women, *Mogador, Morocco 1962* 111. Street, *Tetuan, Morocco 1962*

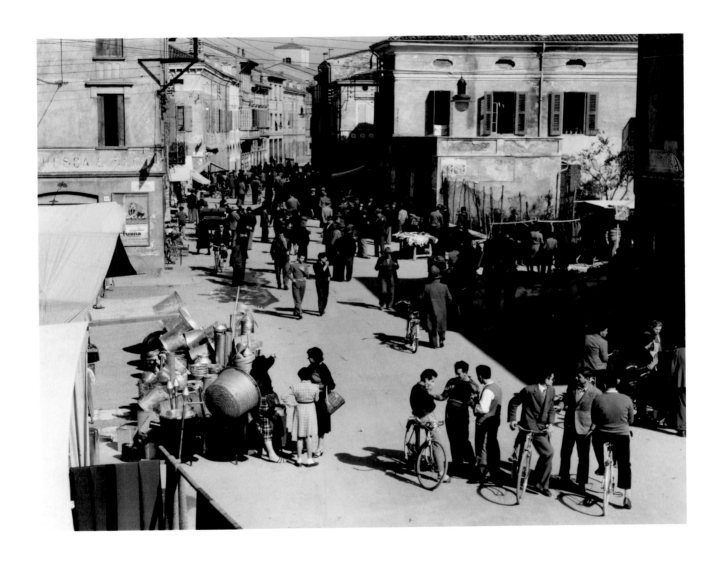

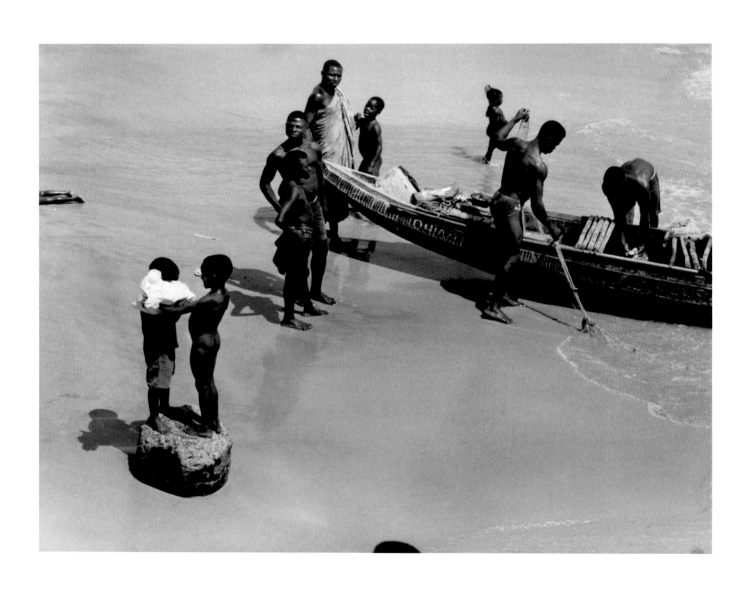

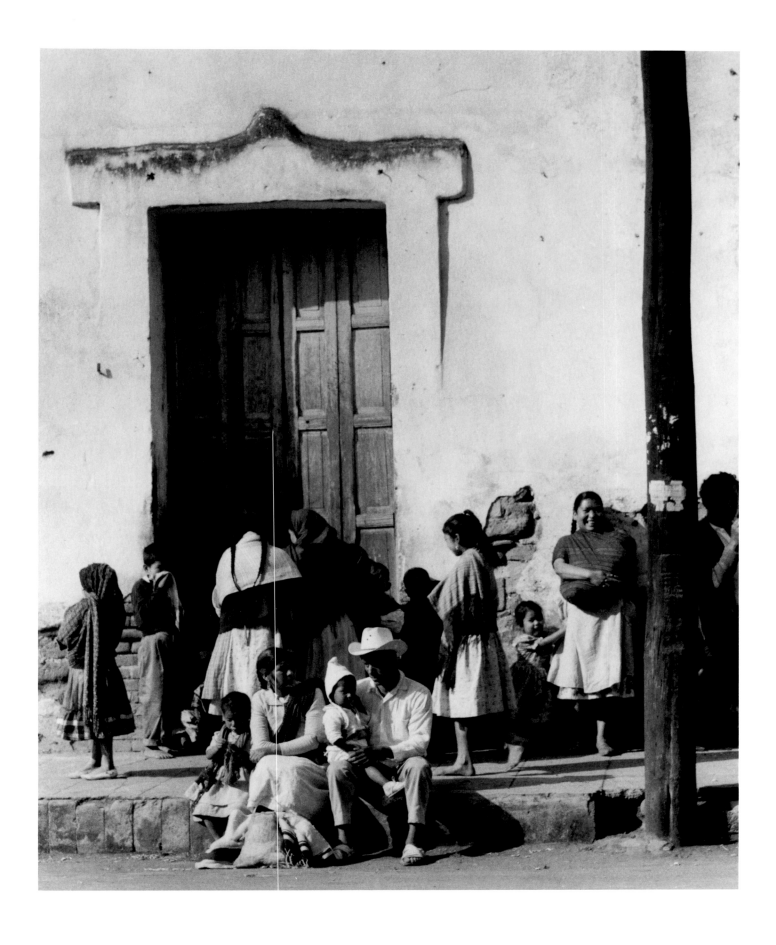

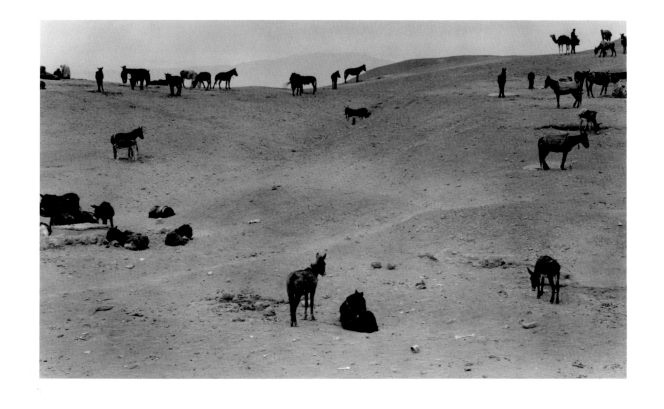

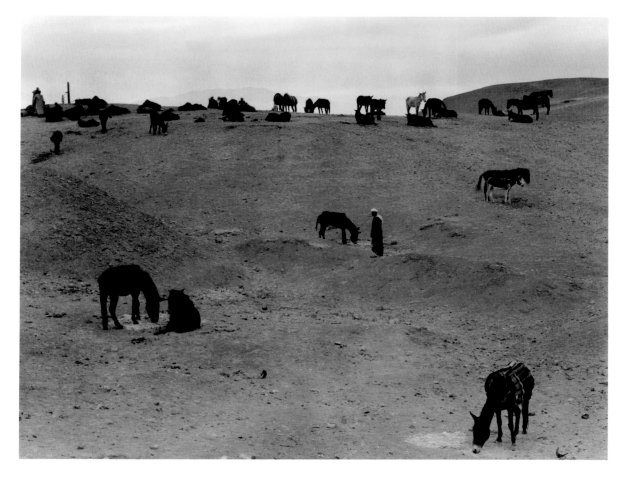

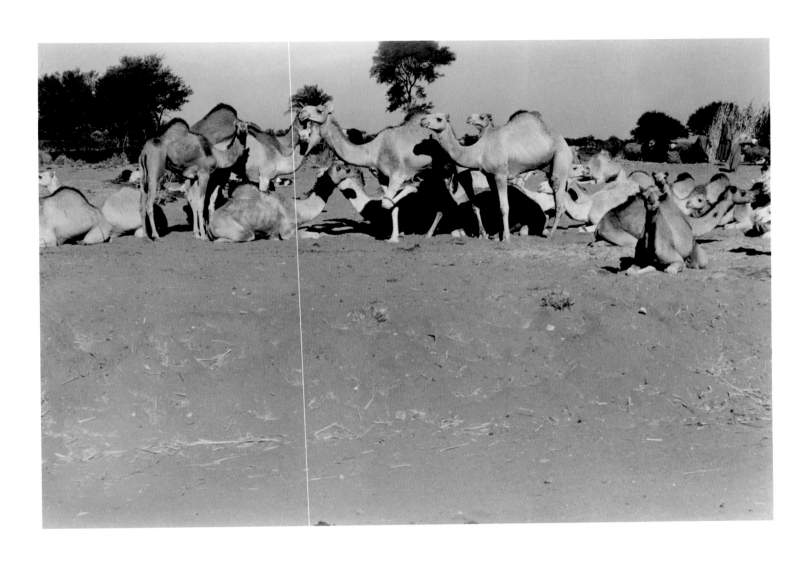

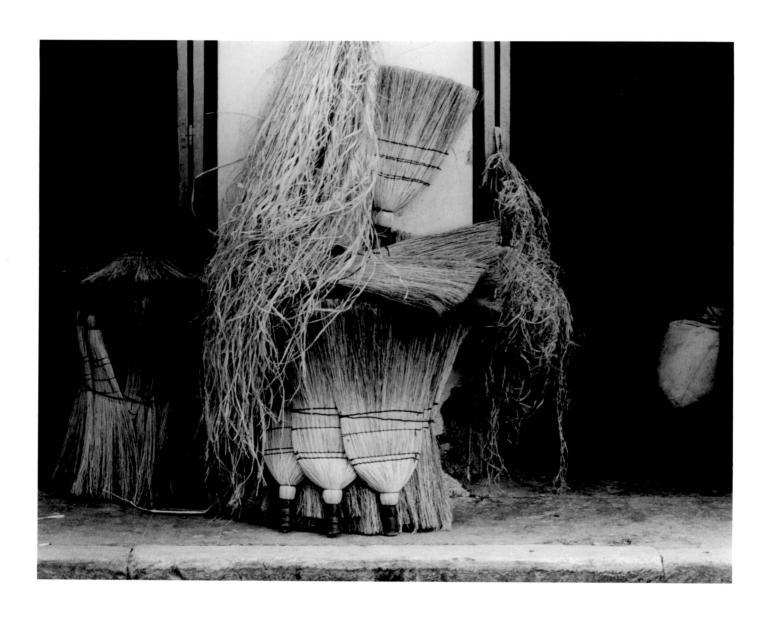

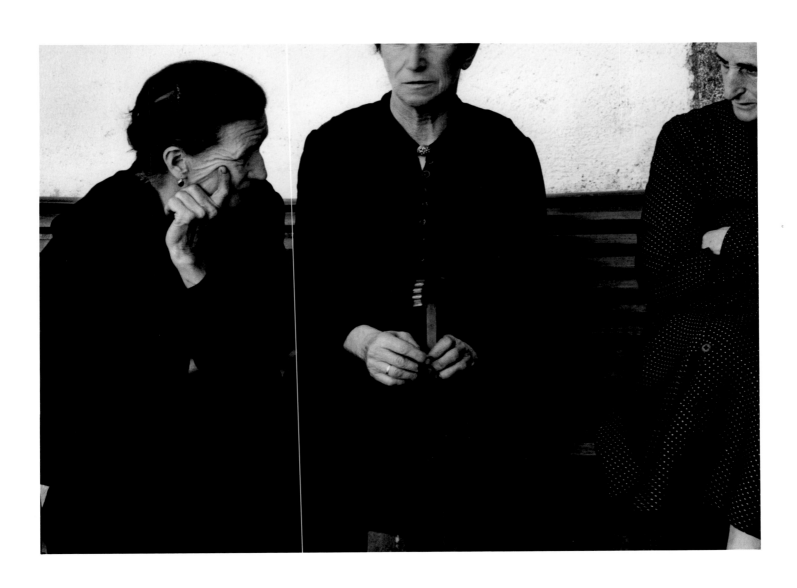

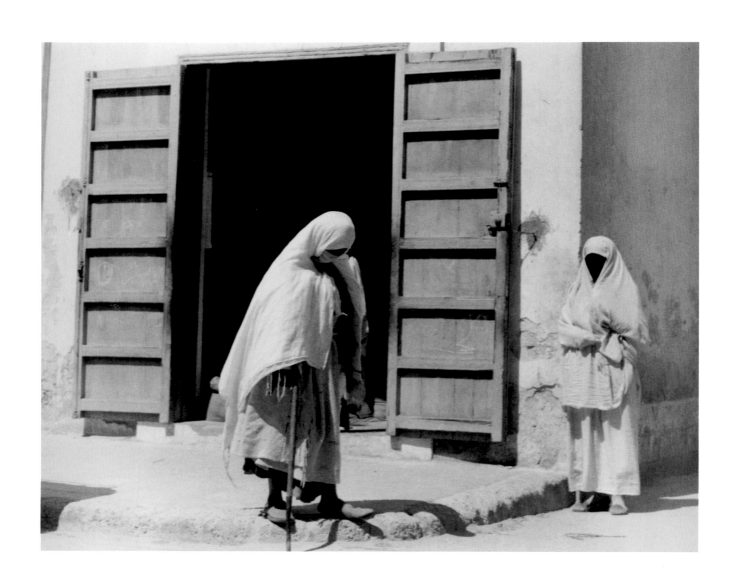

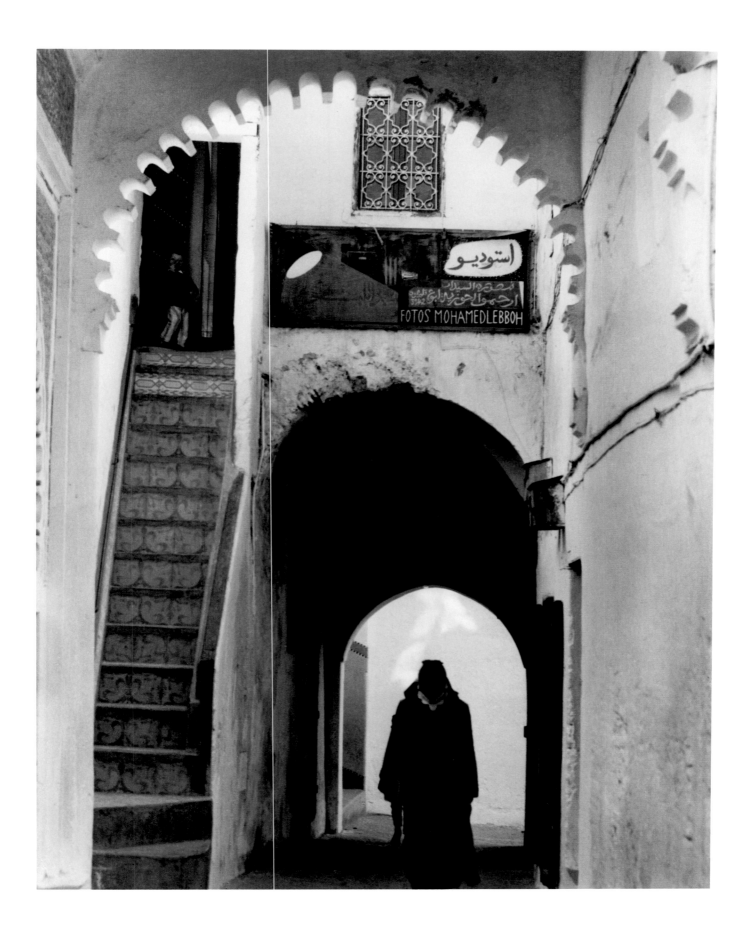

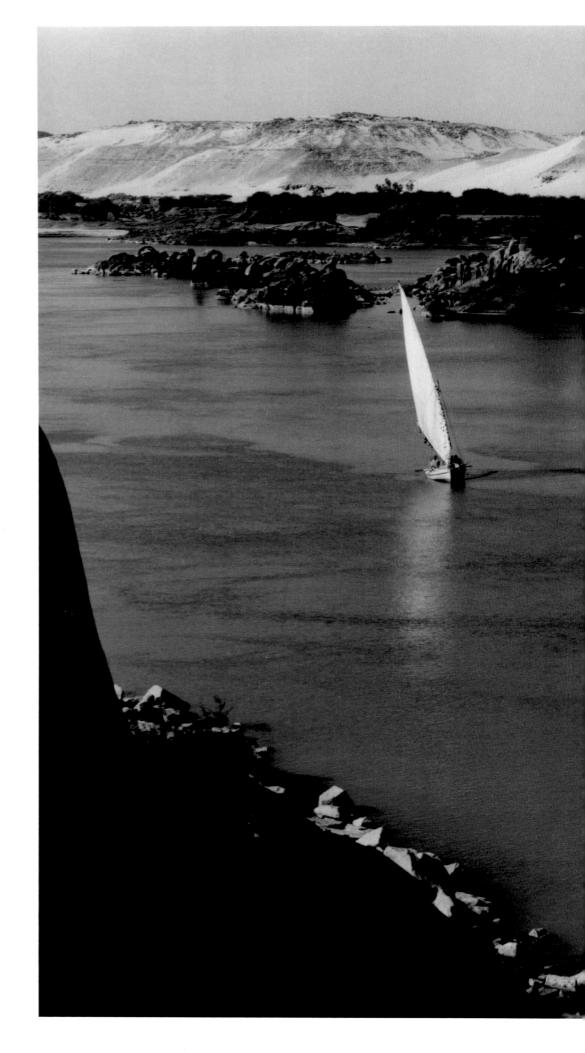

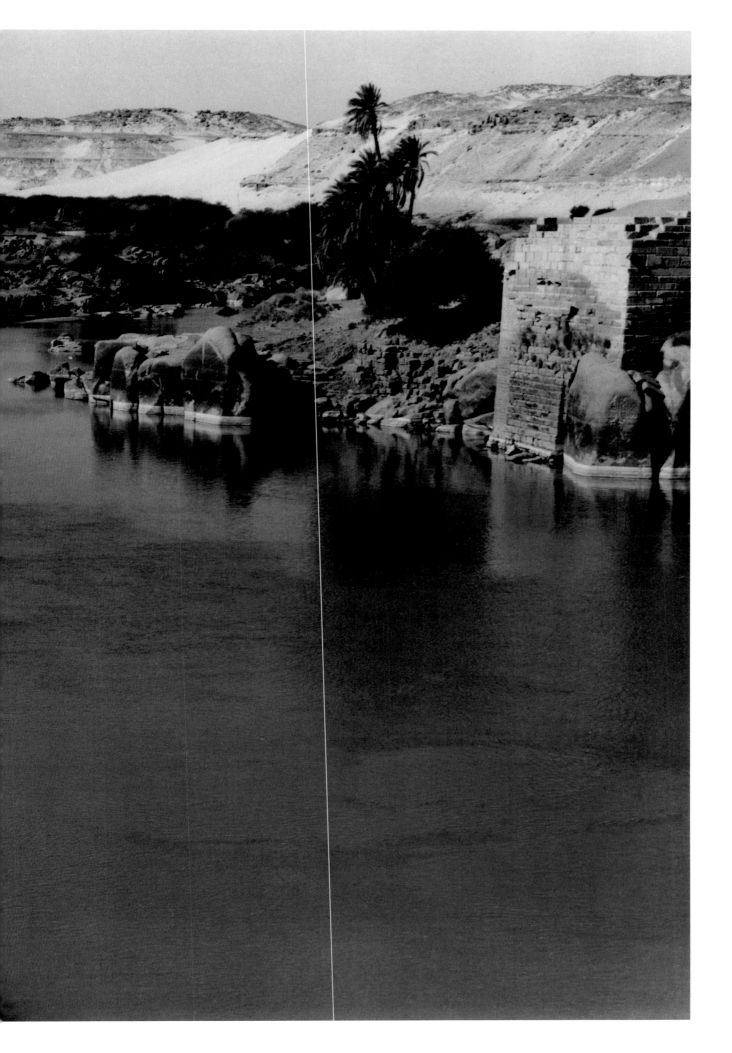

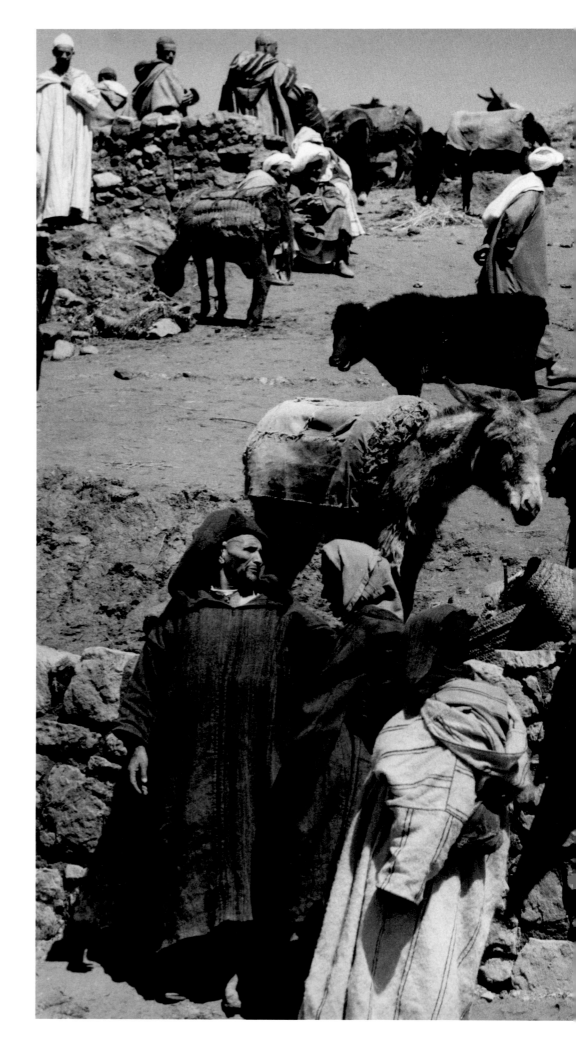

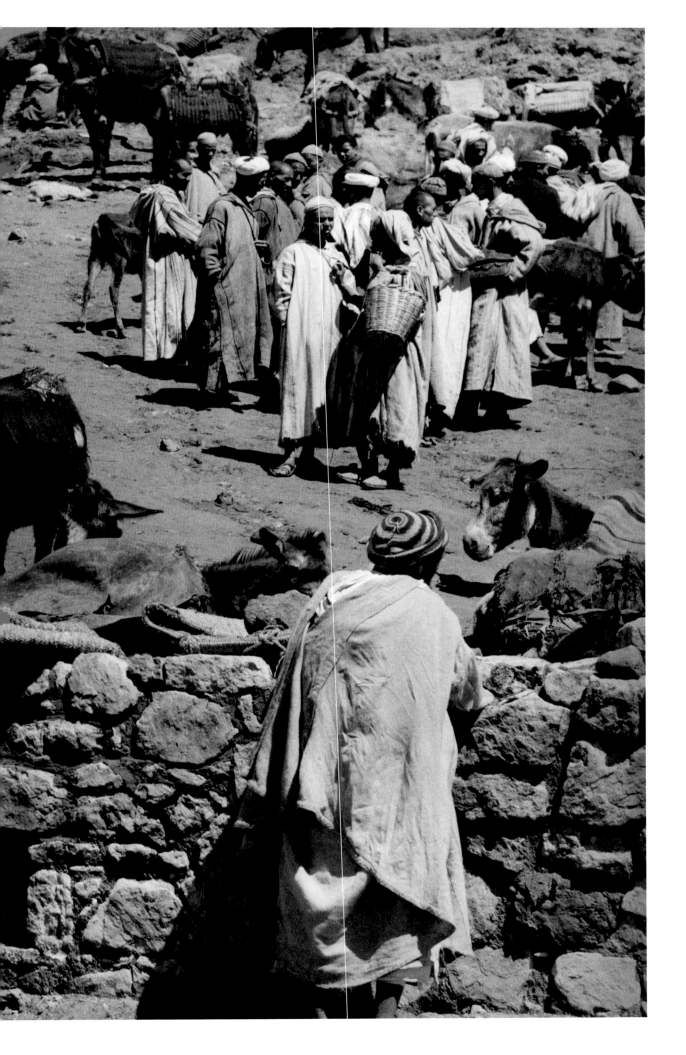

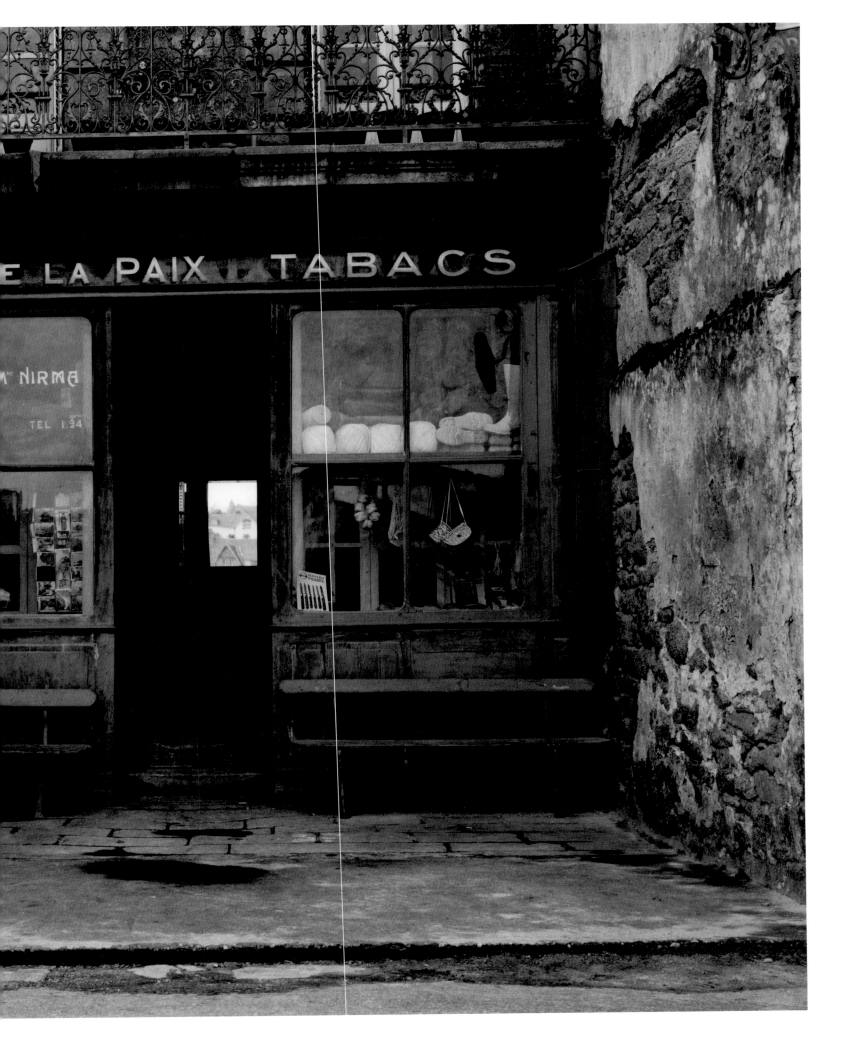

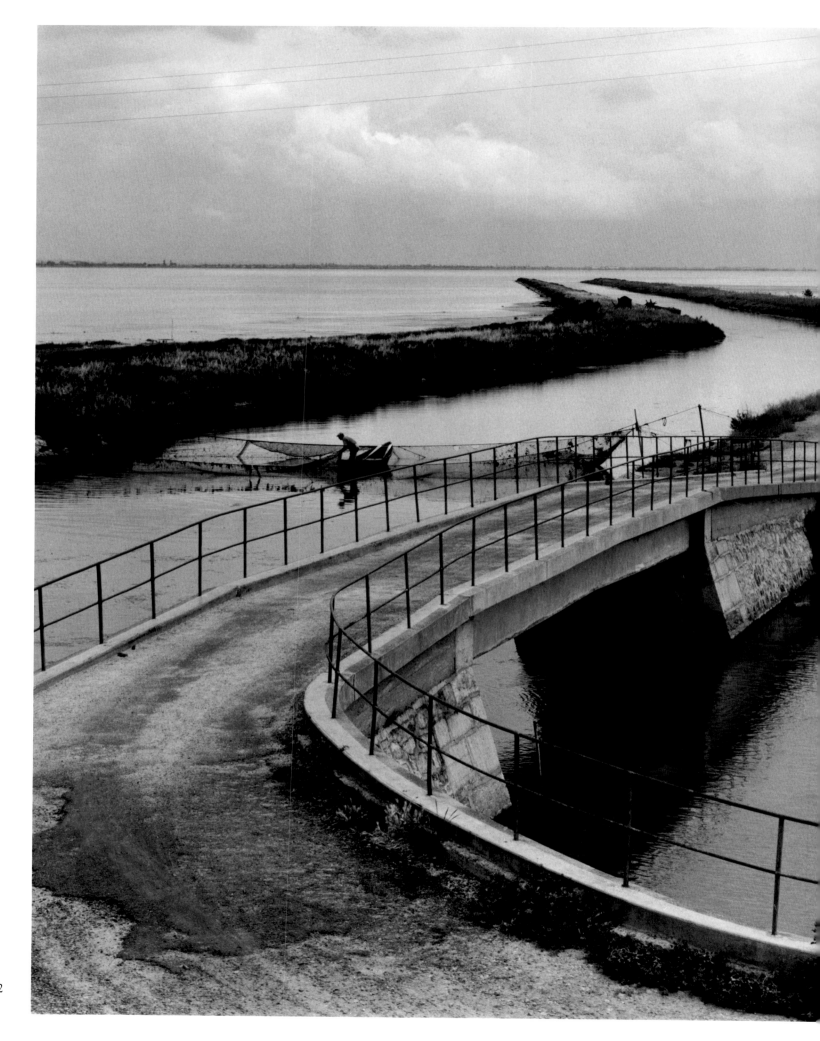

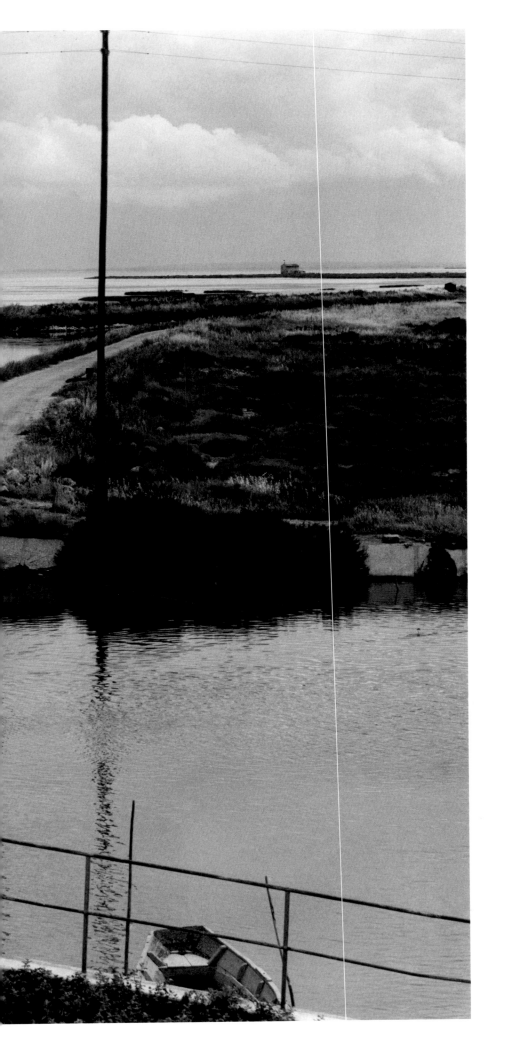

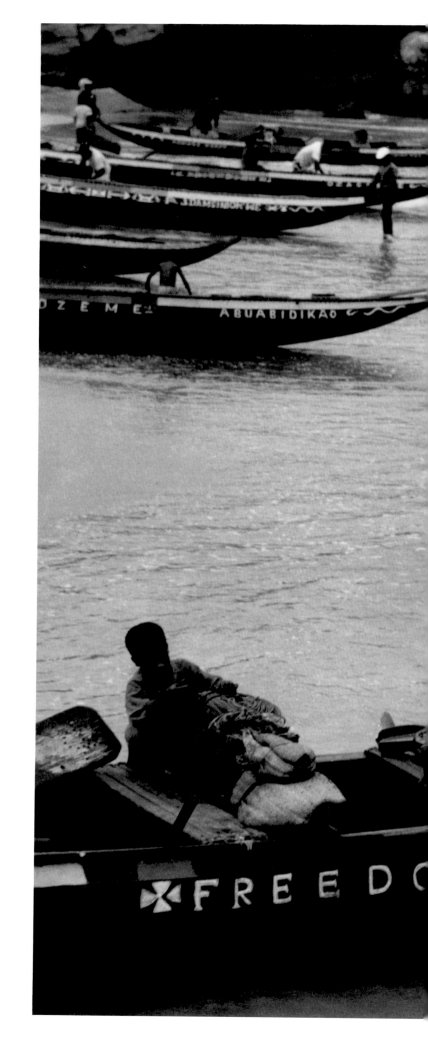

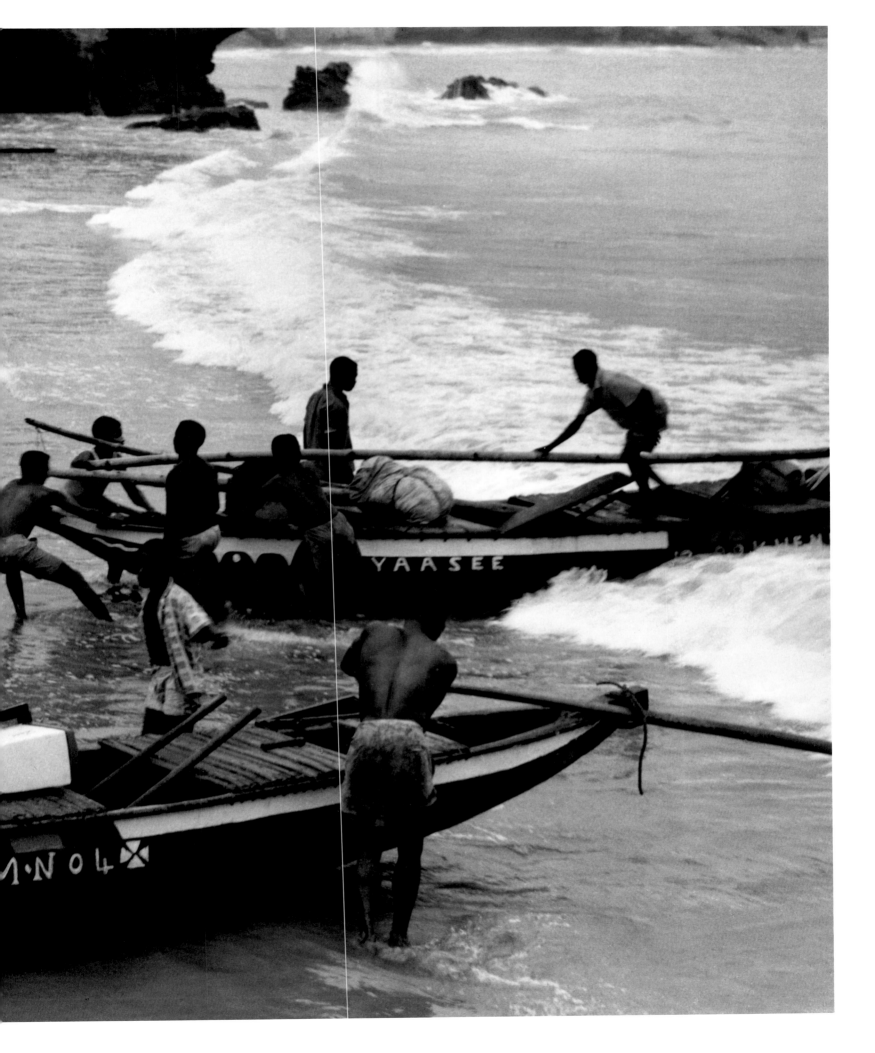

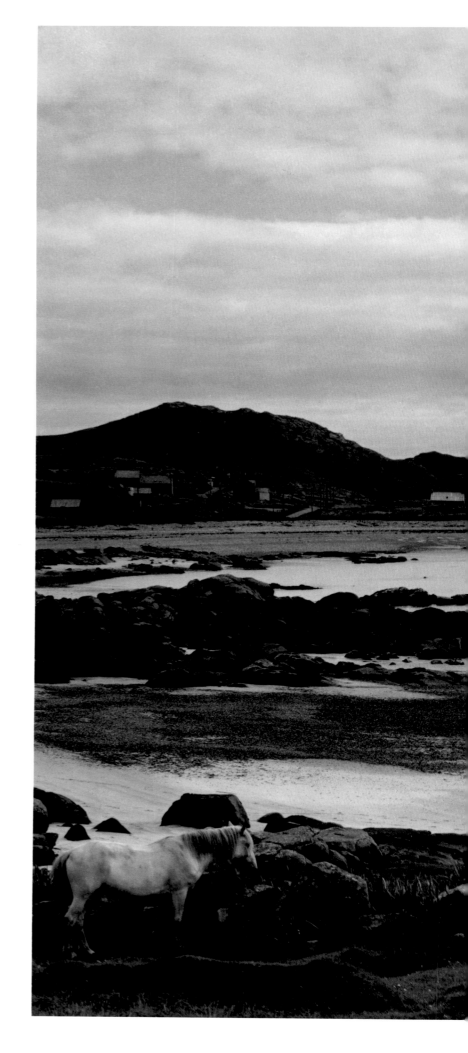

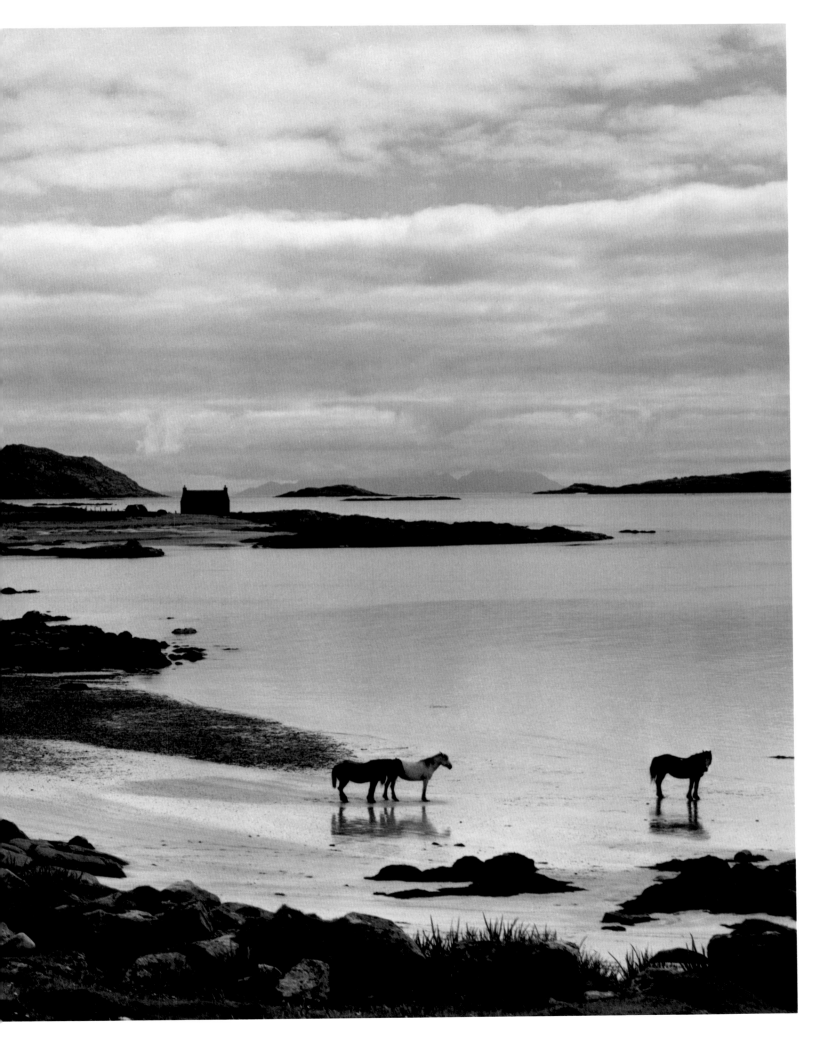

129. Ranchos de Taos Church, *New Mexico 1931* 131. Shop, Le Bacares, *Pyrénées Orientales, France 1950*
132. Street, *Southern France 1950* 133. Levens, *Alpes Maritimes, France 1950*
134. Truckman's House, *New York 1920* 135. From the Viaduct, *New York 1916* 136. Charcuterie, *Montmerle, France 1950*
137. Café Planchon, *France 1955* 138. Worker's Bicycles, *Luzzara, Italy 1953* 139. Southern France *1951*

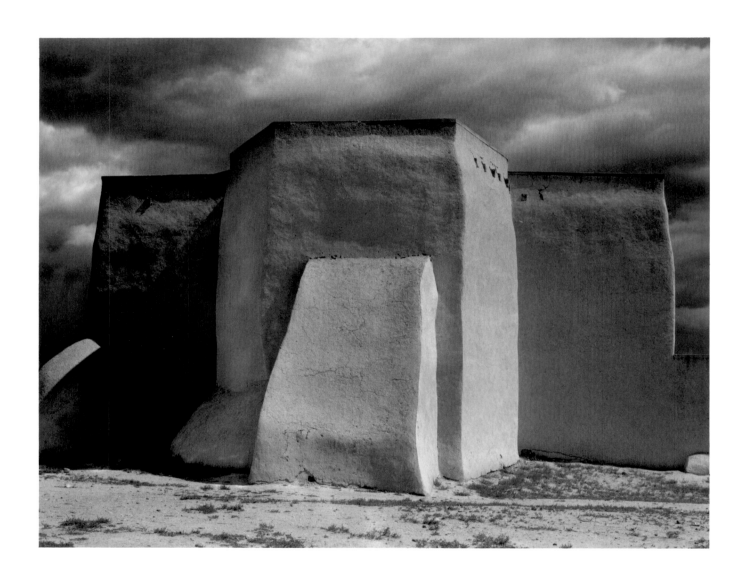

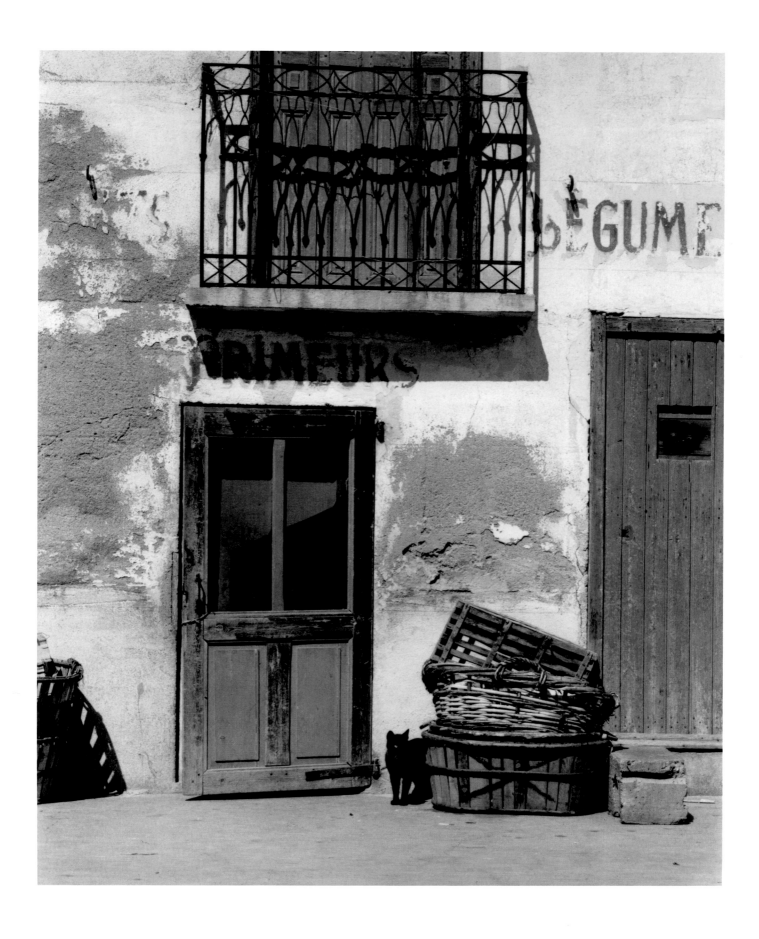

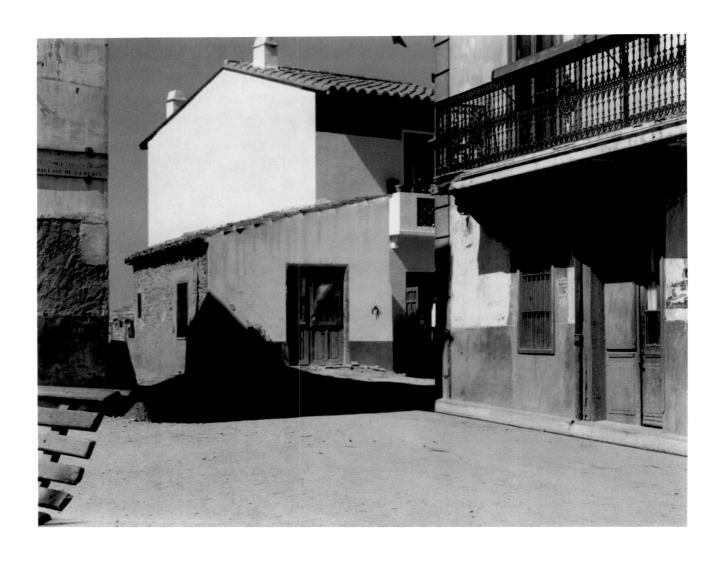

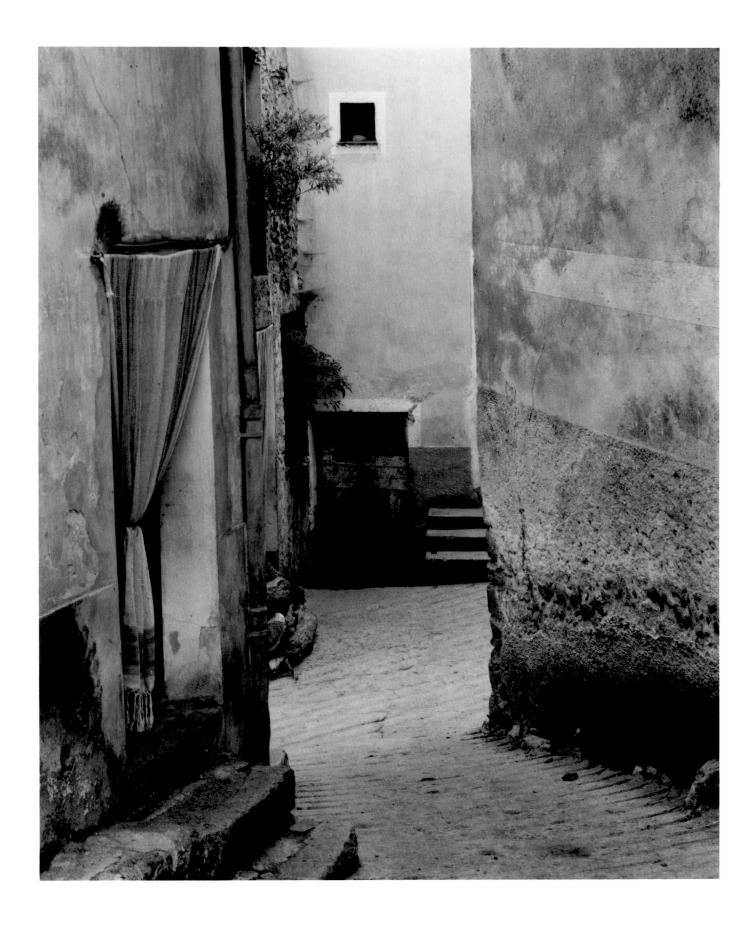

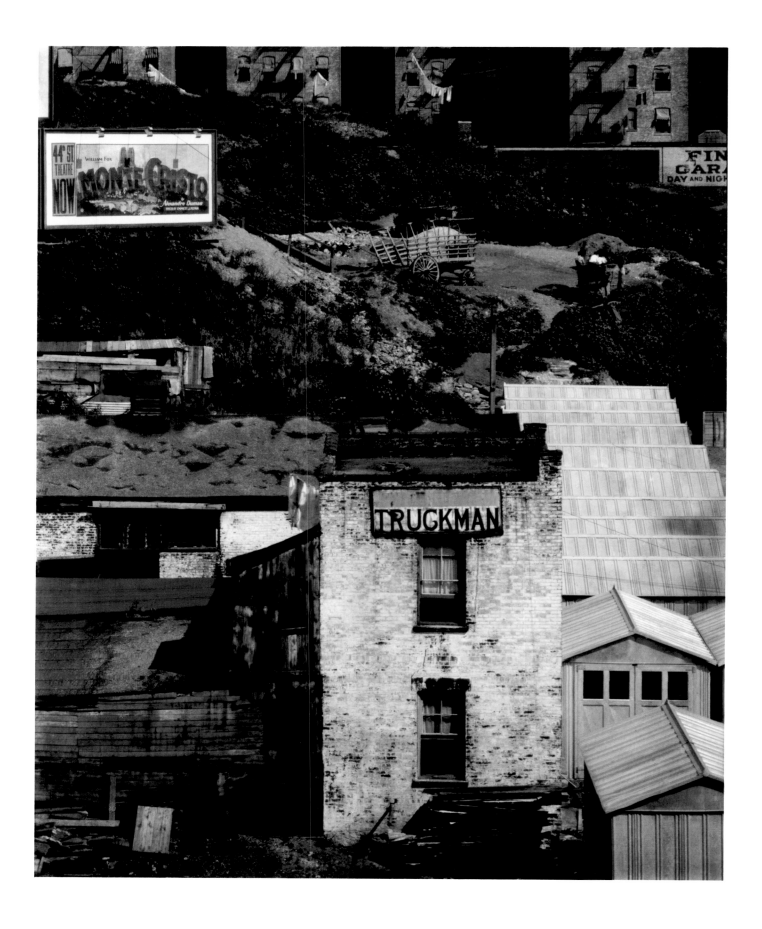

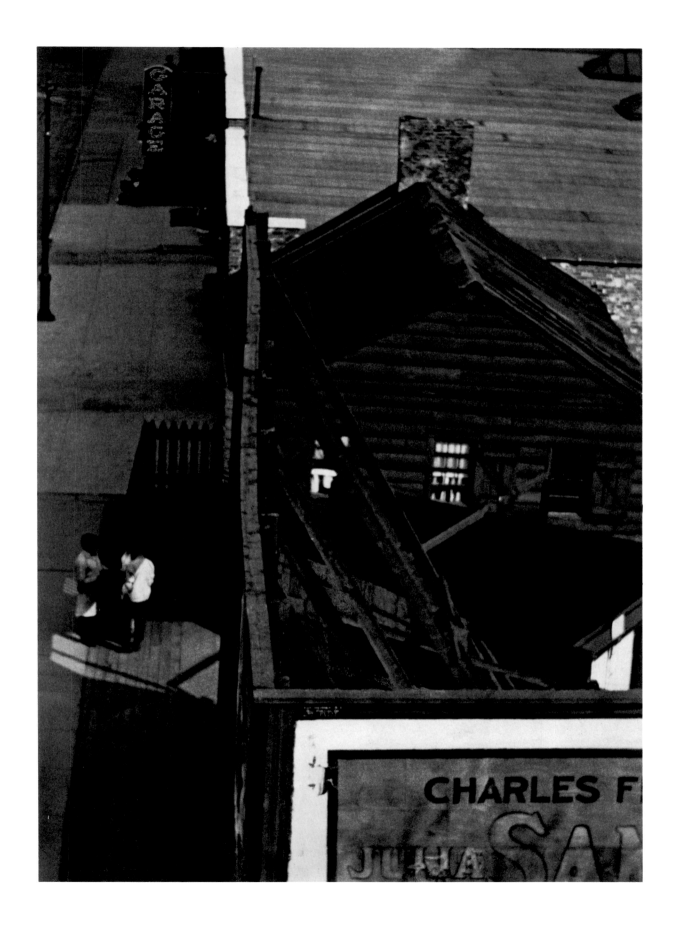

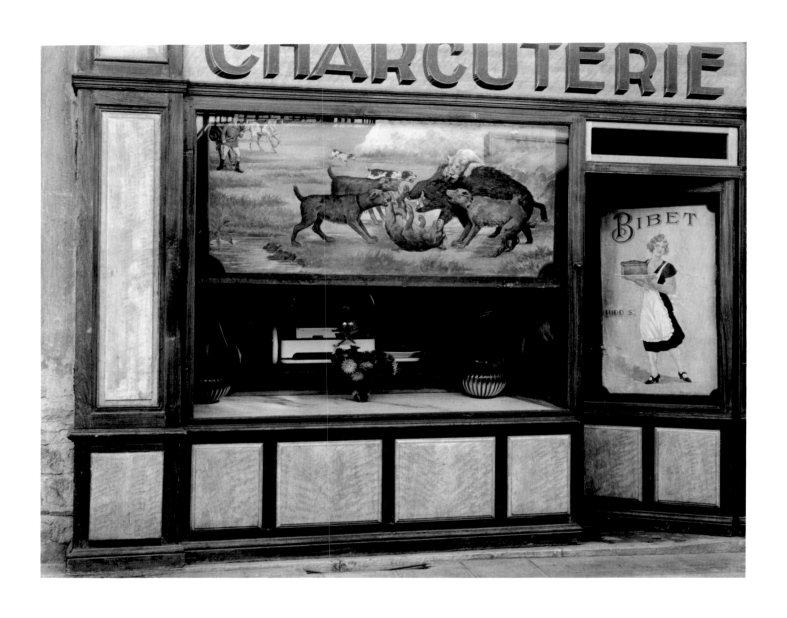

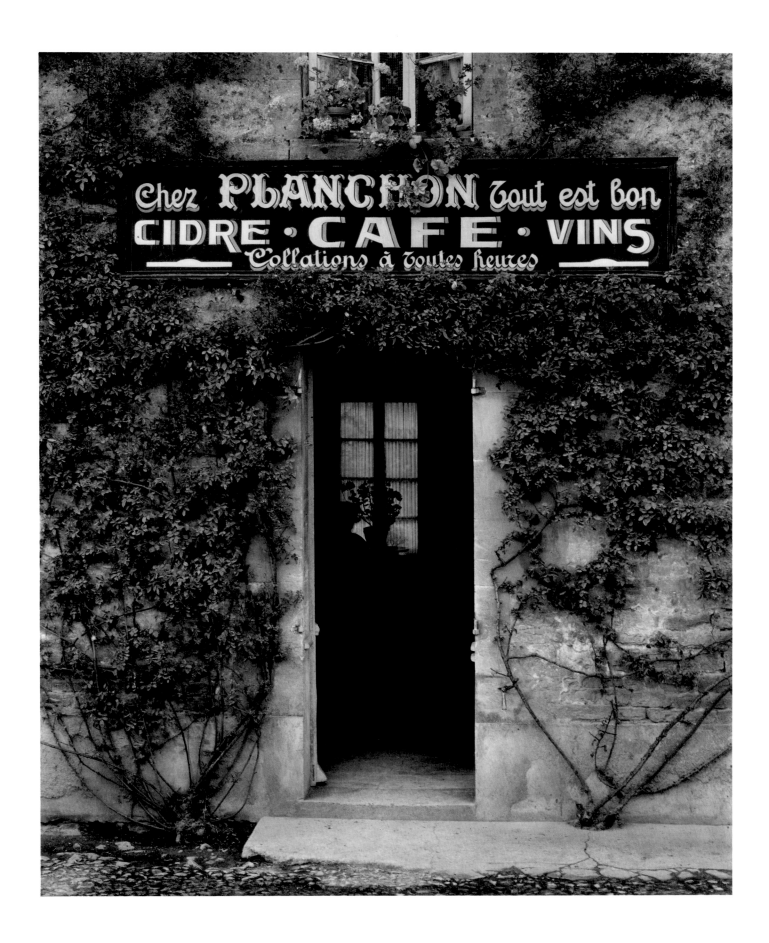

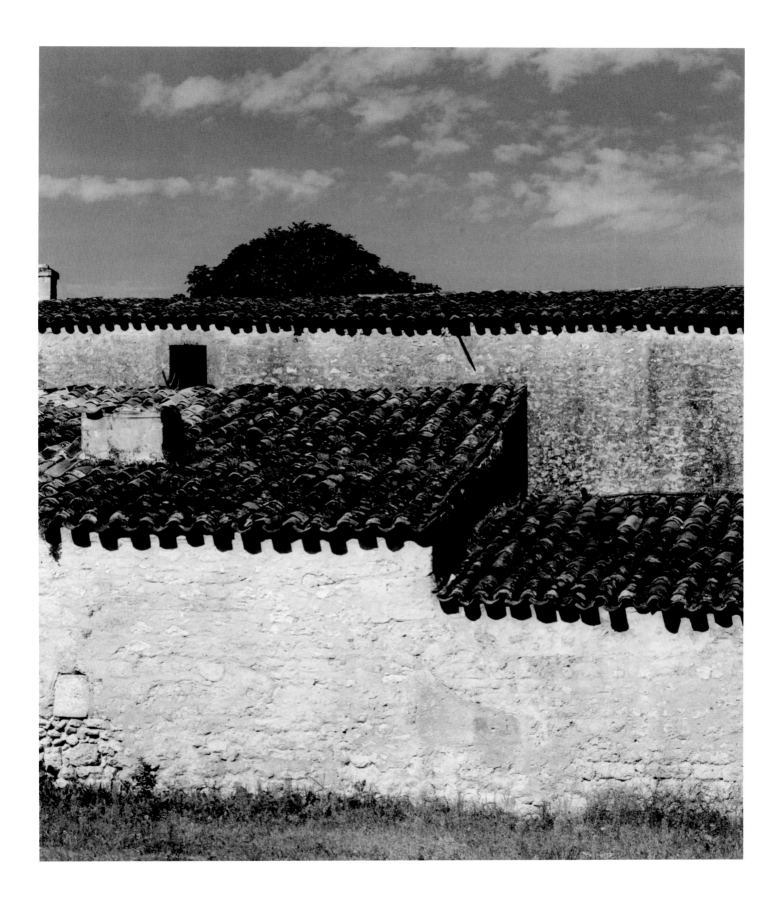

EXCERPTS FROM
CORRESPONDENCE, INTERVIEWS,
AND OTHER DOCUMENTS

I
THE EARLY YEARS

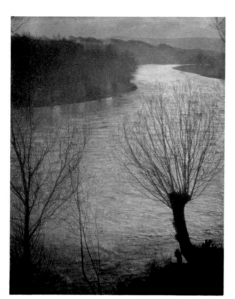

A river scene taken in Europe in 1911. Strand was not certain whether it was the River Neckar in Germany or a river in France or Scotland. A print was shown at 291 in 1916.

In 1909, after graduating from the Ethical Culture School, Paul Strand joined the Camera Club of New York, "his home on Sixty-eighth Street before World War I," where for $50 a year he had unrestricted use of the darkroom. About the Camera Club, Strand said: "I had a locker where I kept my stuff. Not terribly convenient. The atmosphere was stupid, right in the heart of amateurism. I started in the Camera Club when I was eighteen. I made gum prints, carbon prints, platinum prints, big blow-up negatives—it was very useful, and I got technical tips from their library."

Strand began to experiment with a soft-focus lens, gum prints, and enlargements. He said *Trees* (1910) had been done with a soft-focus lens, wide-open, "which is what the lens does best. It flattens and mushifies. Clarence White had used it for a long time. It is Impressionistic and Whistlerian. This lens helped the photographer pull things together. It was a good way to begin."

When Strand was twenty-one, he took four hundred dollars in savings—all his birthday and other gifts since infancy—out of the Bowery Savings Bank on a Monday, purchased a one-way passage to Naples for $60, and sailed on Saturday of the same week. He carried with him a small camera, and was away from March 26 to May 13.

In Algiers, he took what were probably the first of his many cemetery photographs in a Moorish cemetery, "took picture after picture." Naples and Rome: "I have probably taken five dozen pictures already and hope to get some good things." Lucerne: "Took a dozen pictures in Venice and had a . . . ride in gondola." Paris: "will remember reading letters [from home] as the most pleasant experience of the trip."

On his European trip, Strand used an Adams Idento with an Identoscope as a hand camera to produce 3¼ x 4¼-inch glass negatives. The contact positives were enlarged to 8 x 10 negatives and the contact prints made on platinum paper, some hand colored.

Strand's friend Nathaniel Shaw, who carried some of the photographs from Strand's trip with him to Europe in 1912, wrote Strand: "Have you been cursing me for not cabling you full news of the reception given to the famous Paul Strand prints? Luckily we didn't hope for much in London. What I got was a courteous hearing, cordial interest and gracious refusal . . . they told me that if I could sell them for a half a crown, the Americans might buy, at which biting sarcasm I cringed." Later, he wrote: "Tried to convince the few German and English dowagers that it is not pictures of the Jungfrau that they want but of the *Temple of Love*—one is about as suitable for the old hens as the other."

Soft focus is something that weakens a picture, although it gives the photographer an easy way of simplifying reality. I started with a soft-focus lens, and Stieglitz was very helpful in showing me that I was destroying the individual qualities of the life of things that I was photographing. It made grass lose its quality as grass, water lose its quality as water. So I stopped my soft-focus lens down to f/22 to get as much sharpness out of the lens as I could.

I used to wander around New York City, all over it: the Bowery, Wall Street, uptown, the viaduct that leads from Grant's Tomb. I could see everything, but to be able to do something with it, that's another matter! I was not ready until 1915. Before that I was groping, trying to feel my way. I would ask myself, what do Picasso and those other painters mean? Why do they do it that way?—Paul Strand, interviewed by Lou Stettner, 1972

The photographer's problem is to see clearly the limitations and at the same time the potential qualities of his medium, for it is precisely honesty, no less than intensity of vision, that is the prerequisite of a living expression. This means a real respect for the thing in front of him expressed in terms of chiaroscuro . . .

through a range of almost infinite tonal values which lie beyond the skill of human hand. The fullest realization of this is accomplished without tricks of process or manipulation through the use of straight photographic methods. — Paul Strand, *Seven Arts,* 1917

II
THE MAKING OF
A PHOTOGRAPHER
1912–1919

After his return from Europe, Strand began to work as a commercial photographer, but he was never really successful, and his income was never more than $600 a year. In 1913 Strand began to visit occasionally the Photo-Secession Gallery at 291 Fifth Avenue, showing Alfred Stieglitz his pictures.

In 1915 Stieglitz enthusiastically accepted Strand's portfolio of new works, promising to show them in the gallery and to publish them in *Camera Work.* He invited Strand to use 291 and become a part of the circle of painters and photographers who met there. The direct influence of Stieglitz and the artists he exhibited at that time—Braque, Picasso, Brancusi, Cézanne, among others—was an essential force in all of Strand's work that followed.

"Was it a spiritual idea? Was it a man? Or was it a place?" Strand wrote about 291. "As I look back it seems to me that 291 was none of these things, because it was all of them, a complete unity of parts which supplemented and fulfilled each other. The idea . . . freedom of expression through cooperation; the man through whom the idea functioned . . . Alfred Stieglitz; a place . . . three little rooms at 291 Fifth Avenue, by means of which the idea, working through the man could take form. . . .

"The real meaning of life is not killing but creating consciousness. Cooperation in every phase of social structure, for the freedom of the individual, is the individualism of the future. That was the spirit of 291, the only spirit, the only democracy, for

which it is worthwhile that the world should be made safe."

"The reality of the machine as it was literally changing the world had a wide and inevitable impact upon art in many countries," Strand wrote Van Deren Coke about the aesthetic that was emerging in the prewar years in Italy, France, the United States, and elsewhere. "Creative artists do influence each other in various ways. But this is much less deep than the direct influence of the world in which the artist lives and his response to it."

In April and May of 1915 Strand traveled across the United States to the West Coast, taking photographs of college campuses, which he sold through fraternity houses for $2.50 a print.

April 8, 1915, New Orleans: "Been walking in the French Quarter, my camera is busy; New Orleans offers a great deal pictorially and very little has been done. . . . Shall spend part of tomorrow with my camera. Leave Saturday or Sunday for Austin, then Grand Canyon on 17th." April 11, Waco, Texas: "Austin . . . unattractive . . . college not impressive . . . made no pictures . . . Shall finish up with Baylor University tomorrow—shall catch the California special (Santa Fe) to Albuquerque." April 24, 1915, San Diego: "Spent all day at Exposition, more or less boring architecture: Imitation always results in weakness." San Francisco, May 3, 1915: "Fair is wonderful—more interesting in every way than San Diego."

In 1914 Strand began to use the insights he had found in sculpture and painting in his photographs: "Sheeler and I were aware that we were beginning to experiment with abstraction. We all talked the same language—Sheeler, Schamburg, Stieglitz. It had to do with understanding a painting like a Villon or a Braque—in which there is an enormous amount of movement and no recognizable content as a whole. You have to go into a picture; it has to have three-dimensional movement—lovely to

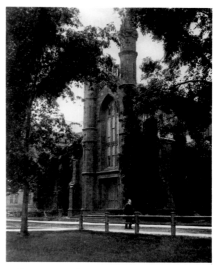

This view of the Yale campus was taken on Strand's tour of American colleges and universities. The photographs were printed on platinum paper and hand colored.

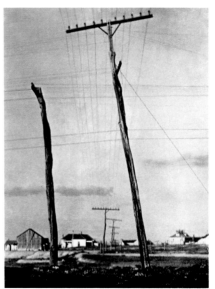

"Texas is interesting," Strand wrote home. "The country is flat. But the way the monotonous plain is broken by shacks and little houses is fascinating. Things become interesting as soon as the human element enters in."

the eye, full of variety of color and shape.

"We each had our own way," Strand said. "We didn't sit down and have discussions. We knew there were new elements in painting and photography."

"I would say three important roads opened up for me," he told an interviewer in 1971. "They helped me find my way in the morass of very interesting happenings which came to a head in the big Armory Show of 1913. My work grew out of a response to, first, trying to understand the new developments in painting; second, a desire to express certain feelings I had about New York where I lived; third, another equally important desire—where it came from, I don't know exactly—I wanted to see if I could photograph people without their being aware of the camera. Although *Blind Woman* (page 37) has enormous social meaning and impact, it grew out of a very clear desire to solve a problem. How do you photograph people in the streets without their being aware of it? Do you know anybody who did it before? I don't.

"The work that I did beginning in 1914, 1915, 1916, which was the nucleus of what I took to show Stieglitz and which was subsequently shown at 291 and published in *Camera Work,* falls into three directions or developments that have continued ever since and are sort of milestones along my particular way. One was the abstract, purely abstract photographs, the experiments which were intended to clarify for me what I now like to refer to as the abstract method, which was first revealed in the paintings of Picasso, Matisse, Braque, Léger, and others. Those paintings were brought to this country through the efforts of Steichen, and Stieglitz showed them as being antithetical to photography, things that were—as he used to use the word—'anti-photographic'; Stieglitz was very interested in this work because nobody here really quite understood why and what these men were doing.

"They made an enormous impression on every American painter who was in any

Though the Armory Show made modern art a subject of popular curiosity, it maintained the traditional boundaries between the arts. Although influenced by the Armory Show, Strand felt that Stieglitz and the artists shown at 291 had a greater effect on his work.

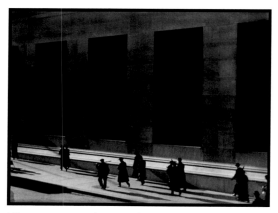

"I was trying to photograph the 'rushing to work,'" Strand wrote about this 1915 photograph of the Morgan Guaranty Trust building at 23 Wall Street. "The great black shapes of the windows have the quality of a great maw into which the people rush."

way open to anything new in painting. And of course they aroused a great deal of bitterness, real bitterness, and hatred among those of the successful American academic painters who felt themselves threatened by anything new and anything very different. My first approach might be illustrated by my work of the summer of 1915. I was in Connecticut, and the simplest of subject matter, or maybe object matter would be a better term in this case—such as kitchen bowls, cups, plates, pieces of fruit, a table, a chair, the railing of the porch, the shadows of the railing of the porch—things as simple as that were my material for making experiments to find out what an abstract photograph might be, and to understand what an abstract painting really was.

"A second line of approach that developed in those days was to begin experimentation to see whether one could photograph the movement in New York—movement in the streets, the movement of traffic, the movement of people walking in the parks. This approach led to such photographs as *Wall Street* and the photograph that I took from the jury room in City Hall Park.

"I realize now that if I hadn't made those photographs, I doubt whether I would have been able to make other photographs like *The Market, Luzzara* (page 103) or some things that I did in Morocco in 1962, in Ghana in 1963–64, and in Rumania in 1968; the same problem was before me, to photograph people in movement.

"The third and equally important approach, was to photograph people without their being aware that they were being photographed. That was the problem: to make candid photographs long before there were any candid cameras. For the solution, I worked with the Ensign camera, and put a false lens on the side of the camera, screwed it onto the side of the camera's very shiny brass barrel, and then shot with the brass barrel directed at right angles to the person I was going to photograph; but the other lens, the real lens, came out

under my arm because it was a long extension. Anyone who knew anything about photography would have known that this was a fraud. Actually it was a very clumsy solution of the problem. All the portraits that I made at that time, however, were made that way. It was quite nerve-racking because there was always the possibility that you would be challenged either by the person being photographed or by some bystander who might realize that you were up to something not quite straight.

"There were two toughs watching me when I made one of the first photographs: 'Aw, he was photographing out of the side of the camera,' one of them said. So, like the Arabs, I folded my tent and went over to the park in Five Points Square and made the photograph of the old man with the strange eyes (page 38). I continued that experimentation with portraits for only about a year because I felt that I had to wait until I had worked out the technical problems.

"These beginnings were like something that grows out of a seed. You come back to them. All through your life they remain important, enabling you to solve the problems posed by whatever you've undertaken to do.

"After the so-called purely abstract photographs that I made in 1915 (not purely abstract but abstract in intention), I never did such things again. I felt no desire and no need to photograph shapes per se.

"I learned from these photographs what the painters were doing . . . and that no matter what is included, that unity must be there and must be continuous. I went next very naturally towards trying to apply the method that I had worked out in pictures, like the shadows of the porch railing and the bowls (page 41), to what I tackled thereafter in landscape—landscape being also the parts of New York that I had photographed from the viaduct.

"The New York photographs were followed by the *White Fence* (page 40), the

Strand used the lessons he had learned from Braque and Picasso in his experiments with abstraction. Porch Railings, 1915 *and* Twin Lakes, Connecticut, *have much in common with the collages he was seeing at 291.*

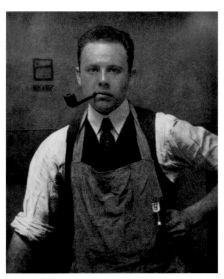

Alfred Stieglitz photographed Strand, then twenty-seven years old, wearing an apron while helping to dismantle the gallery at 291.

next step in abstraction. It was the basis for all the work I've done."

Fifth Avenue and 42nd Street (page 39) was photographed from the windows of the Marius de Zayas Modern Gallery. "The experimentation was an attempt to capture the movement of New York in those days on Fifth Avenue and 42nd Street and around City Hall Park. Physical movement expressed by the abstract spotting of people and shapes—together with the overall emotional expression."

In 1916 Strand was published for the first time in *Camera Work,* number 48, and he had his first one-man exhibition at 291. On August 31 Stieglitz wrote Strand: "*Camera Work* proofs are still going to and from New York to Lake George . . . looks as if the number will finally go to press within a week. It promises to be an unusually live number . . . every word of it has been carefully weighed over and over again. It is serious and still full of humor . . . I think you'll enjoy its spirit."

About Strand's work, Stieglitz wrote in *Camera Work*: "For ten years Strand quietly had been studying, constantly experimenting, keeping in close touch with all that is related to life in its fullest aspect; intimately related to the spirit of 291. His work is rooted in the best traditions of photography. His vision is potential. His work is pure. It is direct. It does not rely upon tricks of process. In whatever he does there is applied intelligence."

Reviewing Strand's exhibition, Royal Cortissoz wrote in the New York *Tribune*: "At the Photo-Secession Gallery . . . are some noteworthy photographs . . . by Paul Strand who has a good sense of composition and the faculty for seeing possibilities of beauty in the most commonplace objects and places."

In 1917 when Strand's work appeared in the last two issues of *Camera Work*, he wrote to Stieglitz on July 3: "Something—somehow—seems missing—the salt is out of things—as yet. Perhaps in a few days there will be a movement towards doing. That is what I hope—what I need."

In the same year Strand wrote in *Seven Arts* magazine, stating his view of photography: "Photography, which is the first and only important contribution, thus far, of science to the arts, finds its *raison d'être*, like all media, in a complete uniqueness of means. This is an absolute unqualified objectivity. . . this objectivity is the very essence of photography, its contribution and at the same time, its limitation. . . .

"It is in the organization of this objectivity that the photographer's point of view towards life enters in, and where a formal conception born of emotions, the intellect, or of both, is as inevitably necessary for him, before an exposure is made, as for the painter before he puts brush to canvas.

"The existence of a medium, after all, is its own justification . . . and all comparison of potentialities is useless and irrelevant . . . To have to despise something else is a sign of impotence."

Strand was inducted into the Army Medical Corps in 1918 and received special X-ray training at the Mayo Clinic in Rochester, Minnesota; he then worked as an X-ray technician at Fort Snelling. "A man can do quite a bit to make his own experience," Strand later said about his time in the Army. "He has to be observant and has to react to what happens. Even in the most menial tasks, I try to make a choice. I got the best job by picking up a broom at the Officers' Mess. I told the story of *Camera Work* to a young man in the Army. We sat in front of our tent. I got *Camera Work* out, showed him two numbers, others gathered—no wisecracks."

About the war, Strand wrote to Stieglitz: "A conscience will be just as much—no more, I am afraid—of a handicap after war as it was before. As far as I have seen here, there is no particular change of attitude, none whatever—over there I don't know. Outside of a material speeding up—I am afraid the war will do nothing for this country. It has been too easy . . . The great compensation as far as I am concerned is activity and a certain amount of knowledge."

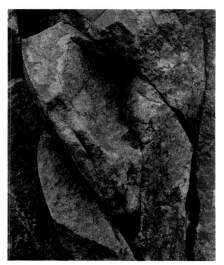

After his release from the Army, Strand took a trip to Port Lorne, Nova Scotia, where he made the first of the rock photographs he later said had been influenced by Picasso, Braque, and Brancusi.

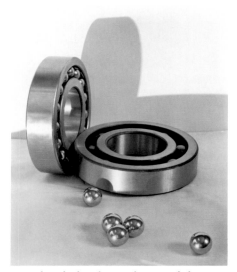

Strand said, that during this period, he never earned enough from his commercial work to support himself. He was paid $300, however, for his first advertising photograph for Hess-Bright ball bearings in 1920.

In 1919 Strand's life changed perceptibly. His mother died of influenza in February while visiting him at the hospital in Fort Snelling. Subsequently, for the first time, his father went into business for himself. In August Strand was released from the Army. "The first thing after the war," Strand said, "was a very brief visit to Nova Scotia with Herbert Seligmann, an old school friend of mine. I think we were there about three weeks. I made a few things at Port Lorne. It was an extraordinary place. It was a great experience: photographically not so great, but in other ways great."

"I couldn't have done the rocks without having seen Braque, Picasso, Brancusi. I used a sharper lens. I never went back to soft-focus. It was one of those inexpensive eight-by-ten cameras bought for forty dollars when I returned—maybe secondhand. I used the lens many years . . . used single elements."

Above all, look at the things around you, the immediate world around you. If you are alive, it will mean something to you, and if you care enough about photography, and if you know how to use it, you will want to photograph that meaningfulness. If you let other people's vision get between the world and your own, you will achieve that extremely common and worthless thing, a pictorial photograph. But if you keep your vision clear, you may make something which is at least a photograph, which has a life of its own, as a tree or a matchbox has a life of its own. There are no shortcuts, no formulae, no rules except those of your own living. There is necessary, however, the sharpest kind of self-criticism, courage, and hard work. But first learn to photograph. That alone I find for myself is a problem without end. — Paul Strand, *British Journal of Photography,* October 5, 1923

To Marin that something which we call America lies not so much in political institutions as in its rocks and skies and seas. He has

begun to find it, in his etchings, as well as his latest watercolors, in nervous, towering New York. To him they are essentially placed and he would seize upon that placeness and hold it. He has said, an American tree is entirely different from a French tree. It is that difference which he would record and which makes the little boats, the wind and shower-swept skies, the cold sunbursts and tree forms, Maine and nowhere else. —Paul Strand, *Art Review*, January, 1922

Marin is keenly aware, as [Winslow] Homer was not, that every element included in a picture must be felt, each part related so irrevocably to the other that nothing can be changed without disturbing the unity of the whole. He is seen struggling, not always successfully but always with a closer approximation to the point where every part of his picture is equally meaningful, without dead spots. Here, indeed, is the problem of Cézanne, the essential problem of those whom we choose to call the great artists of all times, whose expressiveness and livingness is in direct proportion to their having achieved complete organisms, born always of the very particular world of which they were the product and to which they were able, disinterestedly, to adjust themselves. — Paul Strand, *The Arts*, 1921

III
EXPERIMENTATION AND RE-EVALUATION
1920–1931

Prompted by his experiences at the Mayo Clinic, in 1920 Strand began work as a cameraman for a company making medical films. Later, in 1922, when the medical film company went out of business, Strand bought an Akeley motion picture camera and began to work as a free-lance Akeley specialist. He shot newsreel footage for Pathé and Fox, and did special production shots for Famous Players, MGM and other companies, and filmed sporting events.

"When I got back to New York in 1920, I ran into a group of people who were interested in making medical films; they asked me if I wanted to join them to do the

photography. We made several good films with rented apparatus. Then they decided we should buy our own equipment.

"The Akeley people said, 'Our camera is a perfectly fine instrument for the work you want to do. And we'll be glad to prove it to you by recommending one of the people who operate the camera in New York. Let him set up an operation for you and show you what we can do with the camera.' So we arranged a tonsillectomy. The chap with the Akeley shot the film, working with a spotlight into the mouth of the patient. It was excellent. That decided us.

"We bought an apparatus that cost about twenty-five hundred dollars. And we were all set to go and expand this idea when the project simply folded. I never knew why. I was in the clear again without a job. I went to the Akeley shop to say to them, 'I'm terribly sorry about this thing. I ordered this camera for this company. They've disappeared from sight. If you want to sue them, it's quite all right with me. It was a bona fide order and they had no business to behave like that, so irresponsibly.' The Akeley people said, 'Oh, we don't think we'll do anything like that. But why don't you buy the camera?' I said, 'Well, what would I do with it?'

"I had never thought of buying a motion picture camera. They said, 'Well, for one thing, you could make a good living with it.' I replied, 'Well, that's very interesting because I'm high and dry at the moment.' They explained that there were three or four men in New York who had Akeley cameras and who were doing very well. They said, 'You can get your share of the work; there's enough around; we will put you in touch with the news companies.' It so happened that I had inherited just that sum of money at that time and I took it all and put it into the camera. I had fallen in love with the camera. Visually, it was a magnificent instrument.

"And so I started out. The Akeley people told me to call up Fox Films and tell them I had just bought an Akeley camera. Fox responded: 'We'll give you some film, and you go up to Grant's Tomb and follow automobiles as they go around the Tomb so

Strand worked on both newsreel and feature crews, for in the twenties New York was still a major film center. He brought an unusual respect for the role of the director and the screenwriter to his later filmmaking.

we can see whether or not you can really follow a moving object. If you can, we'll give you work.' I got the film and did it.

"And then I got work from the other companies—Pathé and Metro-Goldwyn-Mayer, and Paramount. The field opened up. It was a manifold job. You never knew exactly what you were going to be called for at all. Sometimes dangerous things happened. But it also was very interesting.

"Akeley was a camera especially made to be able to follow a moving object. It was invented by the explorer Carl Akeley, who was associated with the Museum of Natural History. He used to go to Africa, and he was particularly interested in gorillas. He wanted to make movies of them, and there was no camera with which you could follow a gorilla jumping around. So he invented this camera. A company was formed to manufacture it because there was enough of a field for action films, not only photographing gorillas but also football games, the Dempsey-Firpo fight, and so forth. We were called upon to photograph all sorts of things, any kind of material in which movement was involved and which it was necessary to follow with a camera.

"I photographed the Kentucky Derby three or four times; many, many football games; prizefights; polo; baseball. Since I've always been interested in sports, I liked it. It was hard work, however. My equipment weighed about ninety pounds, that is, the tripod, film case, and the camera. I'd climb to the top of the Harvard Stadium or the Yale Bowl with that equipment. It was all hand cranking. And there were no light meters at all. You guessed the light, that's all. No assistant.

"I had to attend pretty strictly to developing my position among the operators here in New York. There wasn't an unlimited amount of work available, and you had to be ready to accept anything that came along. One of the Akeley operators in New York turned over to me an interesting and lucrative job, which was to photograph for the Princeton senior class at least three or

four football games every year, spring practice, and the graduation exercises. The class then kept the movies as a record to show in subsequent years at dinners and so on. That kept me quite busy.

"I had to have prints made; I had to cut the prints; I had to have titles inserted and do all the things necessary to present the class with a complete product. I also tried to develop the idea of photographing racehorses for their owners with the Akeley on the assumption that anyone who owned a very champion horse would want a record of the race as it was run. I went to Saratoga for one summer and did that on speculation. I showed the films at the movie theater in Saratoga and finally got these people interested in buying the films.

"Finally there was a union formed of all the cameramen in the East, and we were among the first members of that union. By 1935 we had built our price up to fifty dollars a day. My work with the Akeley lasted about eight years. And then on the Coast they invented a tripod, a friction-head tripod, to use in following moving objects. It outmoded the Akeley."

In 1921 Strand and the painter Charles Sheeler made a short film about New York called *Mannahatta,* shown at the Capitol Theatre as *New York the Magnificent*: "One day I met Sheeler and he said, 'You know, I've just bought a motion picture camera. It's a beauty. It's a DeBris camera, a French camera. It cost sixteen hundred dollars.' I said, 'Well, that's certainly very exciting, Sheeler. I'd like to see it.' We went to his place and saw this very handsome instrument. I don't remember the details but the upshot was that the idea of making a film about New York developed. Who developed it, whether it was he or I or both of us together, I don't recall.

"The result was a short film called *Mannahatta,* Walt Whitman's title. And we used Walt Whitman quotations for the titles. It was a still film, and it was shown in one of the large movie theaters on Broadway; I think it was the Rialto. I don't

Many of the sequences from Mannahatta were made at locations Strand had already chosen for still photographs in the previous decade; this view represents his fascination with the Manhattan waterfront.

suppose they were satisfied with anything as mundane as Walt Whitman; it wasn't flashy enough, so they called it *New York the Magnificent.* It ran for a week and received quite some acclamation in the press. That was the end of our film work together. And I don't think Charles Sheeler ever did anything more with the camera that I know of."

Strand and Sheeler, neither of whom had made a film before, worked without a script, shooting in Lower Manhattan and the Battery. Robert Allerton Parker wrote in *Arts and Decoration:* "At a time when our motion picture critics are shouting the praises of *Dr. Caligari* and the rest of the German importations, it is strange that they should neglect such a significant achievement as this one of the two American artists. But perhaps those critical gentlemen can register only the merits of imported art and the demerits of domestic.

"In spite of this critical apathy, the Sheeler-Strand picture marks a turning point in the development of the art of the camera. The direct, expansive, unashamed photography, the salient selection and discrimination by which 'cameramen' managed, with the most effective economy, to capture the very spirit of lower Manhattan, the eloquent silence of these brief 'shots,' all lead one to claim that in the hands of such craftsmen the camera becomes truly an instrument of great art."

During this period, Strand began to evaluate the impact of photography. In "Photography and the New God," 1922, he wrote: "For it is in the later work of Stieglitz, an American in America, that we find a highly evolved crystallization of the photographic principle, the unqualified subjugation of a machine to the single purpose of expression. It is significant and interesting to note that this man is not a painter and has never felt any impulse to be one. From the very inception of his photographic work, which covers a period of thirty-five years, he, like Hill, was fascinated by the machine as a thing apart. In fact, Stieglitz knew nothing about painting

until, as the guiding spirit in that little experimental laboratory known as 291, he gave Americans their first opportunity of seeing the development of modern painting together with that of photography.

"Yet with all this he has maintained in his own photographic work a unity of feeling uncontaminated by alien influences; in his own words, 'no mechanicalization but always photography.' In his later work, consisting almost exclusively of a series of portraits made during the past four years, the achievements possible to the camera pass out of the realm of theory and become objective realities in which certain affirmations emerge. For the first time we are given an opportunity of examining and of drawing some conclusions concerning the means of photographic expressiveness, an expressiveness the actual nature of which, together with that of other media, may be safely left to the aestheticians to fight about among themselves."

The purchase of the Akeley camera in 1922 (page 69) had stimulated a series of new speculations and photographs: "I wish you could have seen the camera," he wrote Alfred Stieglitz on July 4, 1922. "It's really a piece of craftsmanship different from anything our friend George Eastman makes."

Later, he wrote Van Deren Coke: "The Akeley was assuredly the chief stimulus to my active interest in the machine . . . I photographed lathes, milling machines, drillers, etc., etc., made in the shops of the Akeley Camera Company (pages 67, 68)."

About machines, he wrote in *Broom:* "We are not . . . particularly sympathetic to the somewhat hysterical attitude of the Futurists toward the machine. We in America are not fighting, as it may be somewhat natural to do in Italy, away from the tentacles of a medieval tradition towards a neurasthenic embrace of the new God. We have it with us and upon us with a vengeance, and we will have to do something about it eventually . . . the new God must be humanized unless it in turn dehumanizes us. And so it is again the vision of the artist, of the intuitive seeker after knowledge, which . . . has seized upon a

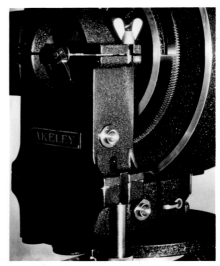

Strand purchased the Akeley camera in 1922, and it became the subject of a series of photographs. The movie equipment he carried when filming weighed 90 pounds.

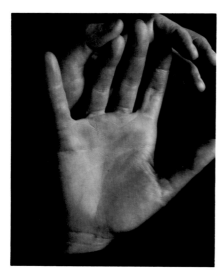

Strand's portraits of his first wife, Rebecca, and the portraits of Stieglitz, page 59, are among the several of persons close to him.

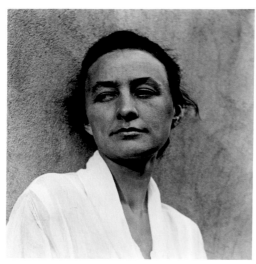

Georgia O'Keeffe was drawn to many of the same New Mexico subjects as Strand—the vast and empty landscape, the relationship between earth and sky, and the adobe buildings. She was one of the first 291 artists to move to the West.

mechanism and materials of a machine and is pointing the way.

"What is the relationship between science and expression? Are they not both vital manifestations of energy, whose reciprocal hostility turns the one into the destructive tool of materialism, the other into anemic phantasy? Must not these two forms of energy converge before a living future can be born with both?"

In September 1922 the review of his exhibition at 291 in *The New York Times* recognized the role of the machine in his work: "Mr. Strand, working with a machine, chooses a machine for his subject, and deliberately, intelligently, turns it into a work of art by selecting from among its qualities those that arouse aesthetic feeling. The fan belts of an automobile are photographed and photographed beautifully, with firmness, clarity, and breadth. . .

"The kind of tactile stimulus Picasso attempted to give by pasting bits of sandpaper and cloth on the surface of his canvasses, Mr. Strand succeeds in giving more naturally and simply."

On January 21, 1922, Strand married Rebecca Salsbury (page 55), an American born in Britain, who later became a painter. His portraits of her form a major part of his work during these years. "So you've done your bridal party to the tune of Lohengrin—I never realized that 'grin' is a significant ending," Stieglitz wrote him.

Strand was becoming a spokesman for the idea of photography as art: "The facts about platinum as a photographic base are as follows," he wrote in a letter to *The Arts* in 1923, answering an attack from Sheeler, whose views had begun to diverge from his on the "preciousness" of photography. "In the first place, it should be noted that silver as a base with albumen was used long before the application of platinum as a basic element. Platinum came into use some thirty years ago, not because of 'material preciousness' but because the metallic platinum image was proven to be and still is the only permanent one with the exception, possibly, of a few of the tissues used in

the carbon process. A platinum image is unaffected by light, atmospheric conditions, or chemical attack, and it will endure longer even than the paper in which it is fixed. . . .

"There are vast differences in the color of image and of paper stock, in scale, and in texture. Furthermore, the weight of the image varies according to the atomic weight of the metals themselves. . . . There is a reproduction of one of Mr. Sheeler's paintings, which derives from and is literally built upon a shot in a motion picture of New York, that he and I made together . . . There is no acknowledgement as to the sources of this painting, the most important being photography. Mr. Sheeler repeats 'the persistent question' . . . how long before photography shall be accorded an importance not less worthy than painting and music as a vehicle for the transmission of ideas? Not until . . . painters and photographers sharpen their interest with respect.

"Now the fact that the Stieglitz exhibition made decisively clear was that no one material is *the* material," he concluded his letter to *The Arts*. "One uses whatever is best suited to the thing to be expressed, and for the intelligent worker the deprivation of any material, which Mr. Sheeler looks upon as a benefit, would seem to be an exceedingly doubtful one. One might as well say that Brancusi would be fortunate if marble or bronze were no longer available and thus blessed by the war, he was compelled to use only wood. Fortunately for him and for us, however, Brancusi can still get and use marble of various colors, bronze, or wood, as his problem demands. Well, the various photographic papers under discussion are just as varied in their potential expressiveness as the above materials, and no one of them is any more a substitute for the other.

"The real menace in the use of materials is not 'preciousness' but *standardization.* In my opinion, many of Dr. Sheeler's own photographs, made exclusively upon gaslight papers, make one unpleasantly conscious of material first and content second. It is obvious that standardization is

possible with any material, whether 'precious' or not so 'precious.' "

"You speak of fame in the photographic world," he wrote John A. Tennant, editor of *The Photo-Miniature.* "Good Lord! Personally, after some fifteen years' interest and work in photography, I have observed mighty little 'fame' in the 'photographic world,' the existence of which I think is also somewhat doubtful. There is plenty of infamy and stupidity, as bad if not worse than in the so-called world of art, and that is going some."

With Strand's sense of photography as art came a growing assertion of the photographer-as-artist. In an essay on Georgia O'Keeffe, Strand equated the artistic statements of the painter, writer, and photographer: "Here in this American land, something rare and unforeseen, something precise and significant in the realm of the spirit has unfolded and flowered in the work of Georgia O'Keeffe . . . For . . . her work . . . revealed the extraordinary fact that without the slightest trace of self-consciousness or of mannerism, the most personal and subtle perceptions of woman have achieved an authentic embodiment for the first time in plastic terms.

"It is this maturity as well as the freedom from all 'masculine protest' which is so remarkable in the work of Georgia O'Keeffe . . . Hers is an achievement which distinctly ranges itself both in spirit and in importance with the writing of Randolph Bourne and Sherwood Anderson, with the painting of John Marin and the photography of Alfred Stieglitz. Like these, it springs from roots as deeply imbedded in the American soil, and is equally expressive of its spiritual reality."

His thinking was a further development of the ideas that Stieglitz had first announced to the American public with *Camera Work* and 291. In 1925 Stieglitz included Strand in his exhibition "Seven Americans," which presented the works of Charles Demuth, John Marin, Marsden Hartley, Georgia O'Keeffe, Stieglitz, and Arthur Dove. Stressing the significance of "Seven Americans" in the history of his gallery, Stieglitz wrote in the announcement:

This Exhibition is an integral part of my life.

The work exhibited is now shown for the first time.

Most of it has been produced within the last year.

The pictures are an integral part of their makers. That I know.

Are the pictures of their makers an integral part of the America of today?

That I am still endeavoring to know.

Because of that—the inevitability of this Exhibition—American.

The young Edmund Wilson writing for *The New Republic* did not mention Strand in his review. But Forbes Watson in the *World* wrote: "Mr. Paul Strand completes the exhibition with a group of photographs which is quite magnificent. The subjects do not make the photographs. The vision of the photographer himself makes the subject." The exhibition had yet another significance in the growth of Strand's work. The paintings, particularly the Marin paintings of New Mexico and Manhattan and the O'Keeffe storm paintings, seemed to parallel themes that had already drawn or were about to draw Strand's attention.

With the summer of 1926, a new subject matter emerged for Strand. He and Rebecca spent a month in Mesa Verde National Park and then traveled by narrow-gauge railroad to Sante Fe. Already present in his mind was the idea of suggesting a total, cohesive, and shared life through photographs—paralleling Edgar Lee Masters' poetic experiment in *Spoon River Anthology.* But he "wasn't ready."

He wrote Alfred Stieglitz: "I have been working steadily—at Mesa Verde I developed as I worked—had a darkroom in the cellar of the hotel at night." About the painters of the region: "I have never seen more trashy utterly commonplace picture-making. It is almost unbelievable that this amazing country can be seen in such a dead way." And from Estes Park, Colorado, he wrote Stieglitz about the new subjects he

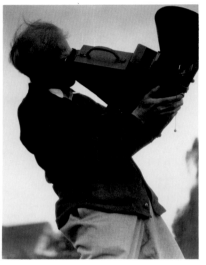

Strand photographed Stieglitz during a visit he and Harold Clurman made together to Lake George.

Strand's trip in 1926 to Colorado and New Mexico provided him with new subject matter. "When I see the paintings out here," he wrote Stieglitz, "the photographs look pretty good.

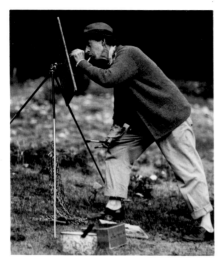

John Marin was one of the 291 artists with whom Strand felt the most affinity—writing about his painting with great appreciation.

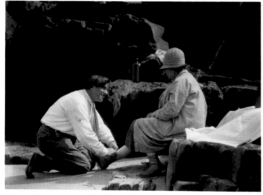

Strand photographed his friend, the sculptor Gaston Lachaise, helping Mme. Lachaise with her shoe on the beach at Georgetown, Maine.

was shooting, including *Stump and Vine*: "It was the first time I had ever photographed that kind of formation. I have made quite a few—used an eight-by-ten camera with tilts—I photographed a number of tree roots, also.

"I developed the Estes Park negatives in the cellar of the hotel, with the bananas and groceries. I worked all night and washed the negatives in the spring outside. I may have used proof paper or printing out paper with the printing frame.

"As one travels away from New York, one is always finding, potentially, New York—its deadness and cheapness, standardized mediocrity—in towns and towns trying to be cities."

In 1927 and 1928 the Strands summered in Maine near their friends sculptor Gaston Lachaise (page 57) and Madame Lachaise. Strand photographed rocks (page 100), plants (page 101), and driftwood.

"In 1927–1928 I went to Maine, to Georgetown, where the Lachaises had a house. I came to know about Georgetown through them. We spent a good part of a summer, my wife and I, in Georgetown. Marin (page 60) lived nearby and used to come over. And Hartley (page 61) was not far away and he used to come over. Those were very memorable summers. At Georgetown I really began the extreme close-ups of growing things. I had made a close-up in Nova Scotia on that first trip in 1919 of a rock; that was the first of that series. Then in Colorado I did some things of blasted trees and stumps very close-up.

"In 1927 I did for the first time things like the cobweb with rain (page 98), iris leaves growing (page 99), the big toadstool with grasses, things of that sort. I did driftwood and other aspects of life on that island. In this first experimentation with things growing I discovered an interesting natural law by sheer chance—which solved my problem; otherwise it would have been impossible. The Maine coast is quite windy, as are any other places near the sea. My exposures were sometimes from a minute to two minutes, long exposures. Nothing would stay still that long except on an ab-

normal day, and one doesn't live long enough to wait for the abnormal days.

"It occurred to me in trying to work out this problem of those branchy things that blew around so much in the wind that it was just possible that if one saw a gust of wind coming, you could start your exposure when the thing was not moving, and then when a gust of wind appeared off in the distance coming in this direction and finally hitting that particular plant, it might be possible to turn off the exposure, close the shutter in ample time while the object was motionless, let it be blown around by the wind, and then wait, opening the shutter as soon as the object went back to complete motionlessness. So I tried that, sometimes opening and closing the shutter maybe ten times during a total exposure, so that at least, when I was photographing, the object was motionless.

"Did that growing plant always come back to exactly the same position that it was in before the wind struck it? I found that it did. There was absolutely no movement in the photographs as long as I waited for the growing plant, bush, tree, or whatever it might be, to stop moving. One could open and close the shutter ad infinitum and still have a perfectly sharp picture."

In 1929 Strand spent the summer in Gaspé. His photographs constituted his first attempt to interpret the landscape: "There are two series of Gaspés. One in 1929, the first ones, which were made with a four-by-five Graflex; and the later ones in 1936 were made with a five-by-seven Graflex. The first ones were hand-held; the second ones were made on a tripod. Their importance is that they were the first, more systematic, conscious efforts to organize a landscape and its elements, all its elements. It was quite well recognized at the time that something new in landscape and in photography had evolved as far as my work was concerned."

The Strands spent the summers of 1931,

1932, and 1933 in New Mexico. Strand continued his research into the landscape in photographs of clouds, adobe architecture, and ghost towns: "I continued to explore the landscape problem working with both a small hand-held camera in 1930 and an eight-by-ten view camera. Beginning in 1931 I changed from a four-by-five hand-held Graflex to the five-by-seven, which I've used ever since. The five-by-seven has to be put on a tripod; it was too heavy to be held in the hand. But it has all kinds of great advantages that the smaller camera did not have. It's a unique camera, which is no longer made. It was originally made by Eastman Kodak especially to photograph children, with a focal shutter which allowed you to make exposures of as much as one second. I felt that however good the camera might be for its stated purpose of photographing children, it was a great landscape camera; and it was.

"It was possible with this special shutter to stop cloud movement and in general most of the movements that one gets in landscape. Getting the depth of focus and still stopping the movement was a great combination. It turned out later on when I began to make portraits, especially in Mexico in 1933, that the Graflex was perfect with the attachment of a prism for photographing the people without their knowing that they were being photographed—which was absolutely essential because the Mexican Indians don't like being photographed.

"The first year in Taos we rented a house from Mabel Dodge Luhan. Hartley had been there, but before we went out. Marin was there two summers, as I recall. One summer he had a house right next to ours, which also was one of Mabel's houses. We saw a lot of Marin and the Marin family.

"The New Mexico photographs continued the start that had been made in Gaspé and expanded it. As Nancy Newhall has pointed out, I became interested in photographing some of the last vestiges of what was the frontier in America, the ghost towns of New Mexico and Colorado. There were some things that I didn't do

that I wanted to do out there—some photographs inside the churches and portraits of the people who lived there, not the artists' colony, but some of the people indigenous to New Mexico. Leaving there in 1932 and going down to Old Mexico was the end of my New Mexico experience."

Photography became for him the symbol of a great impersonal struggle. This machine toward which he so freely moved, through which he was impelled to register himself, was a despised, a rejected thing. It became a symbol of all new and young desire, whatever form it might take, facing a world and social system which fears and thwarts and destroys. Photography became then a weapon for him, a means of fighting for fair play, for tolerance of all those who want to do anything honestly and well. —Paul Strand on Alfred Stieglitz, quoted by Elizabeth McCausland, *Photography*, 1940

Enter the ruined hacienda: see Christ
in sixty different tortured poses,
varnished, carved to semblance of life, endowed
with breath almost: here where the camera eye
restores the initial spirit, reveals
the permanence surviving death: ferret out
a race's history in a finger's curve,
see sun-washed walls flaking to dust,
the dust to powder won by the wind;
deep gashes, rush of rain and sun,
stones fallen, and the black deep grooves
where peons crucified conquistadors,
nailed them to doors, whips clutched
in paralyzed hands, tense in agony . . .

See too the solitary mare
grazing in the barbed enclosure surrounding
the dead mansion of glory: and the mountains
rising beyond, and the pendant clouds
hung in the skies, identical with
horizons Coronado never conquered.
Marks of boot and fingerprint remain
on the rainless scene: nails jut from walls
long cleaned by wind and bird of flesh and bone.

See here, a continent away, the evidence
of grandeur ground to death by time and men,
and the lovely spirit, sun on the anguished eyes
of the carved Christ: and the deep patience

men of another century engraved
on these stone walls and images—lines like words
shouting: "We are enslaved!"
 lines in prophetic
thunder: "We shall rise,
 conquer our conquerors."
Edwin Rolfe, "Prophecy in Stone (on a photograph by Paul Strand)," 1936

. . . I believe that the choice of medium in itself bespeaks a particular inner need and a particular form of perceiving reality. Whether the artist chooses words or music, stone or paint, or the photographic image, will condition absolutely not the content but the form of his work. What is important is that every medium can be a definite road toward "the triumphant reality, toward the real flesh and substance of the art which is about to be born." It is this common direction which Aragon so bravely and brilliantly calls for. The urgency of this common direction is in my opinion beyond discussion. —Paul Strand, letter to *Art Front* in response to an article by French poet Louis Aragon, February, 1937

'Is photography art?' [Strand] declined the invitation, since he did not want to be put into the position of being on the defensive on this subject. *"It's a stupid question,"* he said. *"You might just as well ask, 'Is painting art?' The answer is 'No.' My feeling is that there is no intrinsic merit in materials, but the artist can use them so that they project an experience of reality, a new entity, a something added to life, to which one may return again and again to find endless pleasure and stimulation."* —Paul Strand, interviewed by Etna M. Kelly, *Photography*, March, 1938

IV
THE CAMERA VISION
1932–1941

With 1932 came Strand's decisive break with the past. In April, he and Rebecca Strand were shown together at An American Place: "I hung the show myself, with Rebecca," Strand said. "Stieglitz did not help hang it—not an iota, didn't say why. It was the strangest exhibition a person

could have—no catalogue." Stieglitz's seeming lack of interest disturbed him.

"It is rather by the complete absence of comment that Strand establishes the galvanic immediacy of his visual material," wrote the reviewer for *The New York Times.* Elizabeth McCausland described Strand's half of the joint exhibition: "His first in New York for three years, the current exhibition displays almost a hundred prints: the beautiful driftwood series of 1929 as well as the Gaspé peninsula scenes, some New Mexican landscapes from 1930, and a fine selection from the 1931 New Mexico and Colorado prints. There is endless variety in atmospheric effects, light and cloud formations, chiaroscuro, texture of sand, wood, rock, adobe brick, and plaster, while a composition like the horizontal *City Hall: St. Elmo* reveals a masterly handling of the problem of the repeated clapboard motif, as powerful as the earlier print of a picket fence shown last fall at the Julien Levy Gallery."

Rebecca Strand seemed drawn to many of the same subjects: "Over a score of pictures, many of them set off by fascinating Mexican tin frames, represent Mrs. Strand's work in the curious medium [painting on glass], a medium appropriated almost bodily from the New England antique shop and put to work on New Mexican themes. The head of a *santo,* the full length *santo,* the Mexican woman draped in black, a tiny black figure wandering across a small square of glass, which oddly creates the illusion of great distance, the redness of mesa, the horse at night silhouetted against the mountains' sharp profile, flowers, cactus, sagebrush, are her subjects. Freshly felt and presented, with a charming *naiveté* and precision."

Shortly after the show, Strand's career took him away from New York and his long association with Stieglitz. Later in the year Strand's friend Harold Clurman, the writer and director, wrote him about a conversation with Stieglitz, who was concerned by the break: "The day I was with Stieglitz the main burden of his talk was that you had misunderstood his criticisms. That because you were so superb a photographer—your

prints better than his in many respects—he felt it his duty to counteract glib praise from unqualified people by testing your work by the severest standards and thereby stimulate you to deeper efforts . . . Whatever truth there may be in this . . . your instinct to break away was again a right one. Unless you can be close to Stieglitz without being absorbed by him—as Marin can—he is not health."

Later, in another letter to Strand in Mexico, Clurman, one of the directors of the Group Theatre, explored further Strand's differences with Stieglitz: "The difference between what you see in New York (as you express it in your letter) and what Stieglitz has put down is the difference between Stieglitz and you. Your reaction is sharper, harder, less tolerant, a little aggravated, resentful, and cold (in the sense that you will not have any traffic with those buildings!) whereas Stieglitz is always intimate with everything, always connected as with a woman. He cannot see anything as an *object* outside, separate and off from himself . . . In you (your photographs) the object is seen as having a distinct but separate life, untouched and untouchable by man. This may lead to a view of the object as a kind of gloomy fate—and create a kind of hopelessness—which you never whine about, but which leads to a kind of morose heroism . . . I remember you once saying, in 1929 . . . 'the difference between my photographs and Stieglitz's is that he has hope and I have none.' "

The months after leaving New York, first in New Mexico and then in Mexico, was the longest continuous period of photographic work that Strand had yet sustained. He seemed to be pressing for a totality of vision, a meeting of place and spirit beyond anything he had yet accomplished. Very soon after separating from Rebecca in New Mexico in 1933, he began a series of *bultos* and candid portraits of Indians that moved him even closer to his comprehensive portrait of man and the landscape. "I went to Mexico in the late fall of 1932 having already written to Carlos Chávez," he told an interviewer. "At

One in a series of photographs of ghost towns. Much later, Nancy Newhall observed that Strand had been drawn to Colorado and New Mexico because they represented "the last frontier" to him.

that time he was head of the Conservatory of Music and leader of the orchestra. I had written to him saying that I would like to come to Mexico and did he think he could do anything about smoothing the way as far as customs was concerned with all the camera equipment and so on. I got a kind of official invitation through him that was very helpful at the border. And with two friends of mine—Susan Ramsdell, who is an Indianologist, and her eighteen-year-old son—she was a Texan, and a very fine person whom we had met the first time we went to Taos—the three of us set off in an old Model A Ford to drive to Mexico City."

After a difficult trip, Strand photographing all the way, "we finally ended up in Mexico City. The whole back of the car was broken. I began to find the shibboleths of the time were not true for me. It was always said that you really have to know a place before you start working in it; otherwise you would do something very superficial. Another shibboleth was that you can't make a portrait of a person unless you know that person, and then when you know the person you create the moment or you wait for the moment when they are most alive and most themselves. These shibboleths went out the window.

"I started working in Mexico the minute I crossed the border. It was a continuation of New Mexico although quite different. Even the mountains are different. They're supposed to be a part of the same mountains, but they don't look the same. And they don't have the same kind of character. They have a different feeling, more sinister than the Rocky Mountains.

"In the later years when there was a more conscious effort to photograph a country or an environment whatever its size, I felt that it wasn't an impertinence to start photographing whenever I felt like starting to photograph, and that the length of time it takes to perceive the special character of the place, an environment, really depends on how complex it is and how long it takes to become acquainted

One of many pictures Strand made during his productive stay in Mexico.

with that complexity. The impertinence lies really in trying to photograph the complexity of a people, their environment, their land, in too short a time, but not in when you start photographing.

"Carlos Chávez had been appointed chief of the Department of Fine Arts in the Secretariat of Education. The Minister of Education was a very remarkable, very intelligent, fine man by the name of Bassols. He later became Secretary of the Treasury under Cárdenas and after that became Mexican Minister to France. I had met him almost immediately on my arrival because I had brought still photographs I made in New Mexico. When Chávez saw them he said, 'I think you should have an exhibition in Mexico City.' We showed the photographs to Bassols and he said 'yes.'

"The Ministry of Education had a building on one of the main avenues in Mexico City in which there was a long *sala* on the street level with a ceiling about forty feet high and great big windows. It was the only place that was offered for this show of fifty-five little prints . . . terrific and impossible.

"Marsden Hartley was in Mexico at that time and helped me hang that show. I would hold up the things, and he would tell me whether they were straight or crooked or whether they should go a little bit more to the right or to the left. A painter by the name of Fernando Ledesma put the glass on the pictures and designed a poster announcing the show, which was pasted up all over Mexico City.

"It was one of the most interesting, rewarding exhibitions I have ever had, even though it was there for only a couple of weeks. With the show on the street level, people would go in one door, go through the room, and out the other door. It became part of the street. All sorts of people came: policemen, soldiers, Indian women with their babies, and so on. I've never had such an audience anywhere else.

"After that exhibition was over and I had begun to photograph in Mexico, Chávez offered me the opportunity to go to the State of Michoacán, accompanied by

his nephew who was an art teacher, and make a report on the arts there, the teaching of art and crafts. 'At the same time take your camera and do some photography for yourself,' he said." Strand's report and the photographs made in Michoacán reflected his interest in the relationship between a people and their work, set against history, always tied to the landscape.

During the same visit, Strand arranged an exhibition of children's painting, a precedent established by Stieglitz. In their works, he found a dynamic that he felt might alter the Mexican scene: "It is not necessary that the world be full of painters, but it should be full of artists, that is to say, of human beings who consciously bring to their work, whatever it may be, the attitude and qualities which we find in the free and spontaneous expression of the child. It is precisely the problem of education to prevent the atrophy and corruption of these impulses in the growing generations, if ever we are to have a human society which creates life instead of destroying it and itself—which seeks to give rather than possess, which can meet the problems of adult life with feeling and thinking, uncorrupted by conventional, outworn, and regimented patterns."

"One day Chávez called me into his office and said, 'We are interested in making some films in Mexico. It's an idea of mine that I've cherished for a number of years. I think we can start it now. What we want is to make a series of films—let's call it a five-year plan of films—we'd like you to take charge of it, and we'll work out together what kind of films they should be.'

"I had no real interest in being torn away from my still photography, which was very satisfying and interesting. To make a film was a completely new project for which I had very little background. Even though I had operated a motion picture camera, I hadn't brought it to Mexico. (Later on we sent for it, but I didn't have it then.) Nevertheless, I wrote out my ideas in a memorandum.

"In brief, the memorandum raised the questions of who is the audience to be; what sort of films should one make for that audience once the audience is defined; should the films be more or less like Robert Flaherty's, whom I had known in America and had great respect for (films like *Nanook, Moana*); what were the things that the Government of Mexico wanted to talk about to the audience to be defined; and in general to what extent should the art of filmmaking be used to speak to this audience. I had personally come to the conclusion that if the audience were the sixteen million poorly educated Indians, peasants who made up the mass of the Mexican audience—if that was to be the basic target of such films to be made by a government—Mexico—then I did not think that the films should be like Flaherty's. The films should have characters and there should be a dramatic story.

"Chávez and Bassols agreed that the sixteen million Indians were the basic audience and that the films—and this was *their* great contribution—should deal with the production of wealth in Mexico in its different forms; in other words, that there would be a film about mining, about fishing, about the raising of corn, about cattle raising, and so on. It was agreed that it was not sufficient merely to describe the techniques of production of these various forms of wealth, but that the stories should reflect the lives of the people producing these different things so that the people would recognize themselves and their problems in a form that they could grasp.

"I put it down on paper that way: that the struggle of man against his environment, which is always the basic struggle that Flaherty pictured in one way or another, was not the approach that should be followed in Mexico, but that the social struggle was also a part of the problem, and that once having decided upon the audience, the audience would find their own lives reflected in the films.

"We were not going to film down to people no matter how illiterate they might be—and there was tremendous illiteracy. We would use the most rich and imagina-

Carlos Chávez, the Mexican composer, was Strand's major supporter during his stay in Mexico. Chávez, working for the government, asked Strand to photograph the Mexican people and the landscape and to make a Mexican film.

tive film techniques on the theory that the best art was the one which would reach all people most forcefully. On that basis we went ahead.

"Meanwhile, I had gone down with a young nephew of Chávez's, Augustine Velásquez Chávez, to Alvarado in Vera Cruz on the Gulf to see the fishing and the place. This young fellow and I wrote the story. Then I brought down to Mexico Henwar Rodakiewicz, who had had more filmmaking experience than I had, to work on a shooting script from our story script.

"The following year, 1933, we started production. Henwar had to go back to the States to fulfill a contract. To take his place, he recommended a young man from Hollywood whose name was Fred Zinnemann. He had not made any notable films at that point, but he had a very good sense of filmmaking. He was a good director of actors.

"I did the photography and in general was in complete charge of the production. The script really meant a great deal to me since it grew out of my contact with Mexico and my feeling about life in general.

"In the end of the film it was my idea that the funeral sequence should occur on the dunes around Alvarado, and the body of the fisherman be carried by a continually growing and growing crowd of people. Fred suggested that instead of doing it that way—because you would have needed perhaps six hundred or a thousand people to make a crowd seem large enough—we should do it with boats at the end of the film—the boats increasing, always more boats, more boats. That's the way the film was made. It was not made for intellectuals the world over, although it seems to have interested them.

"Films or any other works of art that I know of are not made by groups of people; they're usually made by one or two individuals who are the centers of production. This was also the case with The Wave.

"Unhappily, the film program which

Carlos Chávez and Bassols had envisaged was not carried out by Cárdenas, who became President of the Republic at just about the time we finished the silent version of the film. President Cárdenas was very appreciative of the The Wave and wrote me to that effect. No further developments of a government project occurred at that time, although a fairly important Mexican commercial film movement did begin."

When Strand returned to New York in 1934 he joined the advisory board of the Group Theatre: "When I came back the Group Theatre was going full blast. That was the time when they were doing *Waiting for Lefty*. And they were either preparing to do *Awake and Sing* or it was in production.

"The Group Theatre was something in which I had been very much interested before going to Mexico. As a matter of fact, I had participated as a spectator in the development of that Theatre and had listened to Harold Clurman and others speak about it to the groups of actors who came there to find out whether they would like to be members. The Group Theatre was built around the idea of a repertory theatre of actors working together continuously, a permanent company dedicated to the techniques of Stanislavski. They put on plays that had as their content something related to the lives of the audience. It was an offshoot of that whole cultural period, born of the 1929 crash, which had stimulated all sorts of growth in the art world.

"At the same time I learned from Harold Clurman that he and Cheryl Crawford were going to Moscow that spring to see the theatre in the Soviet Union. Harold suggested to me that I meet them over there and spend some time with them while they were there seeing the theatre and meeting various people. Several weeks after they had arrived, Harold and Jay Leyda met me at the train in Moscow late in the afternoon. They told me that I had a date to see Eisenstein that evening at his house. I had taken photographs with me, some platinum prints.

Strand set up many of the scenes in The Wave *as if they were stills, repeating the composition to establish a tightly organized visual structure. His close-ups are very much like his still portraits, as are his equations of land, sea, and sky.*

Strand began to discover a profound and visually suggestive relation between man, man's artifacts, and geographical location. In The Wave, *entitled* Redes *("Nets") in Spanish, Strand used the fishermen's nets as a symbol of their fate; the natural and economic forces that worked inexorably in their lives. This still photograph was made at about the same time as the film at Janitzio, Lake Pátzcuaro.*

"It was a very memorable and interesting evening. I think I had a few film clips from *The Wave,* and I showed him those. He held them up to the light and, if I recall correctly, he said, 'Well, I can see that you are essentially a still photographer and not a film photographer.' On the basis of the few clips that he saw, I thought he was a little bit fast. But I didn't mind.

"Later on he invited me to work in the Soviet Union on a film that he was going to make. But the threat of German Nazism was already becoming very strong—the threat of the war was already being felt, which made getting a working visa in Russia very complicated. So I didn't work there. But I did meet most of the great film directors in addition to Eisenstein: Dovzhenko, and Eck, the man who made *The Wild Boys Return to Life.* The whole experience was extremely important and worthwhile for me even though I didn't do any photography.

"I also went to the theatre almost every evening with Cheryl and Harold, which was very exciting. One evening we saw a production of *Romeo and Juliet,* which the Theatre of the Revolution had just completed rehearsing. They put on a special performance for the artists in the Soviet Union. During the intermission we all went back to the director's office, where they served chocolate and cakes. We met Dovzhenko, who was an old man. He was the companion of Stanislavski in the Moscow Art Theatre. Stanislavski himself was quite ill, so we never met him. But the young director of *Romeo and Juliet* was there. It was a fantastic production. We saw many other things in the theatre that were unforgettable."

"Strand has now begun to photograph people with particular attention to their surroundings," wrote Joseph Losey, who had not yet become famous as a film director, in a feature story for the *Moscow Daily News* on May 17, 1935. "One of the chief characteristics of his later work is the drawing of people, nature, materials, into a close-knit composition of textures, light intensities, line, mass. No one element should be slighted at the expense of another, Strand says.

"Strand does not yet know what he will want to photograph here. Where Margaret Bourke-White photographs forty buildings in two days, it might easily take him forty days to select a building to photograph. Usually there is no more than one print of each of his pictures, Strand says, each representing blood-sweating work. It is quality as well as real artistry that Strand has to contribute."

"When I came back from Mexico, I also found in New York a small group of filmmakers, the Nykino, who were profoundly interested in the problems of filmmaking, especially documentary filmmaking. Stimulated by the Group Theatre, they had been brought into contact with the theories and methods of Stanislavski and found them useful in trying to work out some of the problems of the documentary film. They realized that the ordinary documentary approach is a pretty dull affair unless one finds some way of dramatizing the material.

"The documentary film tends to have an aesthetic and an actual structure of a lot of facts strung together one after another with no development, with no conflict, with no drama. There is no story, there is no hero, there is no heroine, there are no characters, as a rule, with whose lives one can identify and follow the development of their destiny.

"When I came back from the Soviet Union, Leo Hurwitz and Ralph Steiner, two members of Nykino, were working on a story outline for *The Plow That Broke the Plains.* They had taken the theme of the dust storms, because they were still blowing hard and people were being blown off the land along with the dust. They sat down and began to write a story outline for this film to present to Pare Lorentz. They asked me if I would like to join them in the writing. And so we all chewed it over together. As an exercise in screenwriting of documentary films it was rather new and unusual. Most documentary filmmakers

Leo Hurwitz was probably Strand's closest working colleague during the mid-thirties and early forties, collaborating with him on both the writing and shooting of the films Strand worked on for Frontier Films. Hurwitz also wrote the introduction to The Mexican Portfolio.

Strand filmed The Plow That Broke the Plains *as he would his still photographs. Perhaps no other filmmaker besides Eisenstein took such care with individual frames.*

simply went out on location with a general theme to be photographed, without a very solid shooting script.

"I was asked to be one of three cameramen on this project. Finally, in September, we started off for Wyoming and Montana. From there we went up to Montana to the Campbell Wheat Ranch. Campbell had an enormous development there. In fact, he was so well known as an expert in wheat culture that he had been invited to the Soviet Union to tell them what he knew about it. We began our real shooting at the Wheat Ranch. In this very remarkable Montana country of rolling prairies, this man Campbell had carved out a very successful project. We saw as we photographed fifteen or twenty harvesting machines come marching towards us, cutting down the wheat, a picture of American agricultural success and richness and know-how.

"What we saw in Montana was a very positive statement, which was shortly to be contrasted with the tragedy of what was happening in Texas. There the land was blowing away, not only because of the uncontrollable and unforeseen drought which lasted for some years, along with the winds that came with it, but also because of man's greed in plowing up lands that were not fit to be plowed. There were no tree belts because there was nothing to hold the grass and the roots down—nothing to act as a brake against the winds if they ever started to blow in a drought as in fact they did.

"When we got to Dalhart in Texas, where we met Lorentz, our director, the earth was still blowing like a cloud about three or four feet above the earth without interruption, just blowing away.

"Hurwitz and I found places where there had been human habitation. We found a house buried in sand. There had once been trees. There had once been green things. Now it was right down to the crust of the earth—nothing but sand. The same kind of sand that you'd find on a beach. Never have I seen in America or anywhere else such a scene of desolation.

"To complete the camera work, we went to Nebraska and photographed a village, which had been built by the Resettlement Administration as an attempt to alleviate the deprivation of many of the farmers of the dust storm area. As a solution to the problem, it was completely inadequate. The size of the area involved was too great."

"The members of Nykino all were very eager to stop working at anything except filmmaking. We decided that the only way to do that was to try to form some kind of organization similar to the Group Theatre, so that we would all work together as a production group and make films which would deal with various aspects of life that we felt our fellow countrymen should know about. We also wanted to make films that had content, we wanted them to have as dramatic a form as possible. The theory was that this was the only way in which the content would have an impact.

"We formed a group which was called Frontier Films. The organizational set-up was simple: I was elected president of the organization; Leo Hurwitz, Ralph Steiner, and Lionel Berman, were vice-presidents. Arnold Perl was secretary. We were listed by the federal government as an educational, non-profit, tax-exempt organization and it was very much non-profit. We always had a very tough struggle to pay very minimum salaries, salaries which in Hollywood would have been absurd. In fact, they were absurd in New York, too.

"The group of people who made up Frontier Films were essentially the same people who formed Nykino, and it continued from about 1937 to 1942, when America went into the war; most of our people became involved in the war effort."

The best known of the films produced by Frontier Films are *Native Land, Heart of Spain, People of the Cumberland,* and *China Strikes Back.* To Strand one of the most significant of the films was *Heart of Spain.*

"*Heart of Spain* was made with material

brought over by Herbert Klein and a young man who had done the photography. It was interesting but could not possibly have made a film without additional material and editing with a very definite film structure. This editing was done by Leo Hurwitz and myself.

"I think *Heart of Spain* is an aesthetically solid and remarkable film. It tells an important story of the extraction of blood from the civilian population, which was then put into iceboxes and transported to the front lines battle area, saving the lives of countless thousands of Spanish soldiers who had been wounded. Historically it was a prophetic film. The program was initiated and started by Dr. Norman Bethune, a Canadian doctor and surgeon in Spain in the first years of the Spanish War who worked in the American Hospital in Madrid. We made the film for the Canadian-American Committee for Spanish Democracy."

"In 1940, I began a totally new project by using still photographs. Lee Strasberg, who was a director of the Group Theatre and who had been very interested in the photographs that I had brought back from Mexico, said, 'Why don't you make a portfolio of these? So many people would like to have them.'

"I began working with that idea. The problem was how to make a portfolio that would stand up to my original platinum prints. The only possibility at that time was to make gravures by hand. The other question that arose immediately was how such a thing was to be financed. It was not anything that a commercial publisher would go for. Lee Strasberg and Bill Golden and other friends who were fired by the thought suggested that we get out a mailing piece and ask for subscriptions. There were to be twenty gravures and the price of the portfolio was to be fifteen dollars, which at that time was quite a lot. The result of the mailing piece was that we got about a hundred and ten subscriptions.

"I took the subscriptions to Charles Furth of the Photogravure and Color Com-

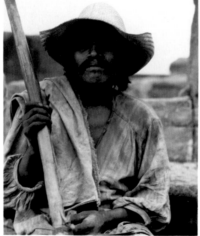

Man with a Hoe, *Los Remedios, Mexico 1933 was one of the twenty plates reproduced in* The Mexican Portfolio.

pany and he was willing to take the subscriptions as a guarantee.

"I gave Mr. Furth six of my negatives to make the first proofs. When I went in to see them, it seemed to me that they had been very much retouched and cropped, and while I have been known to retouch my own work I don't let other people do it. I asked to see the positives made from my negatives. He brought them. They were completely unacceptable. I asked and was given permission to work, with the man making the positives. I said to him, 'Tell me, why has all the retouching been done on my things?' He said, 'That's the way they like it nowadays. We didn't do that at all twenty-five years ago; we just made a nice clean brilliant positive.' So I said, 'All right. Let's go back twenty-five years. Let's make a nice clean brilliant positive and see what happens.' So we did. And from that moment on there was no more problem.

"We went ahead and made twenty positives from twenty negatives, and then they engraved the plates. At that point I switched over to work with the printer, the man at the handpress. We made proofs of the twenty plates, keeping an exact record of how much hard ink, how much soft ink, how much white ink went into the mixture until it gave us the result we were looking for. Finally, once the go-by prints were made, I gave the okay to print all twenty plates. I didn't go near the place when they were printing the edition, which was two hundred and fifty copies of each plate.

"We went on to the problem of varnishing these five thousand gravures. Bill Golden, who was Chief of the Art Department at CBS, and his associate Ted Sandler found a loft where workmen varnished furniture. We were able to go there on Saturdays and Sundays and use it as a place for varnishing the gravures. We hired a man who was an expert at spraying lacquer. We had a long table laid out on which we put thirteen gravures. We cut thirteen mats so that each gravure was protected from getting the varnish on the white paper that surrounded the image so only the photograph was lacquered. We had a belt line there: about five or six

people would come; two people would lay down the thirteen gravures; the professional sprayer would go up and down the line with the lacquer; then two more people would pick up these wet gravures, hang them on the line to dry; the other two people would put the new ones down; and so on. We were able to do about five hundred at a sitting. In a month or two the portfolio was finished; the books were mailed out to the subscribers. The edition (published by Strand's wife, Virginia Stevens, whom he married in 1936) sold out quite quickly."

We conceive of realism as dynamic, as truth which sees and understands a changing world and in turn is capable of changing it, in the interests of peace, human progress, and the eradication of human misery and cruelty, and towards the unity of all people. We take sides. We take sides against war, against poverty, and align our art and our talents on the side of those whom Henry Wallace called the "Common Man," the plain people of the world in whose hands lie the destiny of civilization's present and future well-being. And the world civilization, as I use it, includes the world culture. —Paul Strand, speech to the International Congress of Cinema in Perugia, Italy, 1949

V
"WE, THE PLAIN PEOPLE . . ."
1942–1949

In his photography for *Native Land*, the film about the violation of American civil liberties, Strand orchestrated, most notably in the emergence of the labor movement, many of the themes that were already predominant in his work—a profound interaction of character and place, a unity of vision, a belief in the dignity of work. Some of the images from *Native Land* released in 1942 recur as photographs in *Time in New England*, published in 1950, just as there previously had been an interplay between his still photographs and

his films in *The Wave* and *The Plow That Broke the Plains*. What was added was a new organizing principle, a juxtaposition of images that made a whole. The fellowship of men, "We, the plain people . . ." as it is described in *Native Land*, became the unifying concept, the "wordless faith." Strand later said he could not have conceived the books that began at the end of the forties without the films, implying that the film had suggested a cohesive and unifying structure for all of his work.

At the press conference before the screening of *Native Land* at the Overseas Press Club, Strand said: "*Native Land* represents the culmination of a ten-year effort to bring to the American screen a kind of reality which dramatizes the real problems, hopes, and aspirations of real people in America and elsewhere. It is our belief that the defense of civil liberties and the rights of labor in the years preceding Pearl Harbor strengthened the nation, helped materially to create our present unshakable unity behind the war effort and the Administration. This is the fundamental meaning *Native Land* is intended to have, the meaning whereby the past events it pictures attach to the present moment, and the task of wiping out Fascism forever from the face of the earth."

The period that marked the end of the war and the beginning of the postwar years was a troubling and disillusioning one for Strand. Frontier Films had ended production in 1942, and *Native Land*'s important message was lost in the clamor of wartime propaganda. The issues that the film, four years in the making, had raised about American life and the role of civil rights were not to be raised again for almost twenty years.

In the meantime, Strand shot footage for various films, including several produced by government agencies. "In 1942, I tried to get a job at the Office of War Information," Strand said. "They had one job and asked me to write a scenario called *The Bridge of Ships*. Both Leo Hurwitz and I wrote scenarios. They accepted it and sent it over to Herman Shumlin, the Broadway producer, but they never made it. It was a

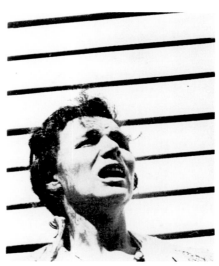

Strand's camera work and Leo Hurwitz's cutting in Native Land *were even more abstract than in previous films; a complicated intercutting of landscape and natural objects that suggested enduring American values. Many of the still images for* Time in New England *are foreshadowed here.*

Strand greatly admired the German propagandist and collagist, John Heartfield, whose work inspired his famous anti-Fascist cover for TAC in 1939. "I am proud to have been called a 'premature anti-Fascist,'" he said later.

film about convoys." Strand worked on *Tomorrow We Fly,* a movie about the Navy, and even shot some factory footage for David O. Selznick's *Since You Went Away,* a Hollywood tearjerker starring Claudette Colbert, Jennifer Jones, and Shirley Temple.

In 1943 Strand returned to many of the political ideas he had visualized in *Native Land,* but in a surprising new format, as the possibility for work in film drew to a close. As chairman of the Committee of Photography of the Independent Voters Committee of the Arts and Sciences for Roosevelt, he edited, with Leo Hurwitz and Robert Riley, a montage of photographs from many sources depicting the twelve years of the Roosevelt Administration. Covering an eighty-foot wall of the Vanderbilt Gallery in the Fine Arts Building on 57th Street, New York City, it was the photographers' tribute to President Roosevelt.

The thematic arrangement of the photographs was largely derived from the techniques Strand had evolved with his films. Strand's "script" had six major elements: 1. "Lest We Forget," photographs of breadlines, apple sellers, bonus marchers, Hoovervilles, runs on banks, and so on; 2. "America Gets New Leadership," Roosevelt's phrase "Our greatest task is to put people to work" linked to photographs of soil conservation, reforestation, resettlement, rural electrification, aid to small farmers, public works, the WPA arts programs; 3. "The Strength of the Nation Lies in the Well-Being of Its People," photographs illustrating the government's youth programs, Social Security, public health and housing, the right of labor to organize and bargain collectively; 4. "The President Warns the Nation," photographs of "scenes of actual effects of Fascist brutality and terror," of lend-lease activities to Great Britain, the Soviet Union, and China; 5. "The United States Is Attacked," photographs of the domestic preparations for war and the Armed Forces, the Atlantic Charter, and a "global map with the spheres of influence of Fascism contracting

in spasm-like waves"; 6. "Forward to the Peace," Roosevelt's "the foreseeable future" and the second Bill of Rights, the right to full employment, full production, and full opportunity for all.

In 1944 Strand made a speech at The Museum of Modern Art that linked the cause of art and the war effort. "Music, architecture, painting and sculpture, literature, theatre, the dance. These come to us out of earliest history. From our own epoch, science has given us photography, the film, radio, and television. Radio is still in its infancy and television is scarcely born yet, but I think it is clear that they have the potentiality of becoming arts, perhaps very important ones. But what are all these things I have just enumerated? It seems to me they are all forms of speech, languages by means of which men seek to communicate with each other. Communicate what? I think Fascism has answered the question. The Nazis say 'when I hear the word culture I reach for my gun.'

"He does indeed reach for his gun and his torch to burn books and paintings, to reduce whole cities and all they contain to rubble, and to wantonly hack to pieces the museum-shrines of a Tolstoy or Tchaikovsky. Why do they do it? They do so because they realize that the whole body of culture, past and present, which we and our allies defend, cherish, and seek to continue, gives them the lie, weakens them. They know that the arts are means, different instrumentalities through which free men of every race and creed speak to each other and record the age-old democratic effort to understand the world, to get at the basic truths of man's relationship to it and to his fellowmen. In short, the arts on their highest level are dynamic, can affect, move, and unify great numbers of people. They are international languages capable of crossing the narrow boundaries of prejudice, capable of counteracting viciously contrived hatreds."

That same year Strand returned to Vermont. "In 1944 I renewed my connections with New England, which I love so much, and became acquainted with parts of it which I hadn't known before, especially in

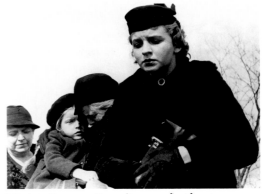

Virginia Stevens, Strand's second wife, appeared as the grieving widow in the last segment of Native Land—*her purse clearly monogrammed "VS".*

The Strand exhibition at The Museum of Modern Art in 1945, organized by Nancy Newhall, was the first given to an individual photographer and was the pivot of Strand's career. It gave him public recognition for his accomplishments as a photographer and provided a new direction for his talent at a moment when his work in the movies was clearly over.

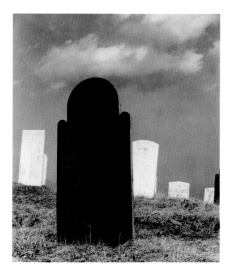

Partly in response to Edgar Lee Masters' use in Spoon River Anthology *of the cemetery as a symbol for human community, Strand returns again and again to cemeteries in his photographic projects.*

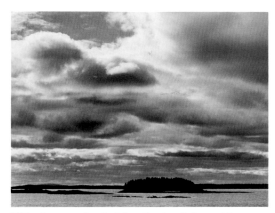

This photograph of a New England sky and islands, taken in 1946, the first picture in Time in New England, *established a precedent in Strand's books. Such landscapes often appear as "establishing shots" in his subsequent work to evoke a feeling of place, the sense of location essential to Strand's visual psychology.*

Vermont. My friends, Genevieve Taggard, the poet, and Kenneth Durant, her husband, had a house in the West River Valley (page 50) in Vermont. It's not far from Brattleboro in southern Vermont. At first I stayed a few days with them. Then I found a neighboring farm that would put me up. I began to work again in that area.

"In 1945 Nancy Newhall, who was taking the place of her husband Beaumont Newhall as curator of photography at The Museum of Modern Art while he was in the Army, invited me to have a one-man exhibition at the Museum. This was put up in the spring of 1945, an exhibition of work retrospective to 1915 and going up to 1945. It was a very satisfying experience. It was the first one-man exhibition that I had in New York after 1932."

The exhibition at The Museum of Modern Art also was the first one-man show given a photographer. In the monograph published at the time of the exhibition, Nancy Newhall wrote: "The photography of Paul Strand has become a legend . . . Strand has been the discoverer of photographic forms and concepts for our time, penetrating with unswerving logic and passion through each succeeding phase of his problem."

"At the end of that show, Nancy Newhall suggested that we should do a book together about New England. She and her husband are both New Englanders. They had a strong feeling that my photographs of New England captured the spirit of that part of America as they know it.

"In reply to my question as to what sort of book we should make Nancy suggested the interesting idea that the text of the book could be made up of writings about New England by New Englanders from the time of the first landing until now. Nancy offered to do the necessary editing of such a text, which meant, of course, living a good deal in libraries. I thought it was a very interesting and creative idea. And I agreed to go ahead with it and return to New England and continue photographing so that we had enough material.

"By 1945 I had gone a number of times to New England in different seasons and had spent a great deal of time there in the winter. We had a dummy that fulfilled the idea that Nancy had suggested, which became a book called *Time in New England*. The book was printed in an edition of ten thousand copies and has been out of print for years.

"In *Time in New England* there is a new relationship between picture and text. We began very consciously and deliberately with a chronological sequence of text limited to people who had written about New England and most of whom, not all, were New Englanders. The subject of the book is three hundred years of writing about life in New England accompanied by photographs which were made to fulfill the spirit and feeling of the writing."

In a seminar at the Chicago Institute of Design in 1946. Strand sought to to define the artistic problems he felt his work had embodied, reflecting the changes he himself was undergoing: "Subject matter is an interesting problem, because one hears many diverse ideas and attitudes toward it—some feel that subject matter is all important; others feel that it doesn't make any difference, that what the artist does with it is what is important. I think both of these are half-truths. It seems to me that subject matter is extremely important to the artist, because until he talks about something that really means something to him, the audience cannot see anything important or very interesting.

"Usually the subject matter in art has been important as an idea or a symbol to the people for whom it was produced. The truth lies somewhere in between. The mere copying of something is not sufficient. It is not sufficient because whatever you copy has its own life and movement, so if you don't get those elements you don't get nature at all. You get a kind of dead, academic thing. Subject matter is extremely important to the artist because it is through the actual factual world that we express life. And in that world certain things are more important to people than other things. People are more important to people than other things. . . .

"The other aspect of subject matter that comes in here is the aspect of journalism, which I think it can be said is a relatively recent thing in the world. It comes with the invention of the printing press, newspapers, magazines, and of course photography plays an enormous role. It is through photography as a process of communication that we can really see all parts of the world and all kinds of people and efforts that are happening throughout the world. Usually journalism records facts and events with varying degrees of truth and depth. Most generally, what we get in the press and magazines deals with the externals of things—it tells you what happens, but it seldom makes the event significant beyond itself. It doesn't tell you, as a rule, the underlying forces that cause people to do things. When it tells you about a murder, it doesn't tell you very much of the background of the people and how it came to be that this thing happened. One can make a statement, but the artist goes further and gives overtones of emotion. . . .

"The character of a work of art is that it is something you can go back to many times. It isn't necessary for you to feel that you must have that picture. But the general character is that you want to come back to the picture and that each time you come back you can find new things—new elements you haven't found before. That is true of all the arts.

"What is the role of the artist-photographer? The artist is one who makes a concentrated statement about the world in which he lives and that statement tends to become impersonal—it tends to become universal and enduring because it comes out of something very particular. . . . We do not photograph some large conceptions of humanity, but rather go very deeply into a single person and penetrate deeply and derive a larger meaning. One person who has been studied very deeply and penetratingly can become all persons. Therefore, it seems to me that art is very specific and not at all general."

Strand said, "I have been very conscious

in the past twenty years that it is very easy to standardize photography. It is easy to find a paper that you like and you make all your prints on that paper. . . .

"Certain things require a different kind of treatment. For instance, these things of the Southwest are platinum prints. Platinum is a beautiful paper—it has a much greater scale than bromide. The Southwest is a land of plenteous sunshine, and the general tone and feeling of the country is warm and rich. Then when I went up to the north to Gaspé in 1929, I couldn't print my pictures on platinum paper. I felt that, photographically speaking, though platinum was a much superior paper, it was the wrong paper. The north is cold, the color that best showed this was something with a black overtone. . . .

"My way of printing may be of interest to you. There is nothing particularly original about it, but since I make contact prints and I wanted to be able to use chlorobromide paper, I found it helpful. I use a printing frame, set on the enlarger easel. I throw the lens out of focus so that the enlarger light is evenly distributed over the whole area. Then by using the f/stop I can regulate the intensity of the light and vary my exposure.

"I got hold of many different kinds of papers in order to try to find one which had the kind of surface I wanted. The ideal paper to me is absolutely smooth. In photography you are not dealing with the texture of your paper, but with the textures in your photograph. I find that a paper which is almost porcelain smooth that allows you to look into the photographic print is the best for my purposes."

The most troubled decade of Strand's career was drawing to a close. When *Native Land* was awarded a prize at the Czechoslovakia Film Festival, Strand indicated that the fears portrayed in the film had not been resolved in America but had taken on new and ominous forms: "The people have suffered defeats but they have won many victories. It is my conviction that now, when once again these liberties of ours are under severe attack, the historic American

love of freedom will assert itself. I believe the time will come when such un-American activities as the blacklisting and threatened jailing of ten of our most distinguished film writers and directors—men like John Howard Lawson, Dalton Trumbo, Edward Dmytryk, Alvah Bessie, and others—the time will come when this kind of thing will be made to disappear from American life by the aroused conscience and good sense of the American people."

Speaking at the International Congress of Cinema in Perugia, Italy, Strand summed up the philosophy that had shaped his work, providing it not only with substance but motive: "I begin with the negative statement that realism is not the mere recording of things as they are, seen through dispassionate eyes in which all things are of equal value, of equal interest—the eyes of a man who thinks he stands above life, above good and evil. Neither does realism consist in the description, no matter how honest, of the exceptional or sensational in life. There is a certain kind of realism in the Hollywood films of violence; the torn and bleeding face of a prizefighter is true in real life, but such truth has no purpose, except to excite the sadistic and masochistic feelings of the audience—to exploit them on an emotional level. For there is such a thing as emotional exploitation, as well as economic exploitation; in fact, they often go together and are equally repulsive.

"In the lives of ordinary men and women, a dynamic realism will find all the drama, the conflicts and resolutions, with which to create the greatest art. To the extent that the artist of the film uses all the aesthetic elements of this great medium to the fullest, creating the richest forms, will this realism move his audiences."

It has always been my belief that the true artist, like the true scientist, is a researcher using materials and techniques to dig into the truth and meaning of the world in which he himself lives; and what he creates, or better, perhaps, brings back, are the objective results of his explorations. The measure of his talent—of his

genius, if you will—is the richness he finds in such a life's voyage of discovery and the effectiveness with which he is able to embody it through his chosen medium. —Paul Strand, letter to the editor, *Photographic Journal* of the Royal Photographic Society, 1963

VI
PORTRAIT OF THE WORLD
1950–1968

Strand left the United States in 1949 and remained in Europe, after his father's death in 1950, for virtually the next twenty-six years. "It's not always terribly clear why one makes very sharp and seemingly drastic changes, like changes of residence," Strand said later. "But it must be remembered that in 1950 I had lived about sixty years in my own country, had seen quite a good bit of it, and had worked very much here. And by going to France, although it turned out to be a long-term and rather definite change, nevertheless it was not inexplicable or very revolutionary. After all, I had worked in Mexico and I had worked in Canada in the Gaspé, and this idea of investigating the lives and environments of people was not completely strange to me.

"I went to France not with the idea that I was going to settle down there for the next twenty years—I had no such idea—but simply to make a book about which I had thought for a long time. Growing up in America, one of my earliest memories of a book that had moved me deeply was the *Spoon River Anthology* by Edgar Lee Masters. Like Masters, I had got the idea that it would be interesting to make the portrait of a village in photography not taking names off the graves, as Masters did, but photographing a village as it is now with the people who live in it. I'd even thought of doing a thing like that in Taos. But I never had enough time, and it wasn't clear enough in my head just how to go about such a thing. In short, I wasn't ready.

"To do a portrait of a village made me gravitate toward France, rather than try to do it in America. Possibly the fact that McCarthyism was rife at that time made me feel that it would be too difficult to do in America. I was very disturbed by the fact that there was so much confusion in the American mind that it permitted such a man to cause so much harm and damage to the lives of innocent people.

"In any case, my wife [Hazel Kingsbury, whom Strand had married in 1951] and I went to France and began looking for a village in which to try out this idea. We never found it in France because we didn't know France well enough. But I did photograph France as we traveled around looking for this mythical village. *La France de Profil* is a result of our traveling and our exploration and wandering. It has a text by the poet Claude Roy that ties our travels together in a new way, not at all like *Time in New England,* because in this case the text was written after the photographs were taken."

Claude Roy wrote in his preface: "Strand went his way—a way that was meditative, capricious, unhurried, a musing and dreaming way, a way that more closely resembled the roundabout path of a schoolboy than the flight of a bird, a way that has no system and no other goal but to capture the maximum of humanity, of the most humble and the most *naked* truth.

"What characterizes Paul Strand is that he neither confines himself to nor lingers over *the first glance.* This 'foreigner' is not attracted by what seems out-of-the-ordinary to foreigners and to Frenchmen themselves. If he has taught us something about our country, our people, our 'way of life'—it was not because his insight had mere freshness, novelty or exceptional candor. Strand did not introduce himself into French life as someone who comes from *the outside.* His harvest as a strolling photographer is disconcerting only insofar as it places us at the very heart of that which we no longer see. He has not sought artificially to renovate his subject, France, with trickiness or ingenuity. He has sought simply to penetrate it. He let himself descend into the silent profundities of the

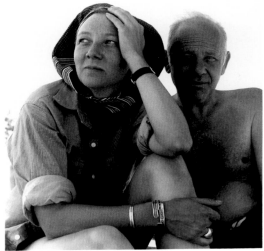

Hazel Kingsbury, Strand's third wife, was also a photographer who traveled widely in World War II and worked as assistant to Louise Dahl-Wolfe, an eminent fashion photographer. Her help made possible the extraordinary last phase of Strand's career—his books and portfolios.

In a rare instance of manipulating his subject, Strand arranged this photograph by combining the bunch of grapes with pesticide-sprayed grape leaves he fancied for the composition.

French nation with the submissiveness of a pebble that falls to the bottom of a well, and he made all kinds of simple discoveries along the way.

"What he had to tell us on his return—this companion of the Tour de France, New England Wise Man—was not gay or flattering or delightful. But I believe it was very beautiful."

Strand continued in describing his projects in Europe: "I am very interested, and always have been, in the problem itself, of putting words with images in various ways. I feel that they enrich each other. The images enrich the text and vice versa. And there is nothing more boring or dull than picture books with some sort of an introduction at the beginning and then nothing but pictures from there on out. I don't like that form. In each one of my books the text plays a very important role.

"After *La France de Profil* I did *Un Paese* with Cesare Zavattini, the Italian film writer. At last we made a book about a village. It was the village where he was born that we finally chose, quite arbitrarily. He says in his introduction that his first thought was to take a pin, shut his eyes, and stick it into the map of Italy, and there we'd make the book. His feeling was that you could make a book like that anywhere. And I think he's right. Also, he was very interested as a filmmaker: he said, 'Well, I like this idea because I've always wanted to make a film on a street corner, only what happens on that street corner.' He was interested in the concentration that the idea implied."

In the introduction of *Un Paese*, Zavattini, who also wrote the script for *The Bicycle Thief* and *Open City*, said: "In 1953, when the American Paul Strand, in his calm, patriarchal tone, first suggested that we do a book together on some area in Italy, I thought first of Sperlonga in Fondi, of Gaeta, Gorino in the Paduan delta, of Bergamo, Alatri, Carrara, the Via Emilia and a trip along the Po from its source to the sea, and finally decided on Luzzara. And he

said, 'First I'll go and have a look.' Strand's idea came at a time when I had already been exploring the possibility of a series called 'My Italy.'

"I met Strand at a cinema conference in Perugia in 1949. Pudovkin was also there with an expression so full of life that it seemed he should never die. The conference dealt with modern man and his responsibility to the cinema. Strand had already made his position clear as the creator of *Native Land,* a work which meant, among other things, love for his country and risking something for that love. I don't think that we even shook hands at that time because his silence intimidated me. I saw him again three years later in Rome and now, here I am with his work in front of me, about ninety photographs of Luzzara which Strand can always show as proof of his genuine interest in his fellow man. . . .

"Strand traveled around Luzzara and its surrounding areas and finally placed fields, faces, and houses on my table. Afterwards, I followed his tracks with the help of the farmer, Valentino Lusetti, who had served as a guide for Strand and his wife, speaking to them in English."

Strand described the project in a letter: "Well, here we are in the Po Valley, beginning work with Zavattini. He has been here for a few days to get everything started. It is not going to be easy, this particular part of Italy. A flat, flat land of fields and vines and little undistinguished villages, which have no traces of historical or present charm or the faintest picturesqueness. All is severe—run down—barred windows, broken and poor architecturally speaking. That sort of junky disorder around houses and yards that goes with poverty. But the people are wonderful—knowing. The landscape and the river difficult to photograph but interesting. In short, a problem and a challenge. Some days we come home . . . full of discouragement about what our eyes have seen. However, I begin to work and the next weeks will be full ones."

Some time later, Strand wrote to explain the feelings the village had evoked: "Finally I did what has been on my mind to

do for so many years—a portrait of a small community, men and women, all ages—different kinds of work—kids—the works. And such wonderful people! When we left it was with feelings akin to the time I spent in Alvarado, years ago. Even in the five weeks we were up and down the main street, coffee in the local cafe, all the little country roads, you get to know people and begin to be part of the life just a little."

The Strands moved on in 1954 to the Outer Hebrides to work on a book with Basil Davidson, who wrote the text. Some eight years after his visit, a BBC broadcast told of Strand's stay: "The man with the camera was the guest of a hospitable race. His record is of their integrity, of the truth of a pattern of life, seen with the artist's precision. . . .

"Here are souvenirs of a pilgrimage, bright curios of a seafaring son—and plates that go back three generations—a Granny's wedding set, now veined and cracked as her old hands, with the brown mottle of age on them. Once they pumped water and scrubbed. They knitted and wove and plaited hair, and knew the rough texture of spade and peat-creel. But they have grown in dignity with the wrinkles and with the rheumatic joints . . . In Uist there are no old folks homes—the past is honored with the present . . .

"Not all are old. Strand caught the children, too, in his camera's eye—here is a girl, large-eyed and timid. A button torn from the coat and a worried air of self-possession. A boy—a Uist Dick Whittington, with a nose as speckled as a gull's egg. He dreams, maybe, not of London but of the sea—so near that he can hear the boom and swish of it night and day"

Basil Davidson followed the Strands somewhat later to the Hebrides to complete his interviews: "As a preliminary report let me record that you and Hazel are well-remembered here, as a good many interviews have testified," Davidson wrote the Strands. "The photographs you sent have been much admired.

"Now on first arriving here I felt strongly that I should not be able to do a good job

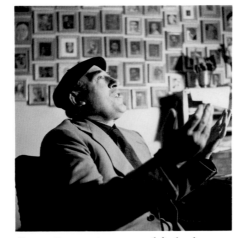

Cesare Zavattini was one of the leading Italian Neo-Realist writers and the village pictured in Un Paese *was his birthplace.*

Strand photographed the hands of Kate Steele in 1954 as part of his book project on the Outer Hebrides.

for you because it seemed to me—it still does—that this is an old and complicated culture, and that for anyone to attempt to describe it after a brief acquaintance would be an impertinence . . . So I talked at length to Dr. McLean—an excellent and hospitable man, just as Hazel said in her notes . . . I have met and talked with some of Hazel's 'starred persons': Skipper MacKinnon of the *Virgin;* Archie and Mrs. Archie Macdonald . . . Murdoch MacRury of Stonebridge . . . I have listened to tape recordings of Mrs. Archie and Mrs. Archie's mother, and of the traditional singers . . . I have chatted with a good many chance people, have walked the hills of Uist, have been on Eriskay and of course Benbecula, and have got a good hold, I believe, of the smell and texture of the place

"What a remarkable culture it is! To hear Mrs. Archie's mum, who says she is 'either 82 or 93, I'm not sure which,' singing archaic Gaelic songs first composed in the third century A.D.—*that* really is a thrill. This must be the oldest living culture in Europe—one of the oldest in the world. And it is true, as you may know, that these old songs stop with Mrs. Archie's generation. To that extent, dear Paul and Hazel, you really were 'just in time.' . . ."

In a letter to Minor White protesting the request that he donate some of his prints for a traveling exhibition in Indochina, where in the ongoing war they might well be destroyed, Strand wrote: "I cannot help but express astonishment that Eastman House is proposing and organizing such a project; that after all the years of struggle to establish the dignity and value of photography as an art form, the only museum wholly devoted to photography, and largely this aspect of photography, should be the one to advance the concept (new to me at least) of the 'expendable' print. . . .

"Personally I find myself compelled to reject this concept of expendability. Other ways, not at the expense of the artist and his work, must be found, of bringing American photography to the rest of the world. Other means which do not degrade

but rather help establish *photography itself* as a serious medium of expression that produces works which are meant to endure and, as such, merit the minimal respect of being cared for accordingly."

Strand also explained to White his ideas for a new French project: "This book will present a cross section of the people of France—the scientists who work on basic problems of a modern society, the workers who build the material base of the nation, the farmers who supply its food, the artists who make . . . French culture known to the farthest corners of the earth; in short, the fabric of a nation."

He explained his technique: "It was a challenge . . . Usually, we went wherever they were . . . I set up a project to cover a whole area of French culture—painting, music, film, theatre—we even thought of bicycle racers . . . because it would be very interesting to have a record of that kind of contemporary life, just as Nadar made about 1856/7. With very simple auxiliary lighting, just a few lamps, with Hazel's help, because I couldn't have done it alone . . . We would barge into somebody's house and I would have to make a portrait of somebody I had never seen before, didn't always know too much about, and without any mystical waiting for the spirit to move or understanding to come—it's just something to be done quickly, directly, and without any fooling.

"Usually I take people into the shade somewhere. I am not interested in lighting as such. After all, you see people in a very soft and normal light; you don't see them with a big smash of light on the side of their face or back-lit, or any of that sort of thing. People don't live in that kind of light; either they're out in the sun on the beach somewhere or else they're in a very soft light indoors.

"My basic philosophy is: anything is all right in photography if you get away with it. I have no objections if somebody wants to make prints standing on his head; it's perfectly all right. I don't mind printing in clouds if they can fool me; I accept those clouds.

"I don't like the 35mm camera—I would like to have a camera that doesn't exist, which should be about two-and-a-quarter by three-and-a-quarter, minimal size, with an eye-level pentaprism, so that you don't work from your stomach (the navel-eye view), but from eye-level. . . . And then somebody should really put their brains to work technically on how to make a release that would move the camera as little as possible—a shutter release and a shutter that don't shake the camera. And if you had all that, you'd have a very, very valuable instrument.

"I take three cameras now: an eight-by-ten, a Deardorff which I bought during the war, a five-by-seven, and a little camera, a two-and-a-quarter by two-and-a-quarter . . . not just that you have something that you can lug around when you get too old, but there are things that you cannot do with big cameras. On the other hand, I wouldn't want to do certain things with a small camera that should be done with a large camera. The Graflex is the one I use the most. I do all my portraits with it; I do all my landscapes with it. It has a special shutter that no other Graflex ever had. In this Graflex you get the full aperture of the film in the curtain. On the other Graflexes the largest aperture is a slit about so wide, but in this model the whole thing goes by, and it's marvelous because for landscapes you can stop down to f/45 sometimes, and for portraits I can stop down to f/32. With a fast film there is no problem of exposure, because this full opening of the shutter at the lowest tension is supposed to be around one second. It's not quite one second; it's about a half a second anyway . . . So it's an extremely valuable camera, and I have never seen anything like it in a reflecting-type camera. I would use a five-by-seven view camera with revolving swing-back and swing-front for straightening lines."

In Orgeval, a small village outside of Paris, Strand bought a house in 1955 and set up a studio. He wrote Beaumont Newhall: "There is so much new work you have not seen . . . There is, for instance, a series in Italy, all parts, not in the Italian

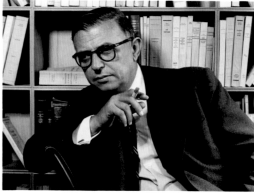
Jean-Paul Sartre, from the series of portraits of French cultural figures.

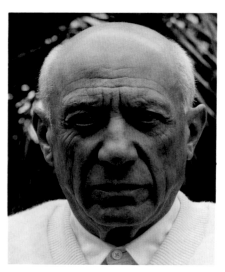
Strand photographed Pablo Picasso in Cannes-sur-mer in 1956—the artist who was one of the major influences on his early work.

book. There is the whole group from the Hebrides . . . a group of things I have also done in the garden. And the portraits from the work on the new book in France. The latter is a real D.O. Hill project—in some ways much tougher than he had it, although the exposure time is shorter.

"You will be interested to know that after forty years of contact printing I bought an enlarger last winter, a very fine one. I wanted to experiment with size, what it might add without undue loss of quality. After all, that is what I told my class in New York to do, so I thought it time to follow my own advice. The very early work, *Blind Woman, Wall Street,* etc., were all considerable enlargements from three-and-a-quarter by four-and-a-quarter. Now I go so far only from five-by-seven to eight-by-ten. Later I will see what happens up to eleven-by-fourteen. . . ."

In 1959 the Strands photographed in Egypt for the book *Living Egypt,* with the text contributed by James Aldridge. A reporter for a Cairo newspaper wrote: "Paul Strand, an American photographer, came to Egypt to make a book of photographs from a new point of view. He was more than 68 years old, but he had the unusual vitality of a student and was a devoted observer of nature and the life of the people.

"He came to photograph a book about living Egypt because the photographers had exhausted the temples and the face of the sphinx. He wanted to photograph the unknown here in Egypt, that is, the common man—the man in the street, in the village, and in factories.

"The source of his inspiration since the beginning of his artistic life was, for this man of the epoch, the hidden beauty of the ordinary simple people and the poetry of everyday life.

"In the hands of an artist, the camera can express all these, perhaps more than the other arts. It can penetrate to the secrets of nature and to the depth of people's lives, both of individuals and of nations. . . .

"He came with his wife and his car and traveled for two months from Alexandria to Aswan and photographed the villages, the factories, the institutions, and the museums, and he had discussions with all ranks of people. When his visit came to an end, he expressed his feelings: 'Egypt is something different, so my book will be something different.' Before he left Cairo he told me, 'I will return—I didn't drink enough water from the Nile.' "

Aldridge wrote in his introduction to *Living Egypt:* "It is Egypt *now* that counts for the Egyptians, not Egypt as it was. The western world wants the ancient temples preserved, the cultural legacy of Egypt saved; it is not only Egypt's heritage but ours.

"In this context the Aswan Dam sets us a civilized problem. When it is finished, it will flood a valley of unexcavated tombs and, in particular, the wonderful temple of Abu Simbel will be submerged. When the Egyptians decided to go ahead and build the dam, the heart and soul of western civilization immediately gathered together—not to build the dam but to save the temple. This is, perhaps, not quite the answer the Egyptians want of civilization, although it is probably the answer they expected. So we ask ourselves, Where does our sentiment end and this new Egyptian future begin?"

The portrait occupied Strand more and more. In 1960 he said: "When you make a portrait, you bring to it not just a momentary vision but an understanding of people and an understanding of life and your outlook on that human being and where he is in life. When you sum him up, it's not just life you are discussing; it is your comment on life, a comment which for me has been seventy years in the making. I suppose it is the same kind of totality that Rembrandt brought to bear when he painted a portrait or Cézanne when he painted a landscape. It's that depth of perspective, that understanding, that feeling, and the ability to tie all these things together in a visual whole which makes for art. . . .

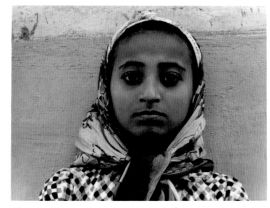

Shaheenazee Tourkee, Sawyet Garawan, Delta, Egypt, 1959. *Hazel Strand kept careful records of the names of everyone Strand photographed.*

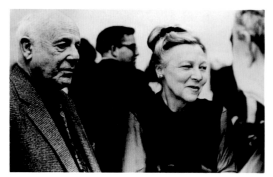

Paul and Hazel Strand attended the opening of the Dorothea Lange exhibition at The Museum of Modern Art in 1966.

"I'm one of those who believes that society owes the artist a living. I think that society owes everybody a living who performs useful work, and I think that when society says to an artist—whether he is a photographer or a painter or a sculptor—that what you do is beautiful, then society owes that person a living because that's saying it is useful. Because actually what society is saying is that your investigations are good enough to bring forth things, that you are creating things in our time which reveal that time to us and make it more vivid, which tell us the meaning of life. That's why it happens so frequently that somebody will say to me that I see things through your photographs; you show me things that I never noticed before, that I never saw before. . . .

"Nature itself and the world which has been created by nature and by men is far more rich and far more complex than any work of art. That isn't to say that the work of art is meaningless; on the contrary, the work of art that begins to extract the significance of this complex life is a great thing. That is the thing which has value for people now and in the future. . . .

"Photography became an art when the first artist used photography. There is nothing theoretical about it. When D.O. Hill made the first good portrait, that was it."

Talking with an interviewer in 1962, Strand explained further his ideas of the portrait: "I work with Picasso, for instance, and he has to go to lunch and I have to go to see Herriot, so after I've made a certain number of pictures, he says, 'You got enough?' So I say 'yes,' but actually I would like to do much more with Picasso, but there isn't any time. I didn't like the way he was dressed, but I didn't want to say, 'change into your old work clothes,' when he was about to go to somebody's for lunch. You have to accept the situation you are faced with and make the best of it.

"Do you remember in the Italian book the old man who is all twisted like a twisted vine? He was in a poorhouse. There are two pictures in that book that were made in the local poorhouse. The only way I could make them was with a prism. I suppose I could have asked, but that would have been awkward. So I made them that way. He is dead now, that old man. I think it's an image, in a way, if my photographs are what I hope they are, an immortal image of an old man who is now dead and who was in a poorhouse. If one thinks, the idea of a portrait has almost disappeared. The last people who made portraits were Cézanne, Van Gogh and of course Picasso."

About the artist and society, Strand said: "I wrote to a young photographer yesterday . . . I'm not impressed at all with the kind of art or artists that just go out and do the sort of thing they like and that appeals to them. There's much too much of that. It's unfortunate, I think, that in our society things are not asked for more explicitly from the artist, and that he is left so much to himself, and so tends to give much more importance to his own reactions and his own whims and his own likes and dislikes than they deserve."

And further: "I am not very sympathetic to the idea that the artist only does things in order to satisfy something in himself, in which his personality and the gratification of his personality becomes the focal point of why he works. I find that a very dead end for art because, from my point of view, life itself is much more interesting and much more complex than art, just as life is much deeper and more complex than science. Science is the process of understanding this enormous complexity of the world in which we live. There is a relationship between the artist and the scientist. Certainly no one would deny that the scientist is an explorer—that is the very basic nature of his activity; and I contend that if the artist is not also an explorer in his particular terms, he is not much of an artist, and what he does is not of any great value. . . .

"Did I express my personality? I think that's quite unimportant. An artist expresses himself only as a by-product. It's of no importance whether he expresses himself, because it's not people's selves that are important, but what they have to say about life that's important."

The Strands in 1962 began a photographic project in Morocco: "They don't like being photographed . . . That's why you need an interpreter. You need to explain to people why you are photographing. After all, if they object, they have every right to object. Supposing somebody came up and pushed the camera in your face? You might not like it. Or if they walked into your front garden and started photographing your house without even saying, 'May I?' It's necessary to have an interpreter who can explain that you're not going to make picture postal cards and you're not going to make money out of them, because they are very, very poor people"

On the eve of his retrospective show at the Philadelphia Museum in 1971, Strand told an interviewer: "There's no problem really about work. There's so much that can be done in the world that has hardly been scratched. If formal problems are the primary interest, then you have to dig out of your imagination to a large extent. But if subject matter is the primary interest, it is so variegated and absolutely inexhaustible, differing specifically from place to place—and each place has its own personality. It's an inexhaustible world. And I would say that very little of it so far has been photographed. People have made photographs almost everywhere in the world. But they certainly have not photographed everywhere in the world what is really there with any degree of finality."

Adam in the Garden, I am to new name all the beasts in the field, and all the gods in the sky. I am to invite men drenched in time to recover themselves and come out of time, and taste their native immortal air. I am to fire with

what skill I can the artillery of sympathy and emotion. I am to indicate constantly, though all unworthy, the Ideal and Holy Life, the life within life, the Forgotten Good, the Unknown Cause in which we sprawl and sin. I am to try the magic of sincerity, that luxury permitted only to kings and poets. I am to celebrate the spiritual powers in their infinite contrast to the mechanical powers and the mechanical philosophy of this time. —Ralph Waldo Emerson, *Journals*, quoted by Nancy Newhall, *Time in New England*

All visible objects, man, are but as pasteboard masks. But in each event—in the living act, the undoubted deed—there, some unknown but still reasoning thing puts forth the mouldings of its features from behind the unreasoning mask. If man will strike, strike through the mask! How can the prisoner reach outside except by thrusting through the wall? —Herman Melville, *Moby Dick*, quoted by Nancy Newhall, *Time in New England*

VII
STRAND'S DOORSTEP
1969–1976

In 1968 the Strands made their last photographic expedition to Rumania, ending Strand's portrait of the world. Working steadily at Orgeval, he returned to the full course of his work—sorting out negatives and choosing or making prints that represented his vision. With Michael Hoffman, the publisher of Aperture, he began to prepare a two-volume retrospective monograph and a comprehensive exhibition of his work at the Philadelphia Museum of Art. "I have been printing early negatives," he wrote in a letter to a friend; "I would like eventually to have a print or two of everything worth the effort . . . Went to a nearby pool when the Aldridges were here and did my first jackknife of my 79th year—Jimmy said, 'Yes, you can still do it.' Set me up no end . . . This week Hazel and I put the second volume of the monograph in four of those handsome

Strand began to photograph the garden of his house in Orgeval in the mid-fifties.

binders. It weighs a ton (172 prints and text), but it looks all right . . . At the same time I have been printing—a start only—for the show—going through many old negatives . . . I want the show to be as rich and complete as possible."

"Making prints doesn't prevent me from continuing to make photographs in my back garden in Orgeval if I see something that I feel I want to photograph," Strand said. "When I was much younger people used to say to me, 'How do you pick out the subjects that you photograph?' My answer always was, 'I don't pick them out; they pick me out.' And that kind of interrelationship continues. If I see something in the garden—and I'm getting lazier all the time about big cameras—and I think, oh, dear, I don't want to lug that great big eight-by-ten camera out there. It's the damn thing that's there, though, that makes me want to do it, that insists you must, you must do it. So sometimes I succumb and it gets the better of my innate laziness.

"I go and get the camera and do it. Photography is a medium in which if you don't do it then, very often you don't do it at all, because it doesn't happen twice. A rock will probably always be more or less there just the way you saw it yesterday. But other things change; they're not always there the day after or the week after. Either you do it or you don't. Certainly with things as changeable as sky and landscape with moving clouds and so on, if they look wonderful to you on a certain day and if you don't do it then, you may never see them again for the rest of your life. So as a photographer you become very conscious—at least I do—that everything is in movement."

Looking back through his boxes of prints and negatives, Strand reflected on the changes that had come to the landscapes he had photographed. About Maine, he wrote Van Deren Coke: "I think it would

be interesting to compare the new photograph of Harrington, Maine, which I made in 1970, with the photograph *Village in a Salt Marsh.* How did this photograph of the identical spot happen? We were driving to Cape Split from Prospect Harbor to visit Susan Thompson and John Marin, Jr., and out of the corner of my eye I saw this group of houses and a white church looking very familiar and attractive. I asked the driver to please stop, and taking my hand camera, I got out and walked over and found myself at the corner of a bridge overlooking the marsh—now more of a river than a marsh—and this view of Harrington, virtually unchanged after twenty-four years.

"Of course, I realized right away that this was almost the same spot from which I had photographed in 1946. It tells something about time and New England and how unchanging, in some cases, New England is. Of course, it is also interesting to see the difference in handling the same subject matter after twenty-four years, this time with a hand-held camera."

As a result of that visit, Strand received a letter from Susan Thompson, one of his most famous subjects, whom he had first met in 1936: "It was good to see you again after so many years and it is a privilege to know the very famous Paul Strand and we like him and so did we always when you with John Marin used to make evening visits to our house after the milking; you were both so much fun."

Strand worked on in spite of his age. He supervised work on two portfolios and, because of their enthusiastic reception, started two more. Often, he would lovingly caress the pages of his books, the legacy of his work. Summing up his accomplishment, Strand wrote in the introduction to *The Garden* portfolio: "The critical moment for the photographer is the moment of seeing, a creative act which involves the perceiving of the subject to be photographed in the first place and the photographing of it in the last place. Between these two actions there is elasticity as to how long the moment may last or what it includes from the artist's point of view.

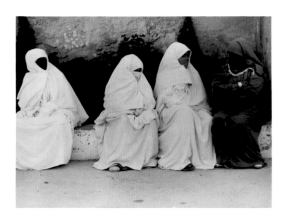

Four women, Essaouira, Morocco, 1962.

Strand varnishing his completed prints in the Orgeval atelier.

"The decision as to when to photograph, the actual click of the shutter, is partly controlled from the outside, by the flow of life, but it also comes from the mind and the heart of the artist. The photograph is his vision of the world and expresses, however subtly, his values and convictions.

"Sometimes the artist's vision is concerned with the evanescent, with things that pass, oddities and exceptional happenings of life in movement. Then, the moment is decisive. A second later, and the essential relationship of objects within the frame will have shifted. The significance of the event lies in an instant's equilibrium between the temporary and the enduring.

"Yet photography is not limited to such moments of immediate insight. Its tempos change according to the photographic problem. A rock hammered year after year by the sea, slow-growing plants, an architectural feature or landmark, weathered by many winters—such things permit long periods of reflection in which to decide what part of the object will be included or excluded; in other words, selection becomes the arbiter of content. Even here, immediacy can be valuable once the problem has been understood and resolved. One may put off the moment of photographing from three o'clock today to three o'clock tomorrow, only to find something has changed that can never be recovered.

"The moment of seeing can also be a moment of revelation for the artist himself. Such moments are closely related to those of the scientist when he discovers his hypotheses concur with the structures and organizations of nature, either by a lucky chance or as a result of patient research. In art as in science, both chance and research contribute to opening new dimensions of harmony for man within his environment.

"One of the most visionary scientists I have known was Harlow Shapley, the great American astronomer. We met in the forties, when he was national chairman of the Peace Organization, grouping arts, sciences and professions, and I was chairman of its Arts Division. In his book *Beyond the Observatory,* he wrote: 'Continually our eyes are opened wider, the depth of our vision is increased. We see the stars evolve, the planetary surfaces like that of our earth change with the flowing of time. We learn that primitive plants and elementary animals develop through the ages into complicated organisms, including those with high sensitivity to their environment. Man, too, has evolved and so have his social organizations. Why, then, should we not expect the penetrating urge toward change that permeates the universe to include the growth of men's groping philosophies? The answer is that we do expect it; to some extent we witness it. And we note that evolution itself evolves.'

"To come on this quotation by chance was like an encounter with my late friend, who as a scientist was saying things such as I have tried to express through photography over sixty years."

In December 1975, four months before his death, Strand wrote in the introduction to the *On My Doorstep* portfolio of eleven prints: "The photographs in this portfolio, made at different epochs over sixty years, summarize the relationship I have had as an artist throughout my life with the material I photograph . . . rather than a linear record, they should be seen as a composite whole of interdependencies. . . .

"Finally it can be seen that what I have explored all my life is the world on my doorstep . . . The material of the artist lies not within himself nor in the fabrications of his imagination, but in the world around him. The element which gives life . . . is the relationship of artist to content, to the truth of the real world. It is the way he sees this world and translates it into art that determines whether the work of art will become a new and active force within reality, to widen and transform man's experience.

"The artist's world is limitless. It can be found anywhere, far from where he lives or a few feet away. It is on his doorstep."

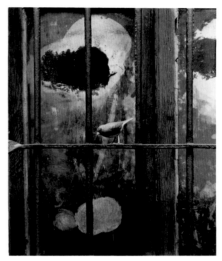

With insufficient strength remaining to set up the camera himself, Strand made his last photograph in the backyard of his apartment at Fifth Street and Second Avenue. Strand placed the wooden bird on the bars of a window of an adjoining house and called the photograph Bird on the Edge of Space.

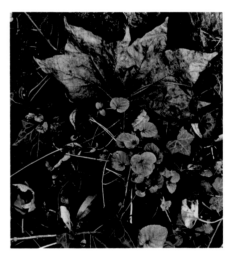

One of Strand's last garden photographs. Strand thought the arrangement of leaves and plants resembled an honorary decoration. Hence the title, Legion d'honneur des Forêts.

SOURCES

I

1. p. 142, "I had a . . .": conversation with Naomi Rosenblum, n.d.
2. p. 142, *Trees* had been . . .": *ibid.*
3. p. 142, "Took picture after . . .": Strand, letters to his parents, March 26 to May 13, 1975.
4. p. 142, "Have you been . . .": Nathaniel Shaw, letter to Strand, n.d.
5. p. 142, "Tried to convince . . .": *ibid.*

II

1. p. 143, "Was it a . . .": Strand, "What was 291?", October 1917, pp. 1, 8.
2. p. 143, "The reality of . . .": Strand, letter to Van Deren Coke, March 27, 1968.
3. p. 143, "Been walking in . . .": Strand, letters to his parents, April 15, 1915 to May 3, 1915, collection of Hazel Strand.
4. p. 143, "Sheeler and I . . .": Strand, conversation with Naomi Rosenblum, July 2, 1975.
5. p. 144, "I would say . . .": Strand, interview, Philadelphia, 1971.
6. pp. 144–145, "The work that . . .": Strand, transcript of interview with Milton Brown and Walter Rosenblum, November, 1971, for the Archives of American Art, The Smithsonian Institution, pp. 1–6.
7. p. 145, "The experimentation was . . .": Strand, letter to Walter and Naomi Rosenblum, n.d.
8. p. 145, "*Camera Work* proofs . . .": Stieglitz, letter to Strand, August 31, 1916, Paul Strand Collection, Center for Creative Photography, University of Arizona.
9. p. 145, "For ten years . . .": Stieglitz, *Camera Work* 1916, no. 48, pp. 11–12.
10. p. 145, "At the Photo-Secession . . .": Royal Cortissoz, New York *Tribune*, March 19, 1916.
11. p.145, "Something—somehow—seems . . .": Strand, letter to Stieglitz, July 3, 1917.
12. p. 146, "Photography, which is . . .": Strand, "Photography," *Seven Arts*, August 1917.
13. p. 146, "A man can . . .": Strand, interview with Brown and Rosenblum.
14. p. 146, "A conscience will . . .": Strand, letter to Stieglitz, November 3, 1918.
15. p. 146, "The first thing . . .": Strand, interview with Brown and Rosenblum, p. 11.
16. p. 146, "I couldn't have . . .": Strand, letter to Peter Bunnell, July 9, 1968.

III

1. pp. 147–148, "When I got . . .": Strand, interview with Brown and Rosenblum, pp. 11–17.
2. pp. 148-149, "One day I . . .": Strand, interview with Brown and Rosenblum, pp. 8-9.
3. p. 149, "At a time . . .": Robert Allerton Parker, "The Art of the Camera, An Experimental Movie," *Arts and Decoration*, vol. 15, October 1921, p. 369.
4. p. 149, "For it is . . .": Strand, "Photography and the New God," *Broom*, November 1922, pp. 255–356.
5. p. 149, "I wish you . . .": Strand, letter to Stieglitz, July 4, 1922.
6. p. 149, "The Akeley was . . .": Strand, letter to Van Deren Coke, July 1967.
7. pp. 149–150, "We are not . . .": Strand, "Photography and the New God," *Broom*, November 1922, pp. 257–258
8. p. 150, "Mr. Strand, working . . .": *New York Times Book Review and Magazine*, September 10, 1922.
9. p. 150, "So you've done . . .": Stieglitz, letter to Strand, July 3, 1922, Paul Strand Collection, Center for Creative Photography, University of Arizona.
10. pp. 150–151, "The facts about . . ." : Strand, letter to *The Arts*, June 1, 1923.
11. p. 151, "You speak of . . .": Strand, letter to John Tennant, *The Photo-Miniature*, May 18, 1923.
12. p. 151, "Here in this . . .": Strand, unpublished manuscript on Georgia O'Keefe, late 1922 or early 1923, Paul Strand Collection, Center for Creative Photography, University of Arizona.
13. p. 151, "This exhibition is . . .": Stieglitz, announcement for "Seven Americans," Intimate Gallery, 1925.
14. p. 151, "Mr. Paul Strand . . .": Forbes Watson, New York *World*, March 15, 1925.
15. p. 151, "I have been . . .": Strand, letter to Stieglitz, September 20, 1926.

IV (continued)

16. p. 152, "It was the . . .": Strand, letter to Stieglitz, July 13, 1926.
17. p. 152, "In 1927–1928 . . .": Strand, interview, with Brown and Rosenblum, pp. 18–21.
18. p. 152, "There are two . . .": *ibid.*, p. 21.
19. p. 153, "I continued to . . .": *ibid.*, pp. 23–24.

IV

1. pp. 153–154, "I hung the . . .": Strand, conversation with Naomi Rosenblum, n.d.
2. p. 154, "It is rather . . .": K. G. S., *The New York Times*, n.d.
3. p. 154, "His first in . . .": Elizabeth McCausland, *The Springfield Republican*, 1932.
4. p. 154, "Over a score . . .": *ibid.*
5. p. 154, "The day I . . .": Harold Clurman, letter to Strand, November 21, 1932.
6. p. 154, "The difference between . . .": Clurman, letter to Strand, March 30, 1934.
7. pp. 154–156, "I went to . . .": Strand, interview with Brown and Rosenblum, pp. 25–30.
8. p. 156, "It is not . . .": Report on Children's Exhibition, n.d. Paul Strand Collection, Center for Creative Photography, University of Arizona.
9. pp. 156–157, "One day Chávez . . .": Strand, interview with Brown and Rosenblum, pp. 30–37.
10. p. 158, "When I came . . .": Strand, *ibid.*, pp. 38–39, 40, 49.
11. p. 158, "Strand has now . . .": Joseph Losey, "Famous U.S. Photographer in Moscow," *Moscow Daily News*, May 17, 1935.
12. pp. 158–160, "When I came . . .": Strand, interview with Brown and Rosenblum, pp. 41–45, 47–51.
13. pp. 160–161, "In 1940, Lee . . .": *ibid.*, pp. 60–64.

V

1. p. 161, "*Native Land* represents . . .": Strand, statement for press conference at the National Press Club before the screening of *Native Land*, 1942, Paul Strand Collection, Center for Creative Photography, University of Arizona.

2. pp. 161–162, "In 1942, I . . .": Strand, conversation with Naomi Rosenblum, n.d.

3. p. 162, "Strand's 'script' had . . .": Strand, typed outline with notes for Roosevelt mural, "Tribute to the President," Paul Strand Collection, Center for Creative Photography, University of Arizona.

4. pp. 162–163, "In 1944 I . . .": Strand, interview with Brown and Rosenblum, pp. 58–59, 65–66.

5. pp. 163–164, " Subject matter is . . .": Strand, lectures at the Chicago Institute of Design, July 30–31, 1946, pp. 79–81, 82–83.

6. p. 164, "I have been . . .": ibid., August 1, 1946, pp. 87–88, 91.

7. p. 164, "The people have . . .": Strand, speech delivered at the Czechoslovakia Film Festival, Marianske Lazne, Czechoslovakia, July 1949.

8. p. 164, "I begin with . . .": Strand, speech delivered at the International Congress of Cinema, Perugia, Italy, September 24–27, 1949. Paul Strand Collection, Center for Creative Photography, University of Arizona.

VI
1. p. 165, "It's not always . . .": Strand, interview with Brown and Rosenblum, pp. 66–68.

2. pp. 165–166, "What characterizes Paul . . .": Roy, introduction to La France de Profil, 1952.

3. p. 166, "I am very . . .": Strand, interview with Brown and Rosenblum, pp. 68–69.

4. p. 166, " In 1953, when . . ."; Zavattini, introduction, Un Paese, 1955.

5. p. 166, " Well here we . . .": Strand, letter to Walter Rosenblum, Guastalla, Reggio Emilia, April 9, 1953.

6. pp. 166–167, "Finally I did . .": Strand, letter to Walter Rosenblum, Paris, May 25, 1953.

7. p. 167, "The man with . . .": transcript of BBC program, "Looking at Uist," December 5, 1962.

8. p. 167, "As a preliminary . . ." : Davidson, letter to the Strands, April 26, 1960.

9. pp. 167–168, "I cannot help . . .": Strand, letter to Minor White, March 11, 1956.

10. p. 168, "This book will . . .": ibid.

11. p. 168, "It was a . . .": Strand, interview with Katz, reel 3, side 2, 1959 or 1960.

12. pp. 168–169, "There is so . . .": Strand, letter to Beaumont Newhall, May 22, 1957.

13. p. 169, "Paul Strand, an . . .": Mohamed Auda, "Love and Understanding," Al Gamhouriya, Cairo, April, 17, 1957.

14. p. 169, "It is Egypt . . .": James Aldridge, introduction, Living Egypt.

15. pp. 169–170, "When you make . . .": Strand, interview with Brown and Rosenblum, 1959 or 1960, pp. 1, 5–6.

16. p. 170, "I work with . . .": Strand, interview with Robert Katz, Orgeval, August 1962, pp. 39–40.

17. pp. 170–171, "I wrote to . . .": Strand, interview with Katz, p. 5.

18. p. 171, "They don't like . . .": Strand, interview with Katz, p. 20.

19. p. 171, "There's no problem. . .": Strand, interview, Philadelphia, 1971.

VII
1. pp. 171–172, "I have been . . .": Strand, letter to Walter Rosenblum, August 1, 1969.

2. p. 172, "Making prints doesn't . . .": Strand, interview with Jan Naar, Infinity, February 1973.

3. p. 172, "I think it . . .": Strand, letter to Van Deren Coke, March 31, 1975.

4. p. 172, " It was good . . .": Susan Thompson, letter to Strand, February 16, 1972.

5. pp. 172–173, "The critical moment . . .": Strand, introduction to The Garden portfolio, December 1975.

6. p.173, "The photographs in . . .": Strand, introduction to On My Doorstep portfolio, December 1975.

CHRONOLOGY

1890 Born in New York City of Bohemian descent.

1907 At Ethical Culture High School, joined the class of Lewis Hine, who took his class to the little gallery of the Photo-Secession at 291 Fifth Avenue.

1909 Graduated Ethical Culture School. Continued photographing on weekends, and joined the New York Camera Club.

1911 First glimpse of Europe during a brief journey.

1912 Set up as commercial photographer. Experimented with soft-focus lenses, gum prints, enlarged negatives.

1913–14 Occasional visits to the Photo-Secession to see exhibitions and to show photographs to Stieglitz for criticism. Began to feel the influence of Picasso, Braque, Brancusi, and others seen at 291 and the Armory Show.

1915 Brought a folio of new works to the Photo-Secession to show Stieglitz. Stieglitz accepted them enthusiastically and promised to show them at the gallery and to publish them in Camera Work.

1916 First publication in Camera Work, no. 48. Close working relationship with Alfred Stieglitz. First Strand one-man show at 291, March 13–28.

1917 Publication in last issue of Camera Work, no. 49–50, devoted to Strand's new works. Began close-ups of machine forms.

1918–19 In the Army Medical Corps, worked as x-ray technician at Hospital 29, Fort Snelling, Minnesota, and became interested in surgical techniques. Upon release from Army, took short trip to Nova Scotia, where he photographed his first landscapes and close-ups of rock formations.

1921 Made film, Manhatta, with Charles Sheeler, which was shown at Capitol Theatre in New York under title, New York the Magnificent.

1922 Bought an Akeley motion picture camera and began to work as freelance Akeley specialist. Continued still photographs of machines, including the Akeley camera itself. Married Rebecca Salsbury.

1923 At invitation of Clarence H. White, delivered lecture at the Clarence H. White School of Photography in New York, which was subsequently printed in British Journal of Photography.

1925 "Seven Americans" exhibition at the Anderson Galleries, New York, March 9–28, with Charles Demuth, John Marin, Marsden Hartley, Georgia O'Keefe, Alfred Stieglitz, and Arthur Dove.

1926 To Colorado and New Mexico in summer. Photographed tree-root forms and Mesa Verde cliff dwellings.

1927–28 Summered at Georgetown Island, Maine, near close friends, sculptor Gaston Lachaise and Madame Lachaise. Took extreme close-ups of plants, rocks, and driftwood.

1929 One-man show at The Intimate Gallery, New York, March 19–April 7. To Gaspé in the summer. First interpretation of a locality. Also Strand's first attempt to integrate a landscape, to find the relationship and unity of land and sky.

1930–32 To New Mexico in the summers. Continuation of research of the landscape problem in clouds, adobe architecture, ghost towns. Strand's marriage dissolves.

1932 Exhibited with Rebecca Strand at An American Place, New York, April. Then further work in New Mexico.

1932–34 To Mexico. Series of *bultos*, and "candid" portraits of Indians. One-man show at Sala de Arts, Mexico City, February, 1933. Appointed chief of photography and cinematography, Department of Fine Arts, Secretariat of Education of Mexico. Photographed and supervised production for the Mexican government of film *Redes*, released in the United States as *The Wave*.

1935 To Moscow to join the Group Theater directors Harold Clurman and Cheryl Crawford on a brief trip. On return to the United States, photographed with Ralph Steiner and Leo Hurwitz, *The Plow That Broke the Plains*, produced for the Resettlement Administration and directed by Pare Lorentz.

1936 To Gaspé in summer. Made new Gaspé series. Married Virginia Stevens.

1937–42 President of Frontier Films, a non-profit educational motion picture production group in which Leo Hurwitz, Lionel Berman, Ralph Steiner, Sidney Meyers, Willard Van Dyke, David Wolf, and others were associated.

1938–40 With Leo Hurwitz edited *Heart of Spain*, first Frontier Films release. Portfolio of hand gravures, *Twenty Photographs of Mexico*, published in New York by Virginia Stevens.

1942 *Native Land* released, a Frontier Film, photographed by Strand and co-directed by Strand and Leo Hurwitz.

1943 Did camera work on films for government agencies. As chairman of the Committee of Photography of the Independent Voters Committee of the Arts and Sciences for Roosevelt, edited exhibition at Vanderbilt Gallery, Fine Arts Building, 57th Street, New York City.

1943–44 To Vermont. Return to still photography after ten years in film work.

1945 One-man show, The Museum of Modern Art, New York, April 25–June 10. Guest of President and Mrs. Roosevelt with 250 American scientists, artists, and writers at lunch in the White House and at the inaugural the following day.

1946–47 Travels in New England, working on a book with Nancy Newhall, subsequently published as *Time in New England*.

1949 Invited to Czechoslovakia Film Festival in July at which *Native Land* was awarded a prize.

1950 To France to begin work on a book subsequently published as *La France de Profil*, text by Claude Roy.

1951 Married Hazel Kingsbury. As new book projects develop, France becomes home and center of work.

1952–53 Makes photographs of Italy, some of which were later used in *Un Paese*, text by Cesare Zavattini.

1954 To the island of South Uist (Outer Hebrides) to make the photographs for *Tir a'Mhurain, Outer Hebrides*, text by Basil Davidson.

1955–57 Worked on series of portraits of prominent French intellectuals and on close-ups of the Orgeval garden.

1956 Exhibited with Walker Evans, Manuel Alvarez Bravo, and August Sander in the exhibition "Diogenes with a Camera III," directed by Edward Steichen at The Museum of Modern Art, January 18–March 18.

1959 To Egypt for two-and-a-half months, photography for the book, *Living Egypt*, text by James Aldridge. Brief photographic trip to Rumania.

1962 To Morocco to begin work on a series of photographs and to continue research into Arab life.

1963 Placed on the Honor Roll of the American Society of Magazine Photographers, New York, June.

1963–64 To Ghana at the invitation of President Nkrumah to make a book with text by Basil Davidson.

1965 Nancy Newhall introduces Michael E. Hoffman, publisher of Aperture, to Paul Strand.

1967 Award of the David Octavius Hill Medal by the Gesellschaft Deutscher Lichtbildner in Mannheim, Germany, March. Return to Rumania to complete photographs begun in 1960. Supervision of second printing of *The Mexican Portfolio* produced by Aperture for Da Capo Press.

1969 Exhibition, Kreis Museum, Haus der Heimat, Freital, Germany D.D.R. Exhibition, Museum of Fine Arts, St. Petersburg, Florida, April–May.

1969–70 One-man exhibition organized by Gilbert de Keyser and Yves Auquier for the Administration Générale des Affaires Culturelles Françaises of Belgium, shown throughout Belguim and the Netherlands.

1970 Exhibition of gravures, Stockholm, Sweden, as guest of the Swedish Photographers Association. At the same time, guest of the Swedish Film Archives, which showed *Heart of Spain*, *The Wave*, and *Native Land*. The Strands work with Michael E. Hoffman on selecting and printing photographs for the monograph and Philadelphia Museum of Art retrospective exhibition.

1971 Retrospective exhibition, Philadelphia Museum of Art, November 24, 1971–January 30, 1972. *Paul Strand Monograph*, published by Aperture, in two volumes.

1972 Retrospective exhibition travels to the Museum of Fine Arts, Boston and the City Art Museum, St. Louis.

1973 The Strands visit the U.S. for the opening of the retrospective exhibi-

tion at the Metropolitan Museum of Art in New York City and at the Los Angeles County Museum. Strand is operated on for cataracts.

1974 The Calvin Tomkins' profile is printed in *The New Yorker*, September 16, 1974.

1975 Photographs in the backyard of the Fifth Street apartment in New York during the summer. Initiates with Michael E. Hoffman plan to print a series of portfolios. Returns to Orgeval to work on the text of a book on his garden with Catherine Duncan. Prepares and signs prints for two portfolios: *On My Doorstep* and *The Garden*.

1976 *Ghana: An African Portrait* published by Aperture. Strand dies in Oregeval, France. *On My Doorstep* and *The Garden*, two portfolios, are published.

SELECTED BIBLIOGRAPHY

Publications

Adams, Ansel, "A Decade of Photographic Art." *Popular Photography*, 22: 44–46, 158–159 (June 1948).

"An American Photographer Does Propaganda Movie for Mexico." *Life*, 2: 62–65, 70 (May 10, 1937).

Bauer, Catherine, "Photography: Man Ray and Paul Strand." *Arts Weekly*, 1: 193, 198 (May 7, 1932).

Berger, John, "Arts in Society: Paul Strand." *New Society* (London), March 30, 1972, pp. 654–55.

——, "Painting—or Photography?" *The Observer Weekend Review* (London), February 24, 1963, p. 25. Reprinted as "Painting or Photography?" *The Photographic Journal*, 103: 182–84 (June 1963). Reprinted as "Painting or Photography?" *Photography Annual*, 1964. New York, Ziff-Davis Publishing Co., 1963, pp. 8–10.

Boddington, Jennie, "Paul Strand 1890–1976: Milestone in Photography." *Art Bulletin of Victoria*, 18: 33–39 (1977).

Brown, Milton W., "Cubist—Realism: An American Style." *Marsyas*, 111: 139–160 (1943–1945). (See also his *American Painting from the Armory Show*

to the Depression. Princeton: Princeton University Press, 1955).

——, "Paul Strand and His Portrait of People." *The Daily Compass* (New York), December 31, 1950, p. 12.

——, "Paul Strand Portfolio." *Photography Year Book 1963*. London, Photography Magazine Ltd., 1962, pp. xiii–xv, 36–51.

Bunnell, P. C., *Choice*, 29 (3): 433 (November 1991).

Caffin, Charles, "Paul Strand in 'Straight' Photos." *Camera Work*, 48: 57–58 (1916). Reprinted from *The New York American*, March 20, 1916, p. 7.

Cahill, Timothy, "Paul Strand's Imprint on Photography." *Christian Science Monitor*, B5: 1 (July 31, 1998).

Cocks, Fraser, "Paul Strand, The Search for a Usable Past." *History of Photography*, 16 (1): 18–27 (1992).

Crowther, Bosley, "*Native Land*, Impassioned and Dramatic Documentary Film on American Civil Liberties, Presented at the World." *New York Times*, May 12, 1942, p. 16.

Coke, Van Deren, "Talk with Paul Strand, France, Summer 1974." *History of Photography*, 4: 165–9 (April 1980).

Clurman, Harold, "Photographs by Paul Strand." *Creative Art*, 5: 735–738 (October 1929).

"Democracy Fights Back." *Popular Photography*, 10: 50, 80 (February 1942).

Deschin, Jacob, "Diogenes III at Museum." *New York Times*, January 22, 1956, p. X19.

——, "Fine Prints by Strand." *New York Times*, January 18, 1953, p. X15.

——, "Honor for Strand." *New York Times*, April 2, 1967, p. D29.

——, "Paul Strand: An Eye for the Truth." *Popular Photography*, 70 (4): 68–73, 108–111, 176 (April 1972).

——, "Strand Portfolio Again Available." *New York Times*, January 28, 1968, p. D35.

——, "Viewpoint—Paul Strand at 76." *Popular Photography*, 60: 14, 16, 18, 58 (March 1967).

Doty, Robert, *Photo-Secession*, Rochester: George Eastman House, 1960, pp. 62–63.

——, "What Was the Photo-Secession?" *Photography* (London), 17: 18–29 (January 1962).

Dreishpoon, Douglas, "Paul Strand." *Arts Magazine*, 65 (7): 83 (March 1991).

Drohojowska, Hunter, "Modern Convert Paul Strand's Edgy 1916 Photos Focus on Current Predicaments." *San Francisco Chronicle*, Mag 10: 2 (May 31, 1998).

Duncan, Catherine, "Life in Stillness: The Art of Paul Strand." *Meanjin Quarterly* (Melbourne), 28: 565–69 (Summer 1969).

Evans, Walker, "Photography." *Quality*, Louis Kronenberger, ed., New York: Atheneum, 1969, pp. 178–79.

Frampton, Hollis, "Meditations Around Paul Strand." *Artforum*, 10 (6): 52–57 (February 1972).

"Frontier Films." *New Theater and Film*, 4: 50 (March 1937).

Gernsheim, Helmut, *Creative Photography*. London: Faber and Faber, 1962, pp. 149, 152, 160, 172, 180.

Gernsheim, Helmut and Alison, *A Concise History of Photography*. London: Thames and Hudson, 1965, pp. 191–92, 205, 212, 214.

Greene, Charles, "Paul Strand." *New Masses*, 55: 30–31 (May 15, 1945).

Harris, Susan A., "Paul Strand's Early Work: A Modern American Vision." *Arts Magazine*, LIX/8: 116–118 (April 1985).

"Highlands and Islands." *Times Literary Supplement* (London), December 28, 1962, p. 1007.

"Honoring Humanity, Paul Strand." *Documentary Photography*, Life Library of Photography, Time-Life Books, New York, 1970, pp. 132–37.

"The Importance of 'When.'" *The Art of Photography*, Life Library of Photography Time-Life Books, New York, 1971, pp. 51, 113–15.

Jeffrey, Ian, "Paul Strand." *The Photographic Journal* (London), pp. 76–81 (March/April 1976).

Keller, Ulrich, "An Art Historical View of Paul Strand." *Image*, 17 (4): 1–11 (December 1974).

Kleinholtz, Frank. "Paul Strand: Radio Interview." *American Contemporary Art*, 2: 10–13 (May–June 1945).

Koch, Robert, "Paul Strand/*Tir a'Mhurain: Outer Hebrides*." *Aperture*, 11 (2): 80–81 (1964).

Kramer, Hilton, "A Master of the Medium." *New York Times*, December 5, 1971.

"The Letters Between Paul Strand and Ansel Adams." *Archive* 27: 49–104 (1990).

"L'oeuvre de Paul Strand." *Le Nouveau Photocinéma* (Paris), pp. 50, 65–69, 106 (October 6, 1972).

Maddow, Ben, "A View from Below: Paul Strand's Monumental Presence," *American Art*, 5 (3): 48–67 (Summer 1991).

Mann, Margery, "Two by Strand: When the People Draw a Curtain." *Popular Photography*, 65: 90–91, 126 (December 1969).

Martin, Marcel and Marion Michelle, "Un humaniste militant Photographe et Cineaste." *L'Ecran* (Paris), March 1975, pp. 36–45.

Mayer, Grace M., "Paul Strand's *Tir a'Mhurain*." *Infinity*, 12: 21–23, 27 (April 1963).

McCausland, Elizabeth, "For Posterity." *Photo Technique*, 3: 40–42 (January 1941).

——, "Paul Strand's Photographs Show Medium's Possibilities." *Springfield Sunday Union and Republican*, April 17, 1932, p. 6E.

——, "Paul Strand's Series of Photographs of Mexico." *Springfield Sunday Union and Republican*, July 7, 1940, p. 6E.

——, "Paul Strand Turns to Moving Pictures." *Springfield Sunday Union and Republican*, September 6, 1936, p. 5C.

McIntyre, Robert L., "The Vision of Paul Strand." *PSA Journal*, 38 (8): 18–21 (August 1972).

Mellquist, Jerome, "Paul Strand's Portfolio." *The New Republic*, 103: 637–38 (November 4, 1940).

——, "Wine from These Grapes." *The Commonweal*, 33: 147–50 (November 29, 1940).

Naar, Jon, "If the Photographer is Not a Discoverer, He is Not an Artist." *Infinity*, February 1973, pp. 7–14.

Newhall, Beaumont, *The History of Photography*. New York, The Museum of Modern Art, 1964, pp. 114, 117–21, 130–31, 196, 198. (See also earlier editions.)

——, "Paul Strand, Traveling Photographer. *Art in America*, 50: 44–47 (Winter 1962).

Newhall, Beaumont and Nancy, "Letters from France and Italy: Paul Strand." *Aperture*, 2 (2): 16–24 (1953).

——, "Paul Strand." Masters of Photography, New York, George Braziller, 1958, pp. 102–17. Reprinted in *Fotografia* (Prague), 8: 202–04 (June 1960).

——, "Paul Strand, Catalyst and Revealer." *Modern Photography*, 33: 70–75 (August 1969).

——, "Paul Strand: A Commentary on His New York." *Modern Photography*, 17: 46–53, 103–04 (September 1953).

"Obituary." *Art in America*, 64: 152 (May 1976).

"Paul Strand." *American Artist*, 9: 40 (October 1945).

"Paul Strand." *American Photography*, 39: 60 (September 1945).

"Paul Strand." *Current Biography*, 26: 40, 42 (July 1965). (See also *Current Biography Yearbook* 1965, Charles Moritz, ed., New York: H. W. Wilson Company, 1965, pp. 417–19.)

"Paul Strand." *Great Photographers*, Life Library of Photography, Time-Life Books, New York, 1971, pp. 150–53.

"Paul Strand, Photographer, Declines White House Bid." *New York Times*, June 14, 1965, p. 44.

Pollack, Peter, *The Picture History of Photography*. New York: Harry N. Abrams, Inc., 1969, pp. 246, 248, 251–52, 264, 331, 530. (See also earlier edition.)

Rathbone, Belinda, "Portrait of a Marriage: Paul Strand's Photographs of Rebecca." *J. Paul Getty Museum Journal*, 17: 83–98 (1989).

Ridge, Lola, "Paul Strand." *Creative Art*, 9: 312–316 (October, 1931).

Rolfe, Edwin, "Prophecy in Stone (On a Photograph by Paul Strand)." *The New Republic*, 78: 154 (September 16, 1936). Reprinted in his *First Love and Other Poems*. Los Angeles: Larry Edmonds Book Shop, 1951.

Rosenblum, Naomi, "Paul Strand: Modernist Outlook, Significant Vision." *Image*, 33 (1–2): 1–12 (Fall 1990).

Rosenblum, Walter, "Paul Strand." *American Annual of Photography*. Minneapolis: American Photography Book Department, 1951, pp. 6–18.

——, Starting Your Photographic Career." Edna Bennett, ed., *Camera 35*, 8: 30–31, 58–62 (December 1963–January 1964).

Rotha, Paul, *Documentary Film*. London: Faber and Faber, 1936, p. 237.

Rubenstein, Elliot, "Notes on Photography As a Fine Art." *Coloquio*, Artes 54: 46–53 (September 1982).

Sadoul, Georges, *Le cinema pendant la guerre, 1939–1945*. Paris: Editions Denoel, 1954, pp. 170–71.

Smith, Job, "Photography as Art." *New Masses*, 36: 31 (July 9, 1940).

Soby, James Thrall, "Two Contemporary Photographers." *Saturday Review of Literature*, 38: 32–33 (November 5, 1955).

Solomon-Godeau, Abigail, "Formalism And Its Discontents: Photography a Sense of Order." *The Print Collectors Newsletter*, 13: 44 (May/June 1982).

Stettner, Lou, "A Day to Remember: Paul Strand Interview." *Camera 35*, pp. 55–59, 72–74 (October 1972).

——, "Speaking Out: Strand Unraveled." *Camera*, 35: 8, 67 (July/August 1973).

Stieglitz, Alfred, "Our Illustrations." *Camera Work*, 49–50: 36 (June 1917).

"The Talk of the Town." *The New Yorker*, pp. 29–31 (March 17, 1973).

Tompkins, Calvin, "Profiles: Look to the Things Around You." *The New Yorker*, pp. 44–94 (September 16, 1974).

Tosi, Virgilio, "Una Testimonianza." *Photo 13* (Milan), 15/16: 20–25 (August 1972).

Travis, David, "Paul Strand's Fall in Movement." *Museum Studies*, 19 (2): 159, 186–195, 207 (1993).

Turner, J. B., "Viewpoint: Paul Strand." *New Zealand Studio*, 6 (3): 8 (1970/71).

Weaver, Mike, "Paul Strand: *Native Land*." *Archive*, 27: 5–15 (1990).

Weiss, Margaret, "Paul Strand, Close-up on the Long View." *Saturday Review*, December 18, 1971, p. 20.

Whitman, Alden, "Paul Strand, Influential Repertory of the Literature of Art." *New York Times*, April 2, 1976, p. 36.

Zabel, Barbara, "Machine as Metaphor, Model and Microcosm: Technology in American Art, 1915–1930." *Arts Magazine*, 57: 100–5 (December 1982).

PUBLICATIONS BY

"Address by Paul Strand." *Photo Notes*, pp. 1–3 (January 1948).

"Aesthetic Criteria." *The Freeman*, 2: 426–27 (January 12, 1921). Letter to the Editor.

"Alfred Stieglitz and a Machine." New York, privately printed, 1921. Reprinted in *Manuscripts*, 2: 6–7 (March 1922). Rewritten for *America and Alfred Stieglitz*, Waldo Frank et. al., eds., New York, The Literary Guild, 1934, pp. 281–85.

"Alfred Stieglitz 1864–1946." *New Masses*, 60: 6–7 (August 6, 1945).

"*An American Exodus* by Dorothea Lange and Paul S. Taylor." *Photo Notes*, pp. 2–3 (March–April 1940).

"American Watercolors at The Brooklyn Museum." *The Arts*, 2: 148–52 (December 1921).

"The Art Motive in Photography." *British Journal of Photography*, 70: 613–15 (October 5, 1923). Précis of text and notes of discussion in "The Art Motive in Photography: A Discussion." *Photographic Journal*, 64: 129–32 (March 1924).

"Correspondence on [Louis] Aragon." *Art Front*, 3: 18 (February 1937). Comment on Aragon's "Painting and Reality," *Art Front*, 2: 7–11 (January 1937).

"The Forum." *The Arts*, 2: 332–33 (February 1922). Letter to the Editor in reply to one by Carl Sprinchorn in *The Arts*, 2: 254–55 (January 1922), which was in response to Strand's article "American Watercolors at The Brooklyn Museum:" *The Arts*, 2: 148–52 (December 1921).

"From a Student's Notebook." *Popular Photography*, 21: 53–56, 174, 176 (December 1947). Various quoted remarks from a lecture at the Institute of Design, Chicago.

"Georgia O'Keeffe." *Playboy*, 9: 16–20 (July 1924).

"The 'Independents' in Theory and Practice." *The Freeman*, 3: 90 (April 6, 1921).

"Italy and France." *U.S. Camera Yearbook 1955*, New York. U.S. Camera Publishing Corp., 1954, pp. 8–17.

"John Marin." *Art Review*, 1: 22–23 (January 1922).

Kleinholtz, Frank. "Paul Strand: Radio Interview." *American Contemporary Art*, 2: 10–13 (May–June 1945).

Various quoted remarks from an interview, "Art in New York." WNYC, April 25, 1945.

"Lachaise." *Second American Caravan*, A. Kreymborg et. al., eds., New York: The Macaulay Co., 1928, pp. 650–58.

"Les Maisons de la Misere." *Films*, 1: 89–90 (November 1939).

"Manuel Alvarez Bravo." *Aperture*, 13 (4): 2–9 (1968). Excerpt reprinted in *Manuel Alvarez Bravo*, by Fred R. Parker, Pasadena, Pasadena Art Museum, 1971.

"Marin Not an Escapist." *The New Republic*, 55: 254–55 (July 25, 1928).

"The New Art of Colour." *The Freeman*, 7: 137 (April 18, 1923). Letter to the Editor in response to Willard Huntington Wright, "A New Art Medium," The Freeman, 6: 303–04 (December 6, 1922).

"Painting and Photography." *The Photographic Journal*, 103: 216 (July 1963). Letter to the Editor in response to John Berger's "Painting—or Photography?" *The Observer Weekend Review* (London), February 24, 1963, p. 25.

"Paul Strand Writes a Letter to a Young, Photographer." *Photo Notes*, pp. 26–28 (Fall 1948).

"Photographers Criticized." *New York Sun*, June 27, 1923, p. 20. Letter to the Editor in response to Arthur Boughton's letter, "Photography as an Art." *New York Sun*, June 20, 1923, p. 22, which in turn was a response to an article by Charles Sheeler, "Recent Photographs by Alfred Stieglitz," *The Arts*, 3: 345 (May 1923).

"Photography." *Seven Arts*, 2: 524–25 (August 1917). Reprinted in *Camera Work*, 49–50: 3–4 (June 1917).

"Photography and the New God." *Broom*, 3: 252–58 (November 1922). Reprinted in *Photographers on Photography*, Nathan Lyons, ed., Englewood Cliffs: Prentice-Hall, Inc. 1966, pp. 138–44.

"Photography to Me." *Minicam Photography*, 8: 42–47, 86, 90 (May 1945).

"A Picture Book for Elders." *Saturday Review of Literature*, 8: 372 (December 12, 1931). Review of *David Octavius Hill* by Heinrich Schwarz.

"A Platform for Artists." *Photo Notes*, pp. 14–15 (Fall 1948). About the Progressive Party's plank on the arts.

"Power of a Fine Picture Brings Social Changes." *New York World-Telegram*, March 4, 1939, p. 11. Various quoted remarks concerning the making of *The Wave*.

"Realism: A Personal View." *Sight and Sound*, 18: 23–26 (January 1950). Reprinted as "International Congress of Cinema, Perugia." *Photo Notes*, pp. 8–11, 18 (Spring 1950).

Sabine, Lillian, "Paul Strand, New York City." *The Commercial Photographer*, 9: 105–11 (January 1934). Various quoted remarks.

"El Significado de la Pintura Infantil." *Pinturas y Dibujos de los Centros Culturales*, Mexico City, Departamento del Distrito Federal, Dirección General de Acción Cívica, 1933.

"A Statement." *Photographs of People by Morris Engel*, New York: New School for Social Research, 1939. Reprinted in *Photo Notes*, December, 1939, p. 2.

"Steichen and Commercial Art." *The New Republic*, 62: 21 (February 19, 1930). Letter to the Editor in reference to Paul Rosenfeld's "Carl Sandburg and Photography." *The New Republic*, 62: 251–53 (January 22, 1930).

"Stieglitz, An Appraisal." *Popular Photography*, 21:62, 88, 90, 92, 94, 96, 98 (July 1947). Reprinted in *Photo Notes*, pp. 7–11 (July 1947).

"The Subjective Method." *The Freeman*, 2: 498 (February 2, 1921). Letter to the Editor concerning various pieces by Walter Pach.

"Weegee Gives Journalism a Shot for Creative Photography." *PM* (New York), July 22, 1945, pp. 13–14.

Weiner, Sandra, "Symposium Report." *Photo Notes*, pp. 8–9 (Spring 1949). Various quoted remarks.

BOOKS AND EXHIBITION CATALOGS

Adams, Robert, *Paul Strand: Essays on His Life and Work*. New York: Aperture, 1987.

Alfred Steiglitz Presents Seven Americans. New York, Anderson Gallery, 1925.

Archive Twenty-Seven: Paul Strand and Ansel Adams. Pittsburgh, 1992.

Camera Work, no. 48, October 1916.

Camera Work, no. 49–50, June 1917.

Concept and Realisation. Kaspar Fleischmann, Zurich, 1987.

Duncan, Catherine, *Paul Strand: The World On My Doorstep 1950–1976.* New York: Aperture, 1994.

La France de Profil. Text by Claude Roy. Lausanne, La Guilde du Livre, 1952. Text excerpted as "An Appreciation of Paul Strand." *U. S. Camera 1955,* New York: U.S. Camera Publishing Corp., 1954, pp. 19, 23, 26.

Ghana, An African Portrait. Text by Basil Davidson. Millerton, New York: Aperture, 1975.

Greenough, Sarah, *Paul Strand: An American Vision.* Aperture Foundation in association with the National Gallery of Art, Washington, 1990.

Grundberg, Andy, "Photography View: Who's More Old-Fashioned—Strand or Atget?" *New York Times,* October 17, 1982, pp. 35, 38.

Hambourg, Maria Morris, *Paul Strand, Circa 1916,* The Metropolitan Museum of Art, New York, 1998.

Haworth-Booth, Mark, *Paul Strand.* Paris, Nathan Image, 1990.

Lachaise, Gaston, *Paul Strand, New Photographs.* New York, The Intimate Gallery, 1929.

Living Egypt. Text by James Aldridge.

Dresden, VEB Verlag der Kunst, 1969. Also published in London, MacGibbon and Kee, 1969, and in New York, An Aperture Book, Horizon Press, 1969. Introductory text excerpted in *Creative Camera,* 63: 330–31 (September 1969).

McCausland, Elizabeth, *Paul Strand.* Springfield, privately printed, 1933.

Newhall, Nancy, *Paul Strand: Photographs 1915–1945.* The Museum of Modern Art, 1945.

Paul Strand. Zurich, Zur Stockeregg, 1987.

Paul Strand Volume II. Zurich, Zur Stockeregg, 1990.

Paul Strand Collection. Tuscson, University of Arizona, 1980.

Paul Strand. Brussels, L'Administration Générale des Affaires Culturelles Françaises, 1969.

Paul Strand. Foreword by Siegfried Huth. Freital, Haus der Heimat Kreismuseum, 1969.

Paul Strand: A Retrospective Monograph. One-volume and two-volume editions, with text selections from various sources. Millerton, New York: Aperture, 1971.

Paul Strand, Masters of Photography Series. New York: Aperture, 1987. Essay by Mark Haworth-Booth.

Photographs of Mexico. Foreword by Leo Hurwitz. New York, Virginia Stevens, 1940. Also published as *The Mexican Portfolio,* with Preface by David Alfaro Siqueiros, New York, produced by Aperture for DaCapo Press, 1967.

Peters, Gerald P. and Megan Fox, *Paul Strand: An Extrordinary Vision.* Sante Fe, Gerald Peters Gallery, 1995.

Rebecca. New York, Robert Miller Gallery, 1996.

Rosenblum, Naomi, *Paul Strand: The Stieglitz Years at 291 (1915–1917).* New York, Zabriskie Gallery, 1983.

——, *Orgeval: A Rememberance of Paul Strand.* Toronto: Lumiere Press, 1990.

Steichen, Edward and Museum of Modern Art, *Diogenes With a Camera III,* New York, The Museum of Modern Art, 1956.

"Stieglitz and Strand." *Photographic Journal,* 3, 3 (May–June 1986) pp. 10–13.

Time in New England. With Nancy Newhall. New York, Oxford University Press, 1950.

Tir a'Mhurain. Text by Basil Davidson. Dresden: VEB Verlag der Kunst, 1962. Also published in London: MacGibbon and Kee, 1962, and in New York: An Aperture Book, Grossman, 1968.

Yates, Steve, *The Transition Years: Paul Strand in New Mexico.* Tucson, University of Arizona Press, 1989.

Tucker, Anne, *Target II: Five American Photographers.* Houston, The Museum of Fine Arts, 1979.

Un Paese. Text by Cesare Zavattini. Turin, Giulio Einaudi, 1955. Reprinted by Aperture, 1997.

Un paese vent'anni dopo. Text by Cesare Zavattini. Torino, G. Einaudi, 1976.

Vrba, Frantisek, *Paul Strand,* Prague, *Státni nakladatelstvi krásné literatury a umeni,* 1961. Text also in English translation.

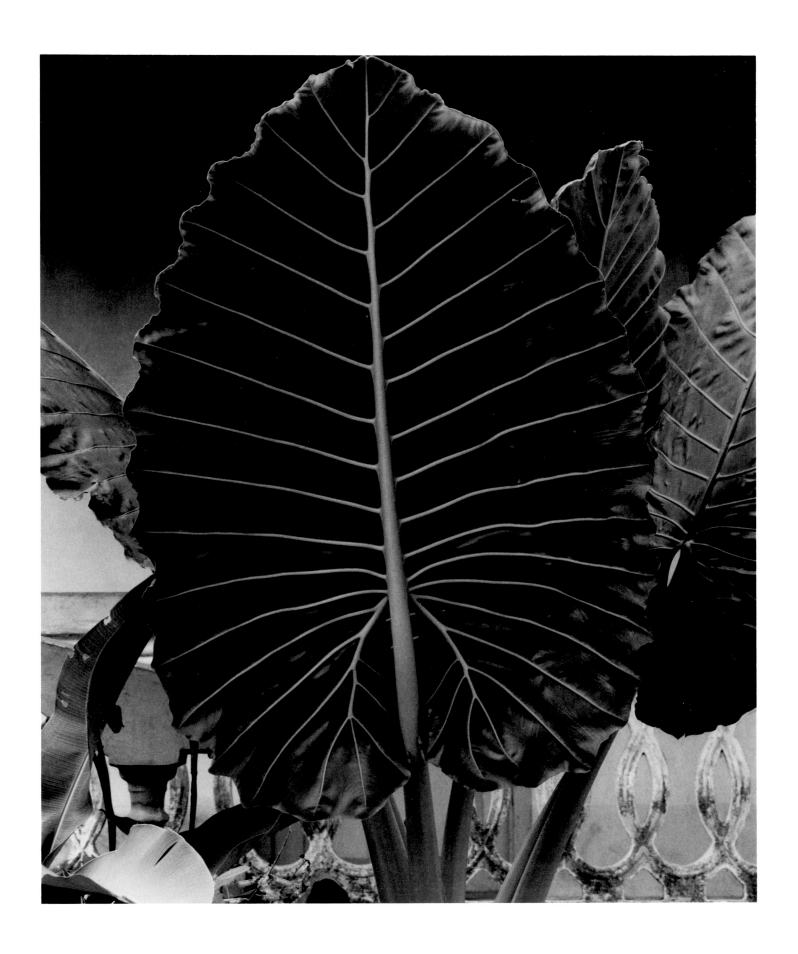

183 Big Leaf, *Ghana 1963*

DATE DUE

OCT 1 2 2004	
DEC 0 6 2004	
DEC 1 4 2012	
MAR 0 3 2024	

GAYLORD PRINTED IN U.S.A.